Universe

AIRE'S 2001

DESIGNERS OF THE NEW AVANT-GARDE

By Stephen Gan
Edited by Alix Browne

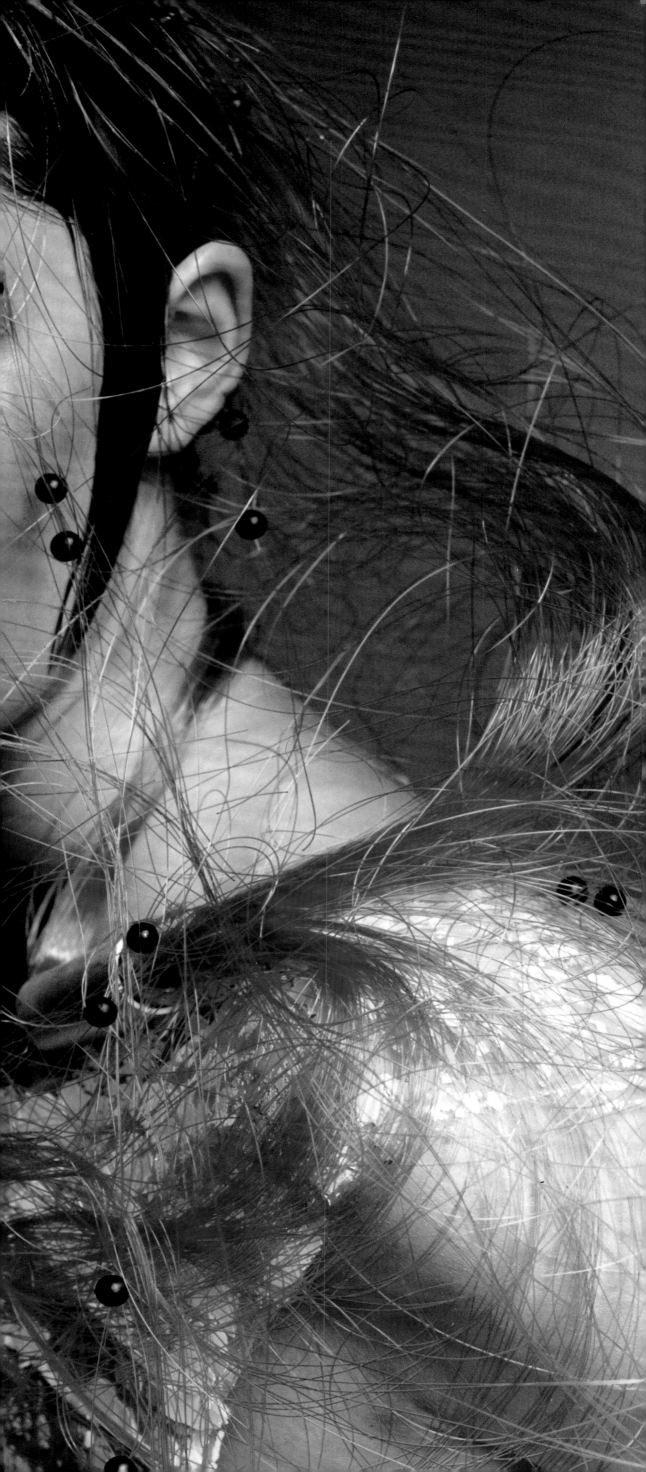

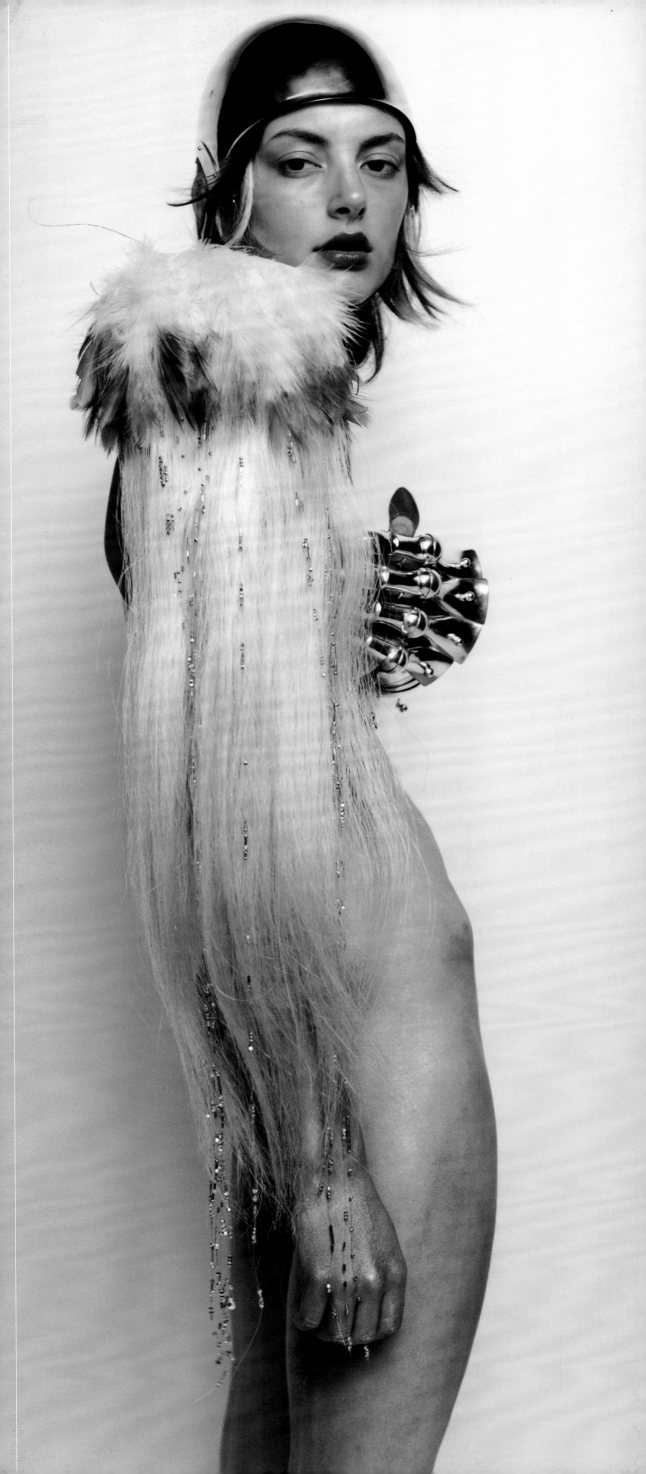

Text: Alix Browne Mark Holgate Sally Singer
Art Direction: Stephen Gan Greg Foley
Produced by: Jorge Garcia Vanessa Bellugeon
Visionaire Design: Judith Schuster Jake McCabe
Junko Honda Heiko Keppel Chris Sams
Thanks to: James Kaliardos Cecilia Dean Tenzin Wild

Front Cover Photo: Inez van Lamsweerde and Vinoodh Matadin
Tuxedo by Viktor & Rolf
Makeup James Kaliardos Hair Danilo Lighting Jodokus Driessen
Model Shalom Harlow

Opening Photo Series by Mario Testino
Clothes in order of appearance:
Dress by Johanne Mills Neckpiece by Amanda Mansell
Shoulder piece by Julien MacDonald Glove and helmet Olle Olls
Dress by Deborah Milner Headpiece by Erik Halley
Dress by Alexander McQueen Ring by Olle Olls
Styled by Isabella Blow Fashion Assistant Emine Saner
Hair Marc Lopez Makeup Ellie Wakamatsu
Model Honor Fraser

Universe Publishing
Publisher: Charles Miers
Senior Editor: Alexandra Tart
Managing Editor: Bonnie Eldon
Associate Editor/Foreign Rights: Ilaria Fusina
Production Manager: Belinda Hellinger
Associate Production Manager: Scott Lavelle

First published in the United States of America in 1999
by UNIVERSE PUBLISHING
A Division of Rizzoli International Publications, Inc.
300 Park Avenue South
New York, NY 10010

©1999 by Stephen Gan

Library of Congress Catalog Card Number: 99-71279

Printed in China

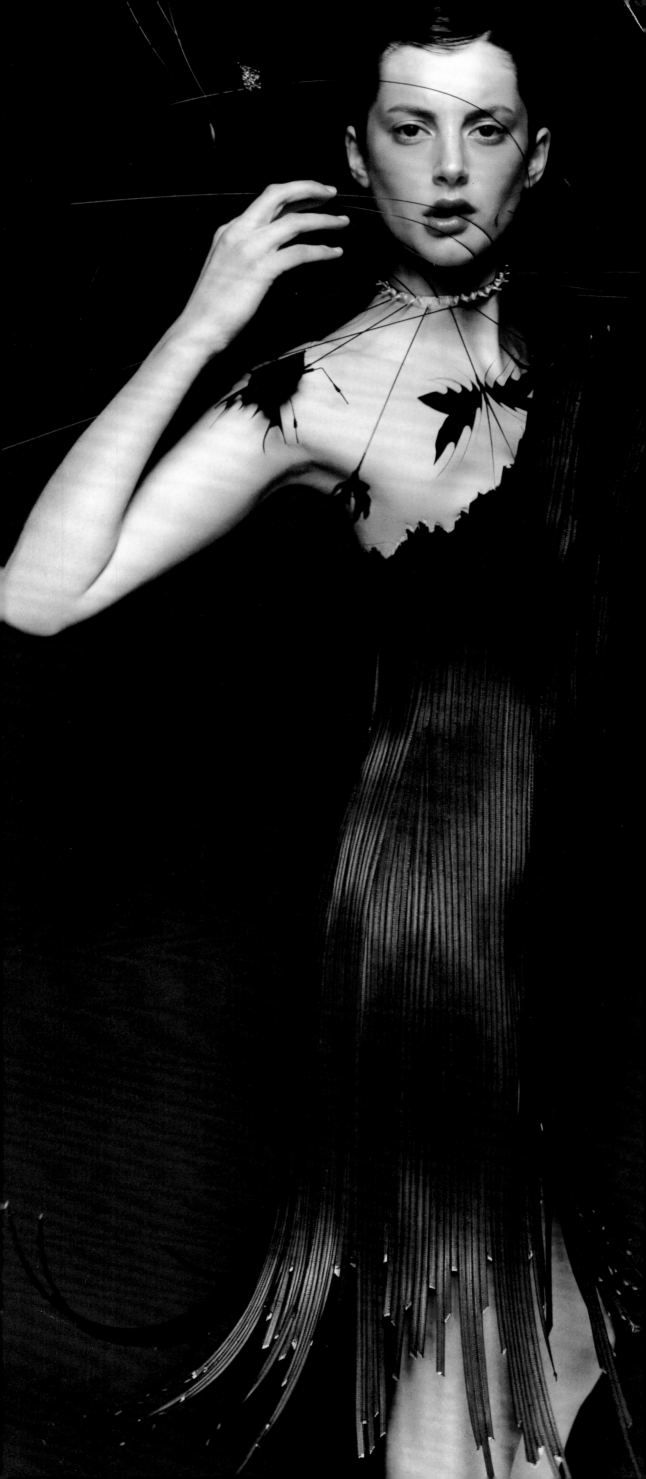

FOREWORD

Since we first published *Visionaire's Fashion 2000* nearly three years ago, an entirely new generation of designers has pushed its way to the forefront. Back then, such names as Raf Simons, Véronique Branquinho, Jeremy Scott, Nicholas Ghesquière, and Josephus Thimister were just starting to creep into our creative consciousness. Now they are becoming a force to be reckoned with. The idea for *Fashion 2001*, a book devoted to the designers of the new avant-garde, came about. In fashion the term "avant-garde" is often used euphemistically, a nicer way of saying "weird," or commercially unviable, or just plain difficult. In formulating our personal definition we tended to throw out such words as brave, exciting, unconventional, and forward-thinking. We found talent germinating in cold, dark basements and garret studios, parking garages and art galleries. Names were enthusiastically volunteered by photographers, stylists, and other intrepid fashion scavengers. And some sixty-four designers later, we could have kept going. "Newness" was not always an operating qualification for admittance (in fashion more than any other discipline, new is so often mistaken for good). This said, there are some important designers we've included—Walter Van Beirendonck, Stephen Jones, Dirk Van Saene, to name a few—who've been around for many years, but whose work continues to produce the same flesh-chilling, mind-blowing effect it has since day one. The majority of the names collected here, however, are new, and if you don't recognize a lot of them, well, that's the point. In the grand scheme of fashion, many of these designers register only as small blips, working as they do out of their bedrooms or borrowed studio spaces and producing their clothes as one-offs or in extremely limited quantities. But if you measure these designers not in terms of sales but in terms of their ideas and the passion and dedication they bring to what they do, their impact is incalculable. Their work is at once inspired and inspiring. Most of the images you will see here they conceived and produced specifically for this book as an exercise in self-reflection. And if the recent installation of such innovators as Martin Margiela and Hussein Chalayan at such commercial powerhouses as Hermès and TSE is any indication of the way the general perception is being altered, there may very well be a market waiting to embrace these young avant-gardists with open arms and minds. This book is a celebration of all of those designers who, by simply following their own visions, challenge us to rethink our own.

Stephen Gan
Alix Browne

A. F. Vandevorst
Akira Isogawa
Alain Tondowski
Alber Elbaz
Andrew Groves
Ann-Sofie Back
Benoît Méléard
Bernhard Willhelm
Bless
Boudicca
Bruce
Christian Louboutin
Consuelo Castiglioni
Dai Rees
Dirk van Saene
Erik Halley
Fee Doran
Francesca Amfitheatrof
Fred Sathal
Fredie Stevens
Hedi Slimane
Jeremy Scott
Jessica Ogden
Josephus Thimister
Jurgi Persoons
Keupr/van Bentm
Kostas Murkudis
Lainey Keogh
Lawrence Steele
Marcel Verheijen
Maria Chen
Maria Cornejo
Mark Kroeker
Mark Whitaker
Matthew Williamson
Morteza Saifi
Nicolas Ghesquière
Niels Klavers
Olivier Theyskens
Oscar Suleyman
Pascal Humbert
Pierre Hardy
Raf Simons
Richard James
Rick Owens
Robert Cary-Williams
Rodolphe Menudier
Roland Mouret
Sarah Harmarnee
Saskia van Drimmelen
Scott Wilson
Sharon Wauchob
Shelley Fox
Shinichiro Arakawa
Sophia Kokosalaki
Stella McCartney
Stephen Jones
Timothy Everest
Tristan Webber
Véronique Branquinho
Viktor & Rolf
Walter van Beirendonck
Xuly-Bët
Yoshiki Hishinuma

DESIGNERS A-Z

An Vandevorst and Filip Arickx, the design team behind A. F. Vandevorst, are not driven by a combative give-take dynamic in which the friction between two creative minds throws off sparks of ingenuity. "Thinking, designing, and other thousands of small things that are elementary to building a collection are all done by the two of us—or better, the one of us," they say. Arickx describes An as having grown up surrounded by contemporary art, which nurtured her own artistic impulses. "First she experimented on her own appearance," he says. "She wanted to express herself and create things, and she thought she'd surely find a way in fashion." Vandevorst tells the story of a young boy growing up in a hardworking family whose parents taught him that to enjoy things was the major goal in life. "He was looking for a way to express his enthusiasm; he knew that for a lot of people, personal appearance is one of the main concerns, so he decided to go deeply into that subject." The two met in 1987, on their first day of classes at Antwerp's Royal Academy of Art. After graduating in 1991, Arickx, who as a teenager had worked for Dirk Bikkembergs, went to fulfill his military obligations, while Vandevorst became the assis-

Photography Ronald Stoops

tant to Dries Van Noten. They presented their first collection together as A. F. Vandevorst in Paris in March 1998. They are not interested in clothes as a means of transformation, but as an expression of an interior landscape— or, in their words, "adding a certain value by creating a transparent packing of the inner." In one collection, in which fragments of a woman's wardrobe were executed in tough leather, soft wool, worn corduroy, and filmy chiffon, zipped or snapped together in a system of interchangeable layers (both literal and figurative), they explored the duality of women, evoking the image of a headstrong woman caught in a moment of hesitation, or a woman at the end of her days searching her past for regrets. Such an emotional investment engenders a sense of vulnerability in their clothes, and it has been suggested to Arickx and Vandevorst that perhaps they should have followed their "guardian angel," Joseph Beuys, and become artists instead. But if somewhere a woman ends up with what she sees merely as a few beautiful pieces of clothing, there is reward for them in that, too. It's like raising a child, they explain. You put so much of yourself into it and then you have to give it away. —AB

A. F. VANDEVORST

> Photography Ronald Stoops Makeup Inge Grognard Hair Johny Drill

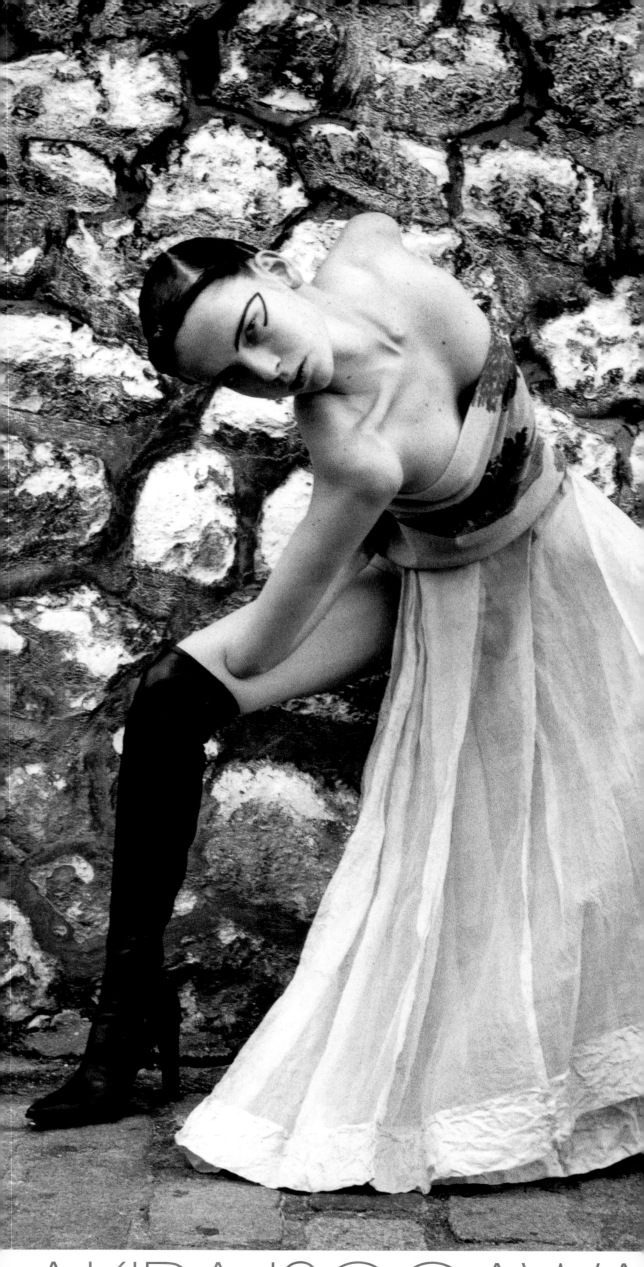

AKIRA ISOGAWA

To launch an international fashion line from the Eastern hemisphere is no simple task. For whom do you design—and, more critical, what do you produce—when your fall/winter is spring/summer in New York, Paris, and Milan? For Akira Isogawa, a thirty-three-year-old resident of Sydney, Australia, the secret to securing a global market is to offer garments of singular, exotic beauty and seasonless functionality. Since 1993, when he opened his boutique in Woollahra, Isogawa has draped and sculpted breathtaking pieces from muslins, fine dyed cottons, antique kimono silks, and velvet laces to worldwide acclaim. Isogawa borrows liberally from classic Japanese and East Asian sartorial techniques and finishings: shiburi dying—in which kernels of rice are stitched individually into a cloth to form small pockets before submersion into color—enlivens sarongs; kimono-shaped jackets and dresses wrap or are bound by obis. He is not, however, in the business of producing ethnic costumes. Instead, he uses traditional forms to both soften and streamline modern silhouettes. A shiburi-dyed amethyst sarong takes the form of a graphic, narrow columnar skirt; a short quilted wrap jacket (lined in vivid floral silk) is both rigidly architectural

Photography Jean-François Carly Makeup and hair Peter Philips Model Zora Starr

and lusciously opulent. "'East meets West' is a global consciousness," said the Japanese designer. "I believe the whole world is cross-culturing." But for all the exoticism and sumptuousness, Isogawa is rooted in an earthy practicality that is uniquely Australian. For fall/winter 1999 he fashioned layerable separates which reversed from rough-hewn wools and muslins to scrumptious velvet dévorés in shimmery reds and blacks. "I thought about traveling to some cold country and having clothes which could cover all aspects of the adventures that could occur," he explained. This need for all-purpose, all-climate gear is one that Isogawa well understands, for he increasingly finds himself en route to Europe and America. Although he presents his collection during Australian fashion week, he meets international retailers and editors during the Paris prêt-à-porter. "The clientele in Australia is small, so I must seek new markets abroad." He has no plans, though, to depart permanently from the antipodes. "Australia provides an endless source of natural stimulation. There is so much nature and space to inspire one. My role as a designer living here is to express the uniqueness of my country."

—SS

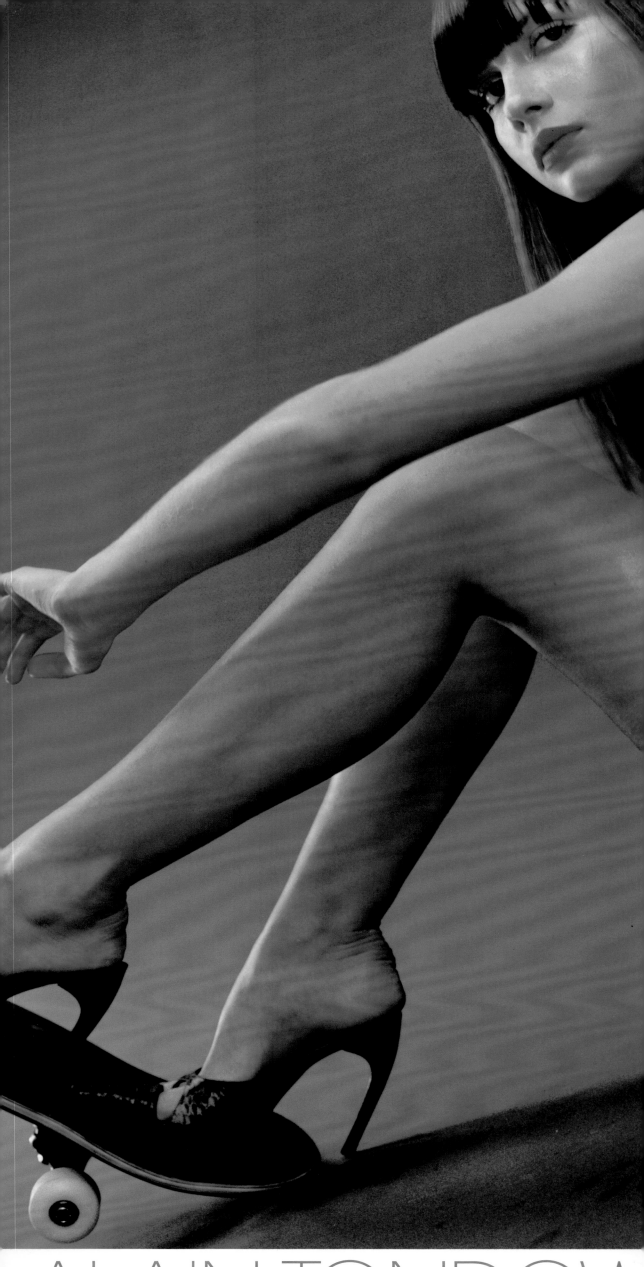

Alain Tondowski is a very tall man with very big feet and an enormous passion for shoes to match. The French designer has been drawing, doodling, and dreaming about shoes for as long as he can remember. "I don't know why," Tondowski says. The most plausible explanation is that like his impressive feet and his imposing height, his infatuation is something he inherited. "Maybe it was because my mother was crazy about shoes," he says. Tondowski studied fashion at Paris's Studio Berçot from 1987 to 1989, and after graduating he spent a year working for Stephane Kélian and then four years at Christian Dior, stepping out on his own in 1997. From fifties kitsch and the succinct Japanese minimalism of the '80s to old European movies and the neo-punk movement, his far-flung and seemingly mutually exclusive inspirations harmoniously converge in the form of bright, pop colors, python and pony skin, irreverent touches of gold chain, and strips of industrial latex. If there is a unifying principle at work, it's Tondowski's distinctive and borderline-radical sense of architecture. "If I weren't making shoes, I'd probably be doing furniture," says the designer, who at times has to remind himself that shoes

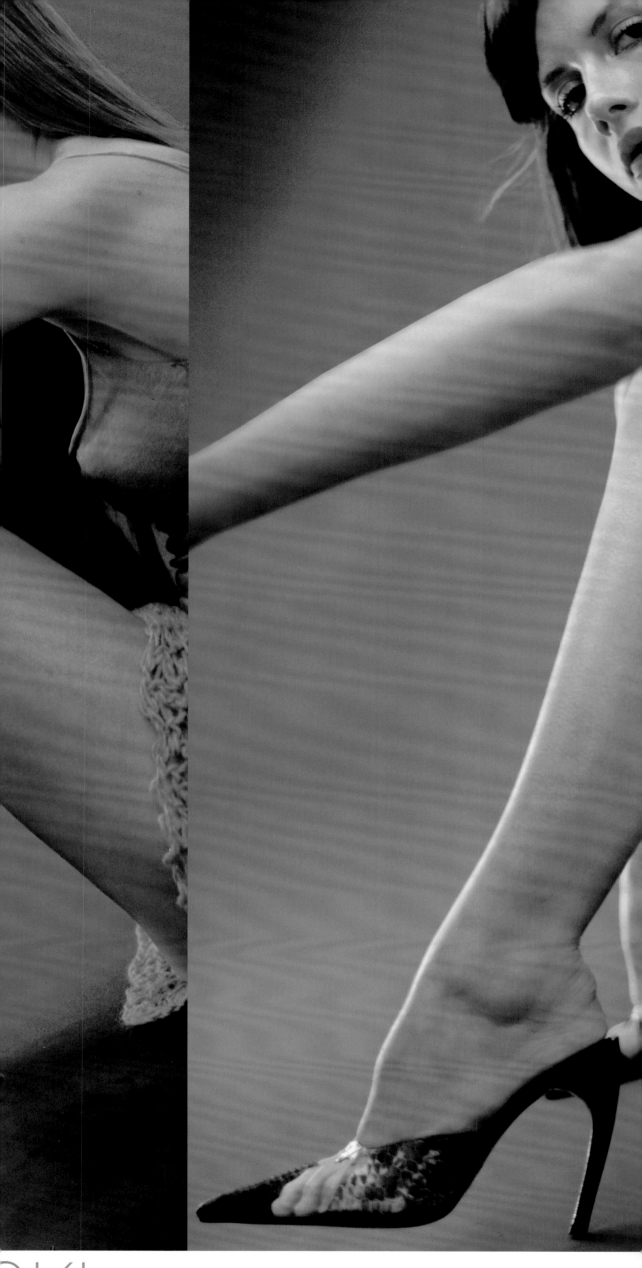

are not objects of pure design, but accessories intended for more pedestrian consumption. Tondowski likes to play angle against curve. The lines are aggressively attenuated but rarely severe, supported at turns by the shiny geometric pedestals he calls hammers or a slender and subtly carved heel. (The latter, it has been pointed out, bears a certain resemblance to a Roger Vivier classic, but Tondowski says he actually picked up the idea from a pair of fetishistic shoes designed by an Austrian shoemaker.) As for the woman he imagines standing up to such shoes? Nina Hagen and Deborah Harry come to mind. Or the character played by Catherine Deneuve in the Luis Buñuel film *Belle de Jour*. "Not Deneuve herself. A bourgeois woman who goes to a hotel to live out a certain fantasy," Tondowski says, explaining the nuances of the reference. And in a way, his shoes do have a similar transformative effect. "It's a different way of showing femininity. I try to mix these references. A woman who has a real sense of power, not like men," he says, repeating the words again slowly and in French for emphasis: "Une femme qui a du pouvoir." And who is no doubt as passionate about shoes as he is. —AB

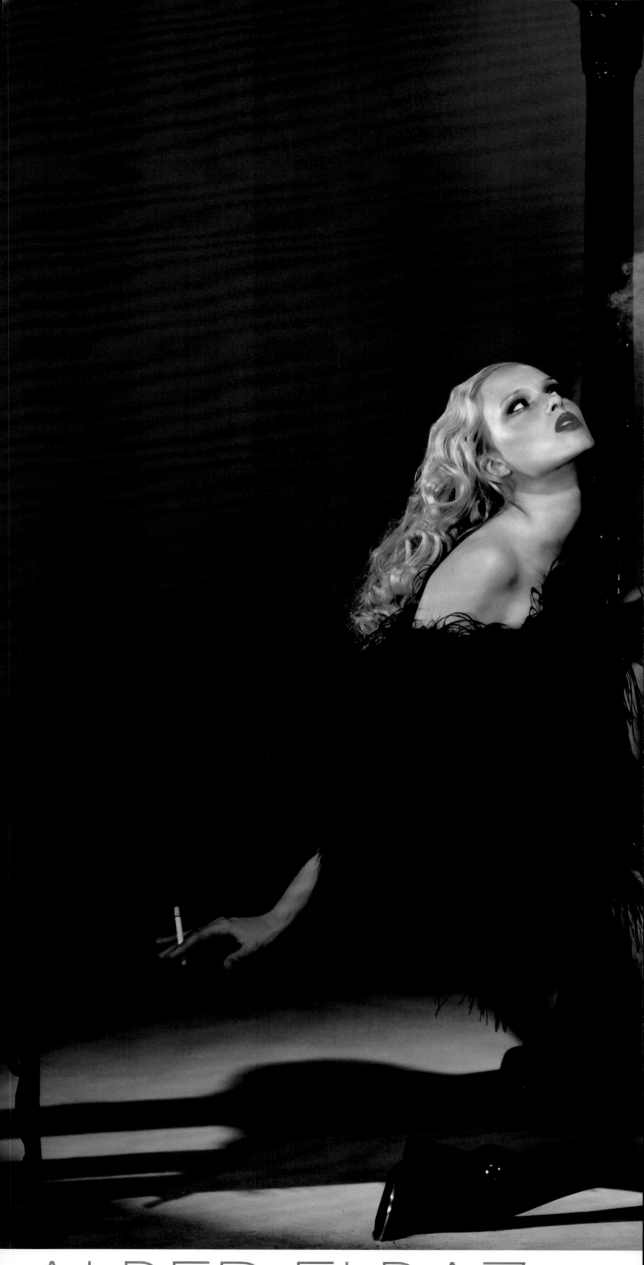

ALBER ELBAZ

A full-force Yves Saint Laurent revival has been a long time coming. Over the past several years there have been stirrings in the form of *petits homages* to *les années seventies* in collections by Marc Jacobs, Tom Ford at Gucci, and even Helmut Lang. But instead of fading away into fashion history, the house of Yves Saint Laurent brought in Alber Elbaz to reinvigorate—and, after one season, the indications are strong—reinvent the Saint Laurent legacy for a new generation. Alber Elbaz grew up in Tel Aviv and graduated from Shenkar College, Tel Aviv School of Fashion and Textiles. He made his way to New York City, where after a two-and-a-half year stint with a company that specialized in mother-of-the-bride dresses, he became the assistant to Geoffrey Beene. He stayed with Beene for seven and a half years. The most important thing Beene taught him, Elbaz said, was to be true to himself, not trendy. He carried this advice with him when he was tapped to become the designer for Guy Laroche in 1996. Two years later, Elbaz joined Yves Saint Laurent as artistic director for women's ready-to-wear. In his first collection for Saint Laurent, Elbaz pulled out the family jewels and gave them a thorough

Photography Marcus Mâm **Styling** Claire Dupont **Makeup** Karim Rhamian/Calliste **Hair** Laurent Philippon/bumble+bumble **Location** Studio Zero **Models** Esther Young/City Marlene/Nathalie

dusting. The chubby fox furs, the trench coats, the classic *smoking*. It was an homage not just to the house of Saint Laurent, but to the designer himself. "You can take everything that is wrong and change it to your own," he told *Women's Wear Daily*, "or you can say, 'This house existed for forty years, so let's see what they did right.' Either you destroy the past, or you analyze and continue. I respect the house, and I want to continue." Elbaz's strategy was to try to understand the essence of why rather than what. He left the signatures of the house—the colors, the strong shoulders, the cut of certain garments—and focused his energy on updating the fabrications, adding leather and raincoat fabrics and industrial zippers where there were once chiffon and taffeta and hidden closures. Those who remembered past Saint Laurent shows could not help but be disappointed. But those who hadn't witnessed the original YSL revolution firsthand, who had only seen it in sexually charged photographs by the likes of Guy Bourdin and Helmut Newton, were captivated. "The woman Yves Saint Laurent dressed was that chic seductive woman," Elbaz says. "This is that same woman but for the year 2000." —AB

ANDREW GROVES

Andrew Groves is fashion's great pretender, a young (or youngish, anyway) rogue who can be counted on to unleash swarms of insects into an unsuspecting audience, or commission accessories made of pubic hair, or set the runway on fire. Like Alexander McQueen, the designer to whom he is most often compared, Groves has an innate sense of the theatrical. His background in fashion includes a year spent with a traveling carnival, stints wardrobing for various ballet troupes, and the successful completion of an advanced two-year course at Saint Martins. His graduation collection, "Ordinary Madness," was inspired by turn-of-the-century drawings by the mentally ill and included pieces studded with four-inch nails and a skirt covered in two thousand dressmaker's pins. "I've always liked extreme things," Groves explains. "I don't like the airy-fairy approach. I want to challenge people's ideas. I don't see the point in doing it otherwise." But while Groves's unsettling clothing has definitely struck a nerve, his penchant for the extreme has also had the tendency to get on people's nerves. Take the insects, for example. Groves's first runway presentation, "Status," featured exaggerated '80s-style shoulderlines and compli-

Photography Jean-François Carly

cated threadwork that affected a desired state of decay. "I wanted to show what was inside that was eating the clothes away," says Groves, who, not able to leave well enough alone, attempted to breed flies from maggots in his studio. In "Our Selves Alone," (translation for the Gaelic *Sinn Fein*), a dark and serious collection of gray suits paired with white shirts and orange sashes and an entire section cut from charred green silk taffeta (lest his audience didn't get the message), Groves set up three thirty-foot burning crucifixes outside after the show. "You have to know what you're taking and use it very carefully," says Groves, who claims he's not just in it for the tabloid headlines. "You are always aware of what you're doing, but you don't know how people will take it or whether they'll even pick up on it at all." What people are picking up on, however begrudgingly, is the fact that there is substance behind all the smoke and horrors. "I'm actually very classical when it comes to cutting," Groves says, offering up this irresistible anecdote: "Lord Litchfield once told me my clothes reminded him of the clothes his mother used to wear. I asked him who made his mother's clothes. He said, 'Charles James.'" —AB

ANN SOFIE BACK

Ann Sofie Back would have you believe that her clothes are boring and dull, that they are marked by the pedestrian, the mundane, and the just plain ordinary—things, she says, that are so common you scarcely realize they are there. And perhaps you would not want to live in that small, gray place from which she draws much of her inspiration (the suburbs of Stockholm, where she grew up), but looking at her clothes, you might come to the conclusion that it would be an interesting place to visit. Back, who attended Bechmans School of Design in Stockholm and went on to complete an M.A. at Saint Martins in London, presented her first collection in the spring of 1998. She describes her approach to fashion as "suburban/realistic," meaning that the pieces are not "intelligent or intellectual," and that they are very easy to copy. Twisted schoolgirl skirt/pants, pleated high-neck cotton blouses, and other reconfigured articles of everyday life are among the pieces that make up her body of work. "I would never want to walk around and be mistaken for a concept," she says. If there is a lofty idea at work here, it is to make a kind of democratic fashion, accessible to all. Back may be an idealist, but she is

Photography Mattias Karlsson Collage by Ann-Sofie Back

hardly a perfectionist. Imperfection, in fact, is something she actively pursues. She works in decidedly unfash-ionable fabrics such as misdyed cotton jersey, denim, wool/polyester blends, and sweatshirt fleece, as well as more "aspirational" fabrics that lie about their not-so-glamorous past (cheap lamé, for example) and their "true identity as crap." Back herself is not above cheating on the solution to the design. She has made "fake" cable-knit sweaters. She will dye half the garment because she can't decide on the color, or she will simply leave it unfinished. If the toile goes wrong, she makes no attempt to fix it; the resulting garment will retain the faults for everyone to see. And if her clothes raise more questions than they answer, that is her intent. "I show ambivalence and indecisiveness in the actual finished garment," Back says. Compounding this are the strange masquerade accessories she makes to go with her collections—clip-on hairdos and masks made from netting, with the mouth and eyes applied with makeup to distort the face and exaggerate imperfections. "It is naive to think that fashion makes you able to express yourself in an honest way," Back says. "Most people lie with clothes." —AB

BENOÎT MÉLÉA

Benoît Méléard doesn't like to use the word sexy to describe the shoes he makes. He prefers the word sex. Sexy is too gentile, he says. And Méléard is right. His shoes could make a stiletto blush. They are all sex, and no innuendo. Many of his designs scarcely resemble shoes at all. They look like boxes or hooves, unforgiving architectural encasements for the foot. Some of his more shoelike designs titillate with a generous glimpse of décolletage. In other words, toe cleavage. "I am always working on the volume," Méléard says. "Not to be vulgar, to be elegant. Strong but elegant." Méléard thinks fashion is inherently cruel, and he may very well have been playing an eye for an eye when he created an extremely high shoe without a heel to stand on. "Everyone works on the shape of the heel," he says. "I wanted to forget about it." His fall '99 collection, in which this shoe made its debut, was called, innocently enough, "tip toe." These heelless marvels came in any number of variations: one pair had metal and leather appendages like airplane wings; another was decorated with buttons (an homage to designer Patrick Kelly); another pair was bound together with a thick strap. Méléard has also created shoes

Photography Les Cyclopes Styling Benoît Méléard Makeup Topolino/Assistant Maya Hair Alexis Imaging Philippe and Christophe/Smith Location Studio Zero Model Debra Shaw/Next

from the hood of a sweatshirt affixed to a block of wood, and shoes with Rapunzel attachments of long silky hair, or sprays of peacock feathers, or stiff side pieces that extend all the way to the shoulder, blurring the line between footwear and clothing. He likes to present these shoes with leotards, lots of leg makeup, and the occasional mask. "I think you can wear them with what you want," he says. "It's not my problem." Méléard, who has worked for both Robert Clergerie and Charles Jourdan, learned to make shoes at AFPIC, a small and exclusive Parisian school. He has won several prestigious awards, and designers such as Jeremy Scott and Pascal Humbert have asked him to make shoes for their shows. In the fall of 1999, Méléard will test his commercial viability when he produces his first collection for the Spanish company Loewe. For now, his own shoes are produced by a Mr. Aris, whose customer base, until Méléard came along, was mostly elderly women. (His previous cobbler didn't work out because he refused to make the models he didn't like, which amounted to a lot of them.) Mr. Aris finally decided that Méléard was not mad; he was an artist. Says Méléard, "I want Paris to become a city of shoes!" —AB

Bernhard Willhelm first became interested in fashion at the age of eighteen, at a time, he says, when fashion was exciting to watch but overrated in terms of its meaning. The young German designer imbues his clothing not with concepts but with his own local history, foregoing the highly philosophical for the highly personal. "When you design, you should always bring aspects of where you come from and where you grew up," Willhelm explains. "It makes it more personal." Willhelm graduated from Antwerp's Royal Academy in 1998 and is still based in that city. He has worked with Alexander McQueen, Vivienne Westwood, Walter Van Beirendonck, and Dirk Bikkembergs, all designers he truly admires. When he presented his first Paris runway collection in the spring of 1999, however, it was obvious that the biggest influence on his designs was Bavaria, the area of southern Germany where he grew up. His clothes are inspired by the folk culture of the region. "The area has a mountain, then a valley, then a mountain, then a valley," he says. "The costumes in each valley are amazing, like they come from outer space—especially the hats." Indeed, the idea for this collection began with a pom-pom hat

Photography Camille Vivier Styling Yasmine Eslami Makeup Tracey Gray/Callisté Hair Maxime/Callisté Location Studio Zero Model Nicolette/Metropolitan

HELM

indigenous to the Black Forest. "Married women wear it in black; available women wear it in red," he says. The collection was comprised of circular skirts; tops cut to look like flowers; dresses with winged sleeves; and a repro-portioned "Sissy, Empress of Austria" riding jacket. There were also hand-knit sock monkeys and dragonflies, pom-pom sweaters, and plenty of hats. He showed the collection on "sweet, normal" girls cast from the street; their awkwardness and decidedly un-mannequin proportions added a note of unselfconscious naiveté. By contrast, the venue was a dark, dungeon-like space that usually served as a Paris nightclub. The result was pure Brothers Grimm: a little creepy, perhaps, but oddly charming in its own way. "When you go to church in Germany, you always wear your best clothes," Willhelm says of the feeling he was trying to convey. "If you have a special jacket or coat, you really look forward to wearing it." Willhelm feels that fashion has become very serious. "No one shows any emotions." For as long as he is able, he intends to be involved in every aspect of the design process. "If you draw something and give it away to someone else to make," he says, "then you don't feel it." —AB

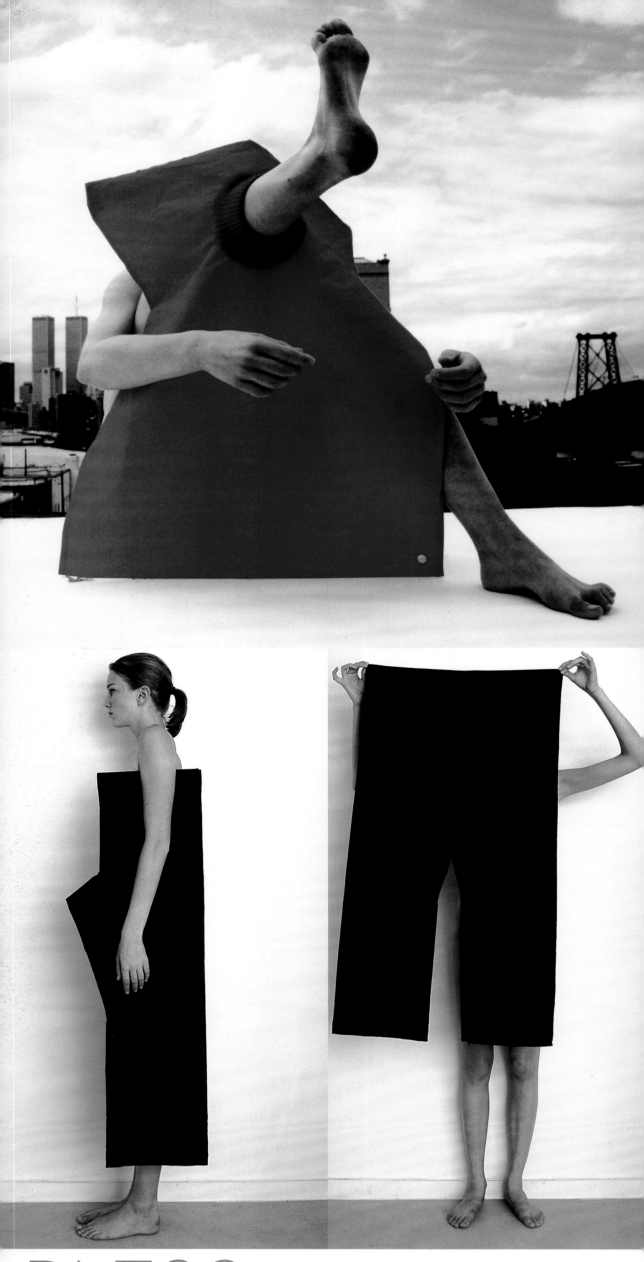

BLESS

"Bless is a visionary substitute to make the near future worth living for. She is an outspoken female—more woman than girl. She's not a chosen beauty, but she doesn't go unnoticed. Without a definite age she could be between her mid-twenties and her forties. She has no nationality and thinks sport is quite nice. She's always attracted by temptations and loves change. She lives right now and her surroundings are charged by her presence." This is how Desirée Heiss and Inez Kaag describe Bless, the label they launched together in 1995. A statement, like the product of their collaboration itself, left deliberately open to interpretation. Heiss, who hails from Paris, graduated from the University of Applied Arts in Vienna. The Berlin-based Kaag studied fashion at the University of Arts and Design in Hannover. The two met by chance when, at a design competition in Paris, they discovered that their work had been displayed next to one another's. A friendship ensued. Then a company. Since then the products they have created under the burgeoning Bless umbrella have included "cut-and-try" recycled raccoon fur wigs (designer Martin Margiela commissioned Heiss and Kaag to make a set of these for

Photography Mark Borthwick

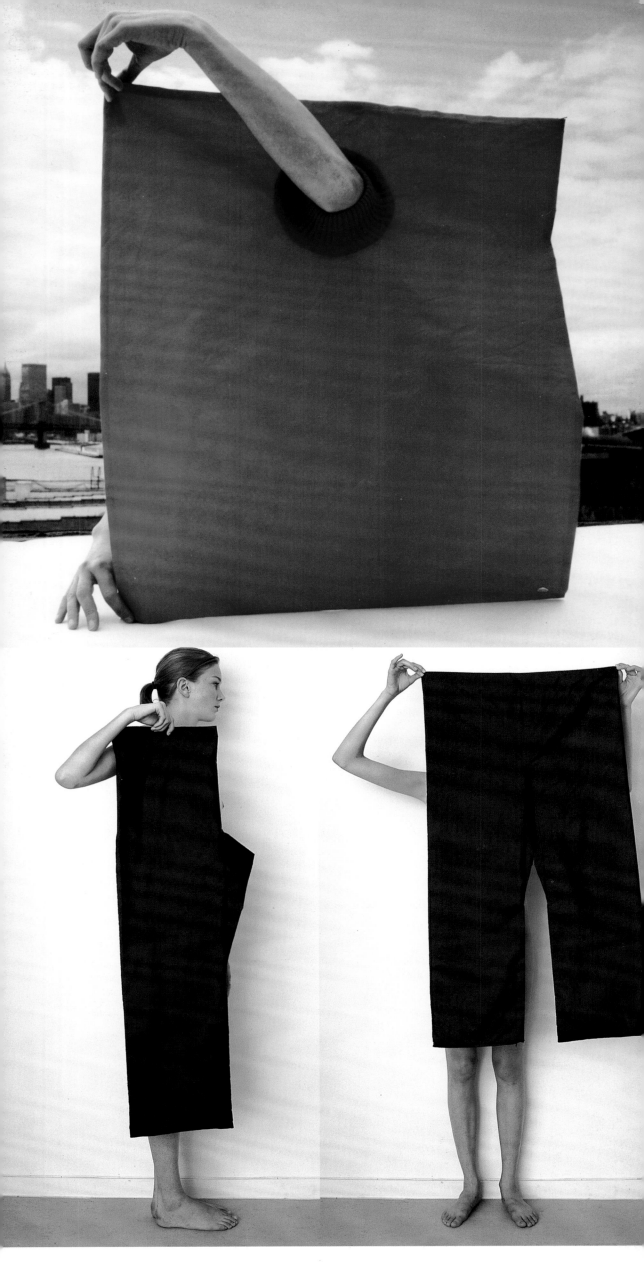

one of his own collections), packages of disposable T-shirts, boot socks, customizable footwear with New Balance or Charles Jourdan soles, material makeup (scraps of paper, leather, and fabric made applicable by a thin elastic band and sold with a suggestive how-to Polaroid), and a series of bags that, depending on which body part you choose to put through which hole, can be manipulated into a variety of useful items of clothing—pants, skirts, tops—or simply carried as, yes, bags. Heiss and Kaag call such inventive, interactive, multipurpose products "Stylefree"; in other words, they are designed to "work against mass individuality and its hidden dangers, i.e. fashion overkill." In effect, what they are doing is encouraging the mindless label-clad fashion masses to break free from their herd mentality simply by giving them a few keys to try. Bless operates on a quarterly schedule, creating each item in a limited edition and taking orders via subscription—a hit-and-run approach that led one magazine to dub them "the unabombers of chic." They view their mission with a decidedly less deadly degree of seriousness. "We just want to break out of the system ourselves." —AB

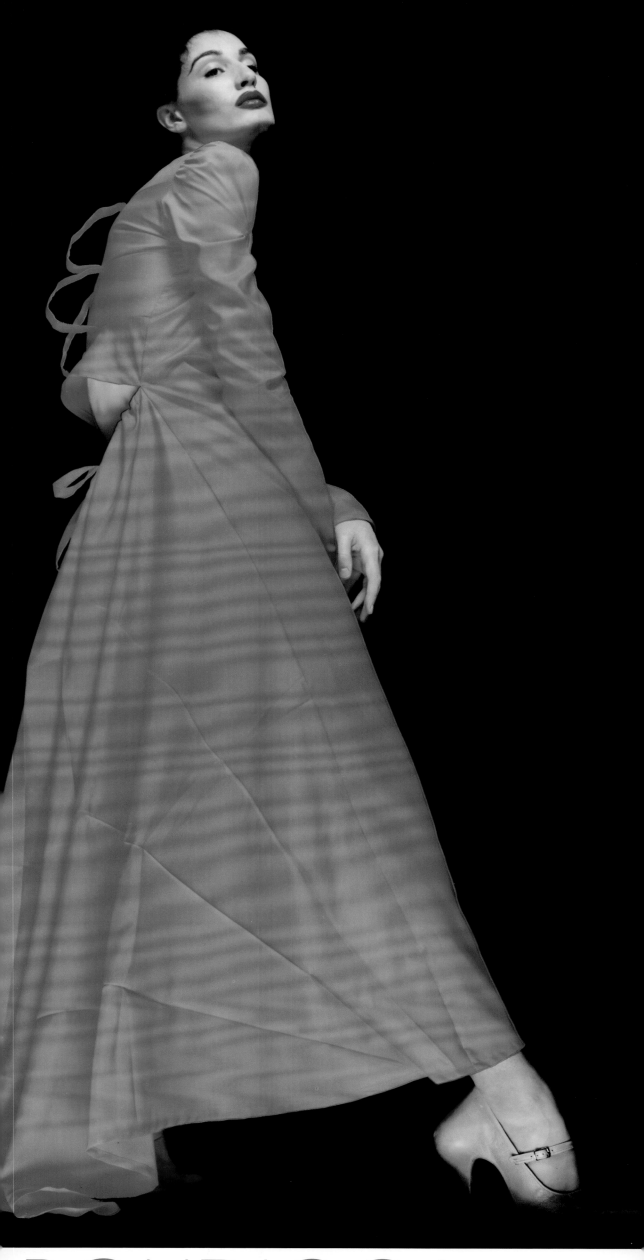

BOUDICCA

Boudicca are Zowie Broach and Brian Kirkby. Kirkby, who is from a small town north of Manchester, England, originally went to school to become a mechanic. He tinkered with his own clothes for some time, and then, realizing that his calling had been misplaced, worked in a factory to save money for art school. Broach claims she'd be peering into petri dishes and staring down microscopes if it weren't for secondhand books, old movies, and the compulsion to create her own clothes and her own image. Both Broach and Kirkby studied fashion at Middlesex University; Kirby went on to do an M.A. in womenswear at London's Royal College of Art. The two eventually crossed paths on a stormy beach in northern Italy; they formed Boudicca in 1996. "Boudicca" is, they explain, the true Iceni pronunciation of Boadicea, the queen of the Iceni tribe who rebelled against Roman rule between 61 and 63 A.D. Broach and Kirkby settled on the name to represent women who show strength in the face of adversity. And if adversity can be described as the pressure to conform to an arbitrary idea of what is fashionable, then their clothes live up to their name. The molded breastplates, deconstructed ball gowns,

Photography Sølve Sundsbø Styling Fiona Dallanegra Makeup Sharon Dowsett Hair Alain Pichon Model Erin O'Connor

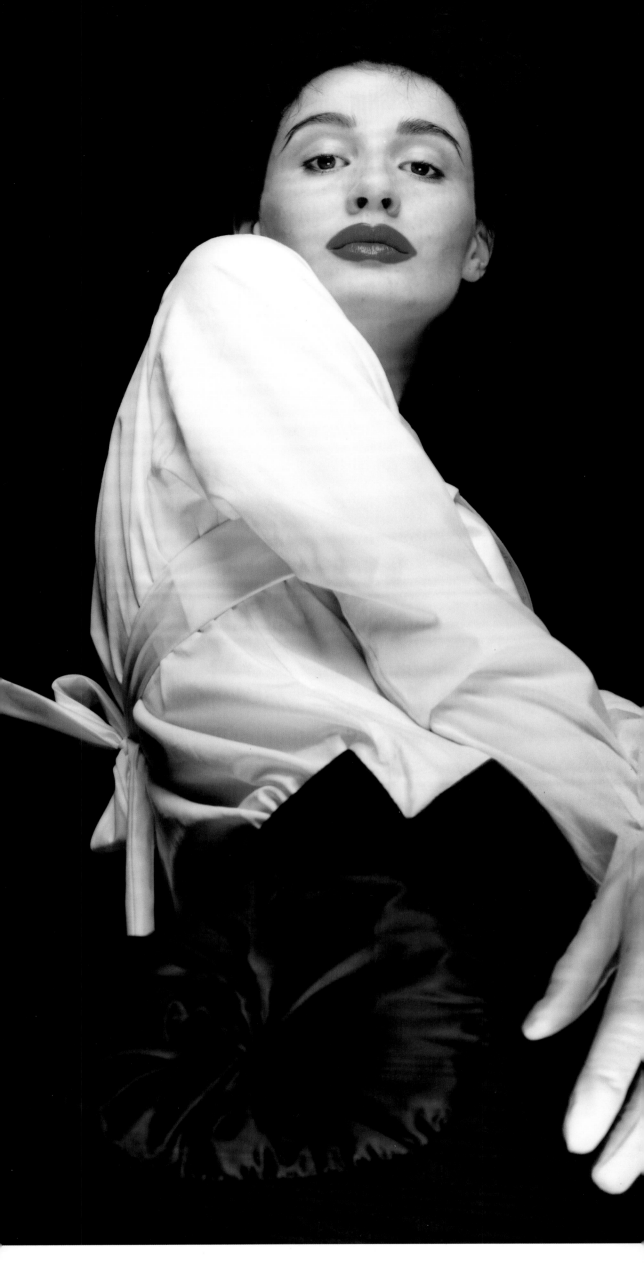

renegade winged blouses, and cropped pants/skirts cut from such materials as silk, satin, leather, organza, and taffeta, are a strange emotional armor. The design dynamic that produces these pieces ranges from discussion to disagreement, but from every explosion, they say, comes a newly formed landscape. "We always start with a concept for a collection, with a list of statements and emotions, then we research abstract interpretations of them." "Leave," their first collection, looked at the concept of evacuation "of a place, your mind, your body, the world." "Bomb" was an exploration of genetics and nuclear power, man's wish to be ultimate creator and destroyer. "Immortality," their appraisal of and emotions toward death and life, included boots made from antique ice skates inspired by the phrase "skating on thin ice." Boudicca has been described as conceptual (often a euphemism for tricky or difficult). "Our clothes are no more complicated than ourselves," they say. "Every piece we construct has its own complex agenda." They refer to their work as hallucinatory. "To halluci-nate is to push your brain to view and consider life and its surroundings in a completely different way." —AB

BRUCE

When Nicole Noselli and Daphne Gutierrez, the design team behind Bruce, were preparing for their second show, they sent out an empty envelope for an invitation. Unsurprisingly, the confused phone calls came pouring in. "What's this about? Where's my invitation?" people asked. As it turned out, all the necessary information—date, time, place—was there in plain black and white; you just had to bother to look for it. More than a simple prank, the empty envelope was a lesson in the way Noselli and Gutierrez operate. Bruce is in the details, and you have to look closely. Both Noselli and Gutierrez are originally from New Jersey (though Nicole is from the suburbs and Daphne from the city), and they met when they were both students at Parsons School of Design. They joined forces after graduation in 1995 and started Bruce, without quitting their day jobs. Each freelanced in various corners of the New York fashion world: the press office at Romeo Gigli, "older female garmento dress companies," DKNY men's, Isabel Toledo, Ronaldus Shamask, J. Crew. "You get a taste of it and decide that this is not what you really want," they say. In fact, the two seem oddly out of step with New York City. Desirability smol-

Photography John Minh Nguyen

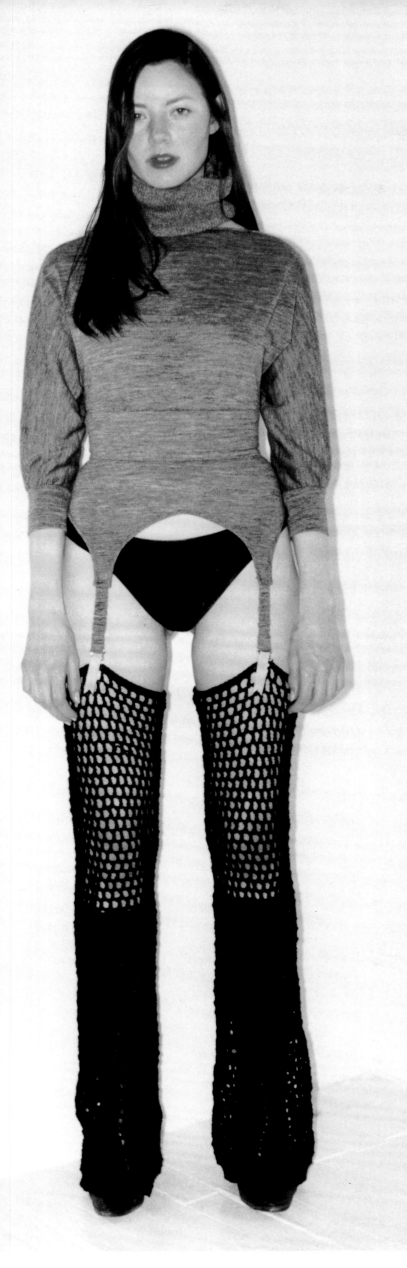

ders quietly beneath the surface of their sexy, street-smart clothes, the sum of bits of handwork, inspired cutting techniques, and the pair's unique design dynamic. Individuality is a word they like to use, and they mean the garments as well as the women who wear them. There are nuances back and front, inside and out, that make each piece look and feel as if it were a one-of-a-kind; some of the pieces *are* one-of-a-kind. They have made dresses from recycled mink coats and old silk kimonos; they once cut a $1.99 cotton T-shirt into a very expensive corset. "It's like the way you look at vintage clothing and there are clues as to the way it was made," explains Noselli. "Big designers take their inspiration from the city," Guttierez says, without naming any names. "It's all about New York for them, living fast. But living is also about noticing things. Things that may not even mean anything." What, then, is the meaning of their name? Bruce, one suspects, may very well allude to Donna, Calvin, Ralph, or any of the single-monickered fashion Goliaths to whom they willingly play David. "It's something very close to us," they say coyly. "It doesn't really hold any meaning, but for some reason it seems to fit." —AB

Christian Louboutin was born in Paris in 1964. He decided to go into fashion when he was about seventeen years old, after he understood that he would never make it as a showgirl. He attended l'Academie Roederer and studied illustration and decorative arts. He met legendary shoe designer Roger Vivier at Le Palace, the French Studio 54. "The most important thing he taught me was that a shoe must be like an object of magic, appearing and disappearing!" Louboutin says. "The shoes must melt in the silhouette, and must be a perfect object of design." (Vivier also taught him how to clean his ears, but that is another story.) Louboutin learned his craft working for Charles Jourdan, Chanel, Yves Saint Laurent, and Maud Frizon, among others, in both ready-to-wear and haute couture. In 1991 he stepped out on his own and opened his own Paris boutique. His mentor, Vivier, taught him well, as his shoes are indeed extraordinary feats of design. "I have no working technique," Louboutin says. "I can start from a fabric, from an object that will become a part of a shoe." The foot of a table, an aluminum Guinness can, even a gilded statue of a nude woman can become a heel. "My only technique is to leave my technique

Photography Greg Broom Styling Anna Levak

at the service of my imagination, and never the opposite." Louboutin's vast repertoire includes platforms with hydrangeas suspended in clear lucite, golden heels, and "Pensée" mary-janes inspired by Andy Warhol, all with his signature red soles. He has stapled "garbage" (ticket stubs, scraps of paper, and the flotsam and jetsam of the Paris streets) onto open-toed slides; he has bedecked the most delicate of high heels in dazzling gemstones. Louboutin is an amateur landscape gardener and the colors and the textures he cultivates often find their way into his shoes. But what has become of his original dream of becoming a showgirl? The time Louboutin spent hanging around the Lido and the Folies Bergères has been essential to his work. "What is a showgirl?" he asks. "A woman naked with feathers and shoes!" The right shoes can give a showgirl the particular posture Louboutin says makes them look like birds of paradise, and a dancer knows the maximum height a heel can be before it becomes completely unmanageable. Shoes are weapons to them, and they are like soldiers. "The showgirls are very serious about their shoes because if they don't fit, they know they will not reach the sky." —AB

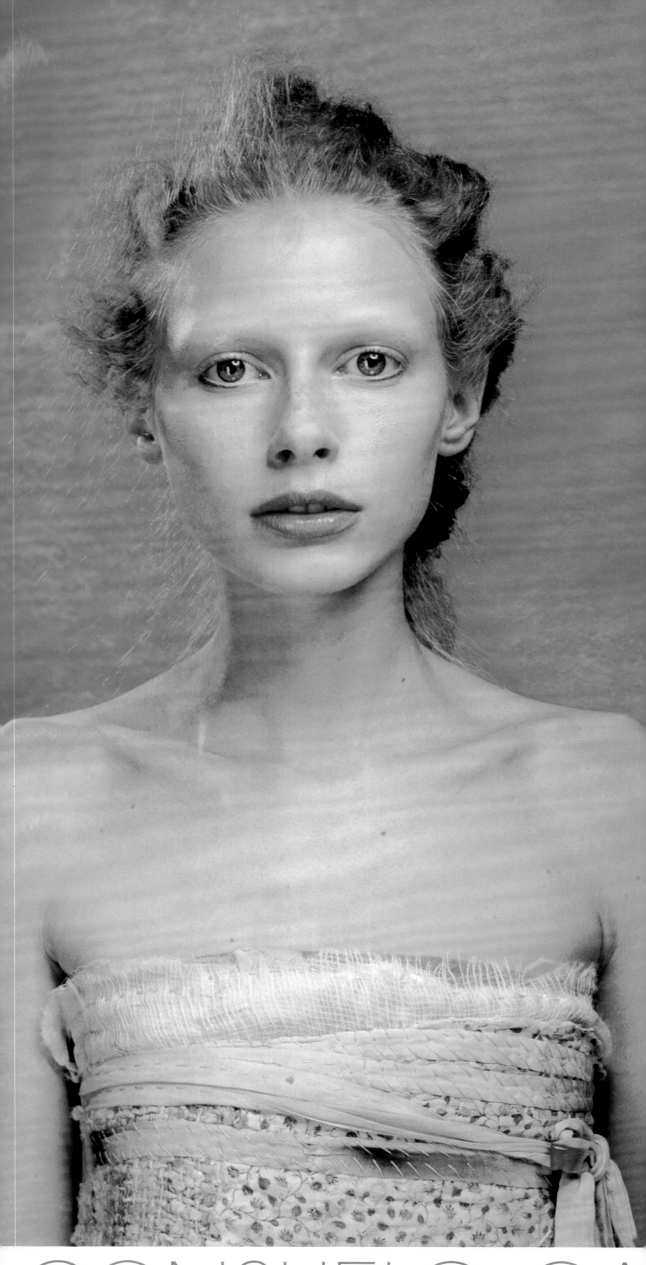

The 1999 fall/winter collections in Milan saw a wholesale shift in the city's sartorial sensibility. Gone were the sporty, high-performance details, the body-conscious silhouettes, and the muted palette that had lent Italian fashion its sexy, urbane international reputation in the '90s. Instead, there were piebald ponyskin coats in Crayola colors, fabulous abstract and floral patterns (often layered three-a-piece), and homespun, artisanal finishings. "My God, we're watching the Marni-fication of Milan," whispered one editor, when, at the close of fashion week, even the industry's most diehard purveyor of Hollywood slink flirted with earthiness and psychedelia. What is Marni and how did it come to redefine Milanese chic? Designed by Consuelo Castiglioni, this small, eccentric line is the fashion face of her family's highly respected fur and leather concern. The raw ingredients of a Marni look are typically Italian—luxurious cashmere and ponyskin, handfinished seams and embellishments—but the styling has more in common with British aristo-bohemian eclecticism than local notions of proportion and patterning. For fall/winter 1999, raw silk muslin sheaths were adorned with patches of velvet and Sonia Delauney–worthy prints and then

Photography Sinisha Art direction Philippe El Koubi Styling Beat Bolliger/ADCOM Makeup Max Delorme/Callisté Hair Paolo Ferreira/Callisté Set design Pierre Glandier Printing Laboratoire Janvier

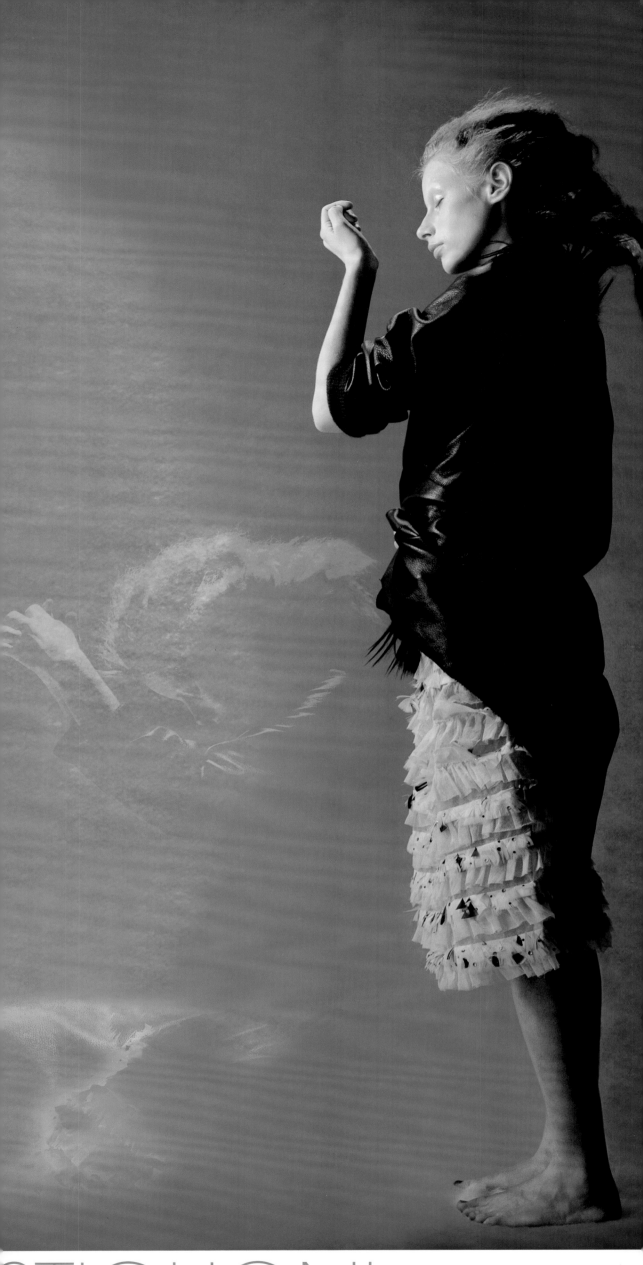

quilted haphazardly with decorative basting stitches. Over the sheath the wearer might bind her breasts with a randomly patched, hand-embroidered obi sash. And to top it all off? A super-sheared goatskin coat in spiky white and black or a scarlet pony jacket. For spring/summer 1999, Marni girls layered peasant tops and flouncy skirts in naive pajama-print florals (in cotton or silk) under boiled mohair separates (fused onto gauze) in sky-blue, fuchsia, and lemon. They finished their look with piebald ponyskin clogs. The Marni signature, which Castiglioni has developed since the collection's debut in fall/winter 1993, involves mixing extreme natural textures—the roughest ponyskin; the softest, gossamer-sheer cashmere; the nubbliest boiled-wool felts—in mouthwatering, sensual colors with gypsy-esque abandon. "I appreciate seeing women in the street wearing Marni," says the designer, "because you can always tell that it is not for everyone and is indeed quite special." Why Marni, with its rural long skirts and office-unsuitable coats-of-many-colors, should so capture the imagination of the urban fashion flock has everything to do with the millennial preoccupation with value, credibility, and originality. —SS

Location Studio Picto Model Ray/Next

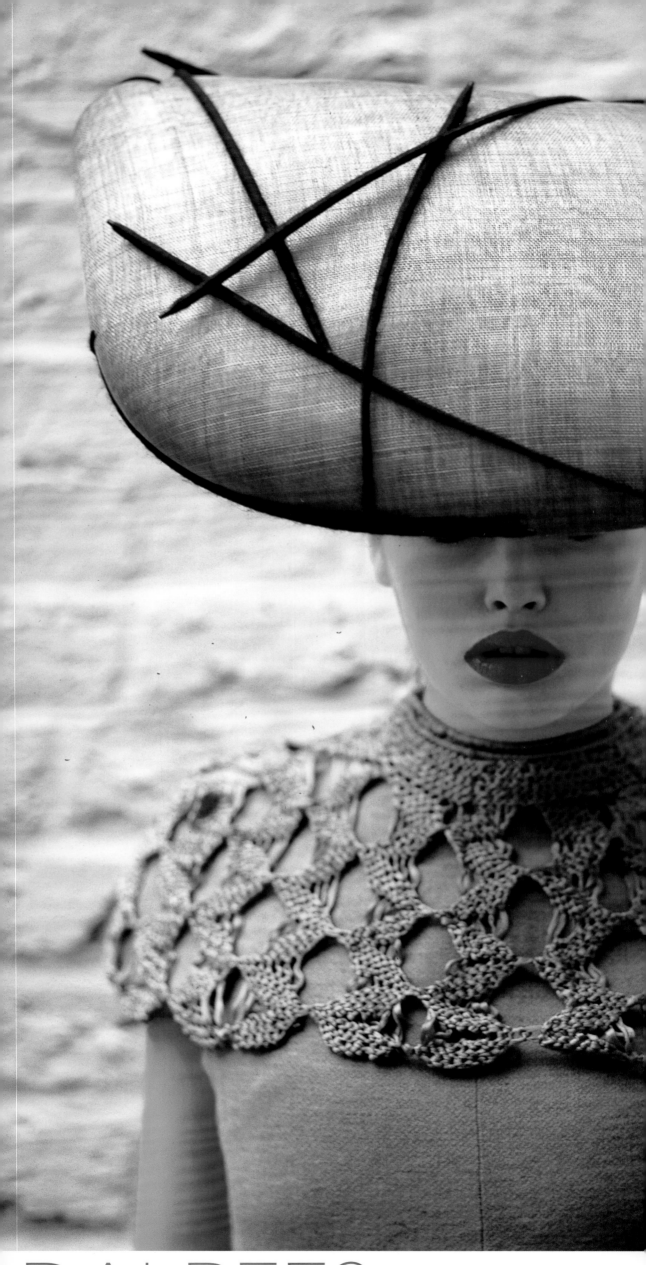

DAI REES

By the time you read this, chances are that Dai Rees will have moved on to something else. It's difficult to pin down this Welsh designer. Just when you think you've got him tagged—milliner is how he has most often been described—he's off and doing something else. He certainly confounded expectations with his latest project—his first collection of clothes. Rees presented his collection in February to an audience that included Manolo Blahnik, Lulu Guinness, and Isabella Blow. They were there to check out the man who had created some memorable moments for Alexander McQueen (cages and tribal masks constructed from quills and feathers—his trade-mark—that encased the models' heads) and for knitwear designer and fellow Welshman Julien Macdonald (Rees collaborated with him and photographer Sean Ellis on an installation). "Designing clothes is something that I've wanted to do for ages," says Rees, "but I was cautious about doing so. At one point, I thought about bringing in another designer to do it, but in the end I thought it had to be me." Trying his hand at clothing design wasn't such a big challenge for a man whose career has included periods as a welder, a chef, and a student at both

Central St. Martins College of Art and Design and the Royal College of Art. "I knew that people were sitting there thinking, 'What the hell is he going to do?'" he continues. "They were so used to seeing the hats I'd done for Lee or Julien—a look that was wild and theatrical." While Rees claims that he wanted to do something "quiet and modest, nothing noisy," his collection was a greater achievement than he will admit to. Taking his cue from "really early Celtic clothing," he showed dresses and coats that wrapped and tied or fastened with horn toggles—all cut from traditional British and Irish tweeds in pebble colors. "I love scarves and shawls," says Rees, "and I wanted to translate those accessories into clothes." He showed his collection with tooled leather belts, flat lace-up shoes, and headpieces that didn't resemble hats as much as they did radical architectural experiments in organic form. "The hats were there to give the clothes a sense of balance," he says. "And it was interesting to conceive of the two together simultaneously. More often than not, milliners are brought in at the eleventh hour to create something to go with a designer's collection." In the future it may just be the other way around. —MH

DIRK VAN SAEN

Dirk Van Saene is, by his own admission, a late bloomer, a designer who after working in fashion for nearly twenty years, is just now starting to come into his own. One of the original Antwerp Six, he graduated from the Royal Academy in 1981 and later opened a small store called Beauties and Heroes, filling the racks with clothes he made in his upstairs studio. After winning the Golden Spindle award in 1983, he produced his first real collection in the summer of 1984. While he recalls his early shop-keeping days as a chaotic search for a creative identity, steeped in research and experimentation, he has avoided pinning himself to a particular style. Just look at the various muses he has conjured over the years: model Penelope Tree, silent film star Clara Blow, photographer Diane Arbus, and artist Louise Bourgeois. But if there is a common thread that has run through his collections it is a distinct couture feeling based on traditional know-how. Van Saene's finely-crafted, clean, and structured aesthetic was noticeably out of place at a time when his deconstructionist neighbors were ripping fashion apart by its seams. Van Saene himself was busy deconstructing old pieces by Chanel, Balenciaga, or Dior in order to

Illustration Hiroshi Tanabe

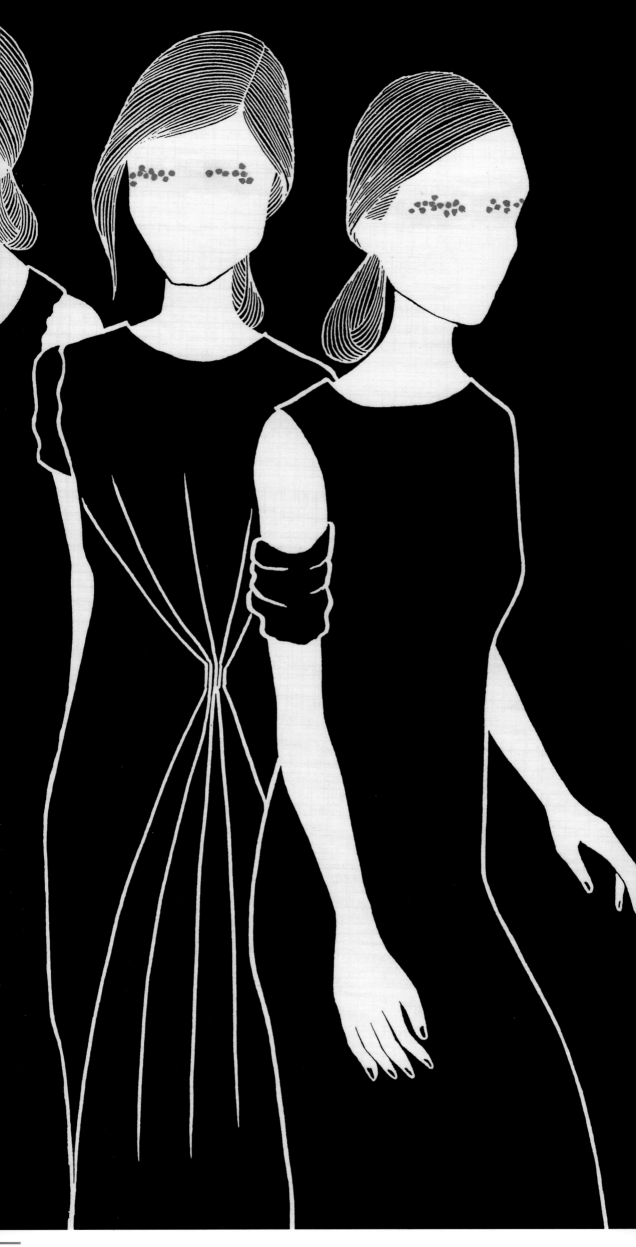

uncover the secret details that make such garments so beautiful—and so expensive. "I always wanted to do a prêt-à-porter with finishing details of couture," he says. "But that, of course, is a contradiction." Van Saene, who has a veneer of innocence but a mischievous heart, is not one to shy away from contradictions. In fact, he seems to revel in life's little deceptions, things that appear as one thing but are actually quite another. He has split dresses and coats in two and cavalierly paired the mismatched halves together. He has introduced a kind of two-dimensional tailoring in the form of trompe l'oeil bows, ruffles, lapels, and pockets—all of which draw attention to the tailoring process but stop short at proclaiming it. But the most delicious contradiction of all has to do not with how these clothes are made but how they are perceived. A collection may seem to be about innocence and romance on the surface, but odd details—such as a sleeve with a disconcerting hand-like appendage emerging from its hem—hint at the fact that there just might be something wicked lurking beneath. "It's like a children's fairy tale," Van Saene says. "You realize only afterward that there was something a little creepy going on." —AB

ERIK HALLEY

Erik Halley doesn't design accessories, he creates three-dimensional fantasies: a choker that encircles the wearer in a cloud of feather-butterflies suspended by buoyant carbon fibers; a scarf made out of Perspex plastic molded to be perpetually blowing in the wind; a resin half-mask that fits on the face like the shell of a broken egg; another mask made of magnifying material designed to distort the face like the reflection in a funhouse mirror. In the tradition of surrealist designer Elsa Schiaparelli, Halley once turned a shoe into a hat, only he took this idea a step further, melting and elongating the shoe and adding a wispy feather for a heel, so in the end the hat scarcely looked like a shoe—or for that matter a hat—at all. When Halley describes these pieces as "very chic but very weird," he is not so far off. His greatest personal achievement to date is a lobster hat he created using a real animal carcass, that he painted and covered in Swarovsky crystals (he also tried this with a crab but the effect wasn't quite the same). The lobster made him very excited and very proud. He received five or six orders for pieces just like it. Halley didn't always make such fanstastical things. He started his career in fashion working in sports-

Photography Nick Knight for British Vogue 1997

wear, channeling his creativity into designing mundane items like jogging suits. He began working with feathers as a hobby. Soon his hobby became a passion. Now it is a calling. "My point is to discover things, new techniques," Halley says. "An object has to be attractive on its own. When you wear it, it becomes something different." He gets inspiration from his ever-growing collection of picture books. "I flip through them quickly. I don't ponder them." And more important: "I dream a lot and I remember a lot of what I dream." Halley has created showpieces for other designers, collaborating on some sixty collections in his three short years as a professional. These have ranged from medieval feather headpieces for Alexander McQueen to spiked ear clips for Hussein Chalayan. Completely at odds with the minimalist camp, who think accessories weigh down a silhouette or detract from the purity of line, Halley's work is at turns playful, poetic, and provocative. He doesn't drag the clothes down, he sets the imagination soaring. "Everyone sees something different in the same piece," Halley says. In fact, accessories like his beg the question, "Who needs clothes at all?" Halley has plans to present a couture show all his own. —AB

FEE DORAN

DJ–club promoter–designer Fee Doran creates clothes inspired by the London club scene she inhabits and the Essex scene that, try as she might, she just can't seem to kick: corseted jumpsuits, spray-painted bikinis, skin-tight jeans hand-embroidered with graffiti, something called "rockulottes." These one-of-a-kind pieces play to her rock-chic aesthetic in a fusion of heavy metal, kitsch, hip-hop, funk, and glam, and dance circles around any modicum of good taste. Fiona Doran was born and raised in Essex, England, a place she describes as a white-stiletto, fake-tan town, miles away from the fashion crowd. "I was a bit different," says Doran, who made clothes for herself and her friends and worked in a handful of local boutiques. In 1986, Doran put on a fashion show in a nearby nightclub. She didn't know how to sew at the time, and to hear her describe the "collection" it was nothing more than bits and pieces of fabric haphazardly taped and pinned together. But Doran's mother, as only mothers can be, was impressed and showed her work to a professor at Southend School of Art and Design. Doran was accepted into a year-long fashion program. "They took me on as a joke, a character in the class," she

Photography Steve Lazarides Embroidery Laura Lees

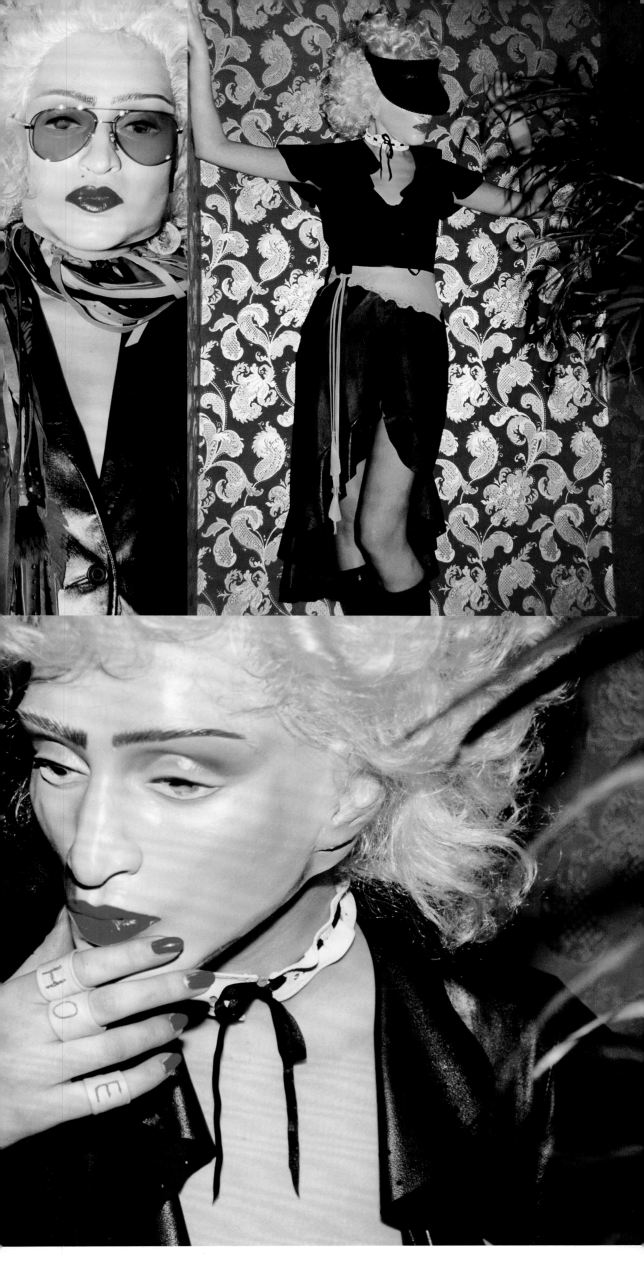

says. "At first I tried desperately to fit in, but then I figured I'd be true to who I was." She continued her degree at Rochester College and was invited to present her thesis project at a group show in Latvia. Taking cues from *Alice in Wonderland*, the collection featured Tweedledee and Tweedledum as transvestite twins, a Queen of Tarts, a Mad Hatter-cum-pimp, and a White Rabbit with a fluffy bum. But then Doran has always preferred to see "characters" wearing her clothes—real ones as well as cartoon and fairy-tale ones—over people showing all the individuality of an Ikea coffee table. Trademark pieces include a neon-sprayed fur she sewed by hand ("It was a very intense experience, my hands were bleeding, it was hurting me, but I had to carry on."); whiplike leather neckpieces that she originally crafted from her scrap basket ("Being poor you have to use everything. Now I have to buy the leather and actually cut it up."); and a natty track suit that would wear well with the folks back home. "Half of fashion I like," Doran says. "But I think I continue to play on the Essex thing because I can't bear the other side. I just want it to be fun. No philosophy. Just dressing up and going out." —AB

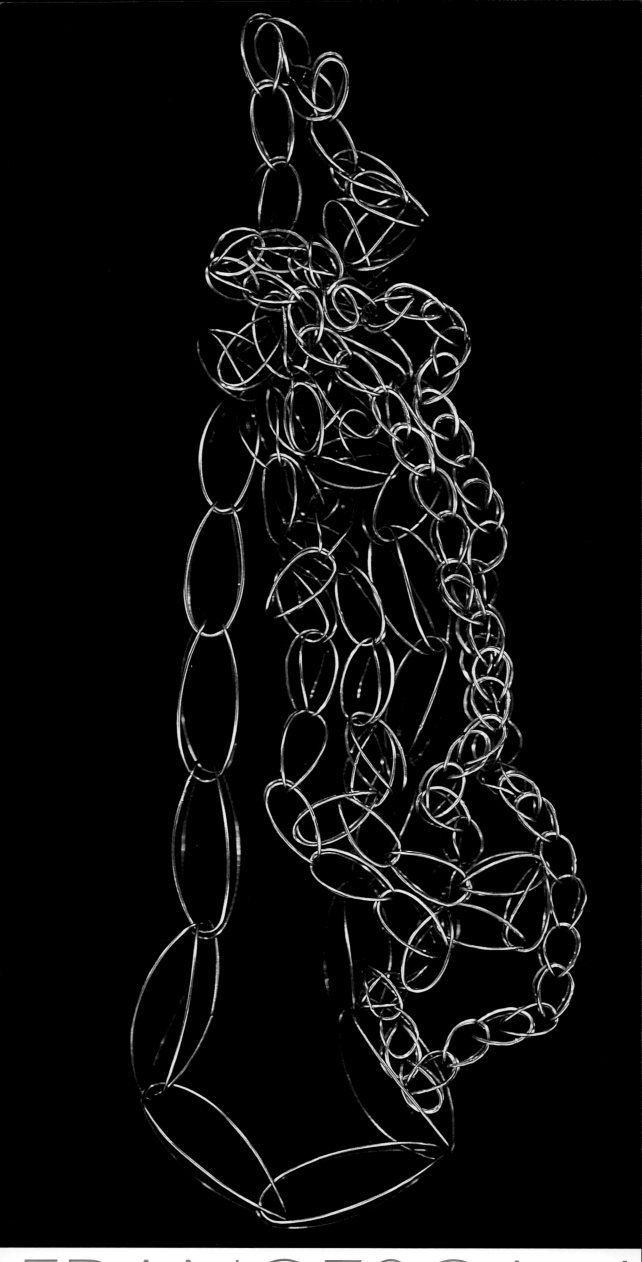

FRANCESCA

Francesca Amfitheatrof—a Russian-Italian who was born in Japan, lives in London, and carries an American passport—makes jewelry that crosses aesthetic boundaries with the ease and grace that have characterized her geographical journey. Take, for example, her signature rings: skinny gold bands adorned with a single large ovoid bauble of gold, silver, or semiprecious gems. Worn with bauble exposed and possibly layered two or three bands to a finger, the rings function as confident cocktail jewels for grand public display. Turn the bauble (or baubles) to face the palm, and Amfitheatrof's bold creations become worry beads—private, soothing, and oddly functional. She makes studded cuffs—a hard-core, youth-culture staple—but prefers pink python bands to black leather and thorns to spikes ("they are refined punky things"). Her permanent tag bracelets are inexpensive skinny bands that come in faux medical packaging with instructions for fitting: once installed on the wrist, they can only be removed by being cut and therefore destroyed. They make you think very hard about the disposable nature of identity, about why you wear jewelry and what value you place on it. Issues of impermanence have long been

Photography Fabien Baron Styling Karl Templer

AMFITHEATROF

of concern to Amfitheatrof. As a child of itinerant parents, she changed countries and languages every three years. Her situation finally stabilized when she was sixteen, when her parents moved to Russia and she to London. Amfitheatrof studied for seven years in her adopted city—at Chelsea College of Art, Central St. Martins College of Art and Design, and the Royal College of Art—before being hired by Alessi, the Italian home-design manufacturer. Three years ago, she set up her own business making fine jewelry ("I mix all my own gold alloys"), while continuing to design bowls, key rings, and tea strainers under her own name for Alessi. But, of course, it is as a jeweler that she has made a name for herself in the design world. Past seasons have seen collaborations with Fendi as well as fellow transnational Rifat Ozbek. There is nothing retro in her work and very little (save the occasional medical graphics) that could be described as kitsch. The humorous and referential quality stems from a cerebral wit and an appreciation of the tactile and the sensual. She is also alert to the complacency of extremism: "My work is never too decorative or too hard-core," Amfitheatrof says, "so one doesn't get bored of it." —SS

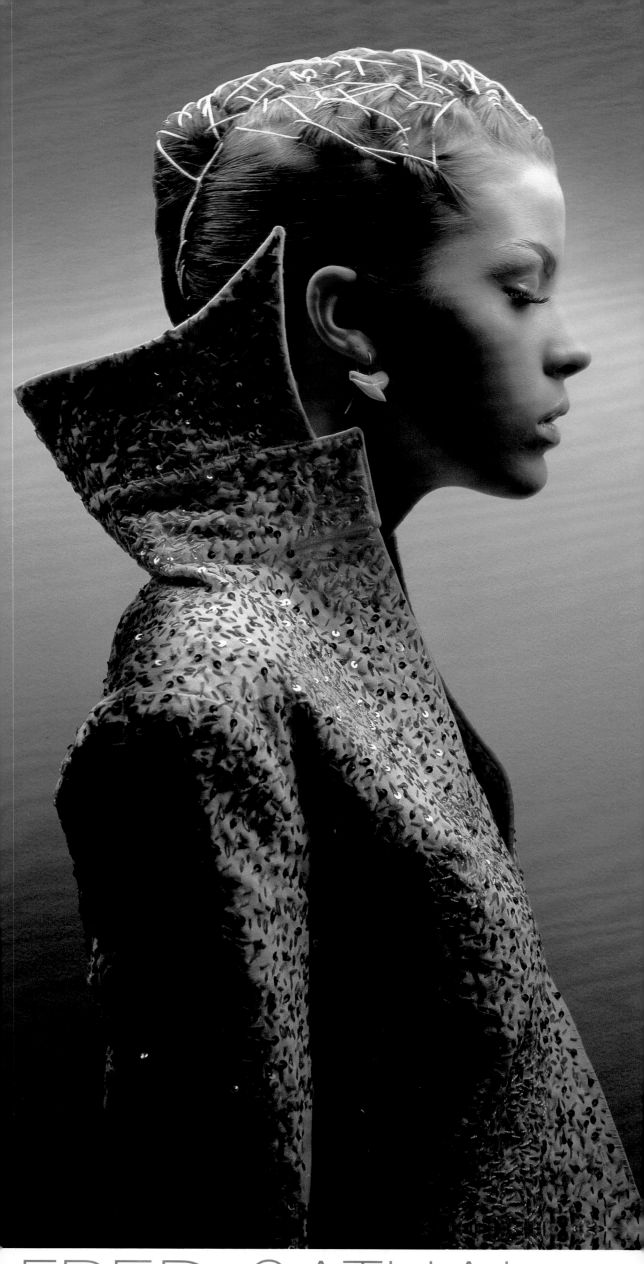

FRED SATHAL

"My clothes are sincere," says French designer Fred Sathal. "I'm interested in trying to work with different influences in seeking beauty and magic." Sathal, who was born in Marseilles in 1966, came to Paris and initially found work as a costume designer. "I'm self-educated when it comes to fashion," she says. "I was assisting Genvieve Sevin-Doring who really contributed to my learning. She opened up my thinking about clothes." Sathal presented her first collection, "Etoiles de vie filantes," in 1994. Sathal, who has described the creative process as a necessity ("like oxygen"), prefers the word "createur" to the other, more commonly used French word "styliste." Making clothes, she insists, entails far more than the mere cutting of cloth. Sathal has in fact created her own language of design, enriched by an ever-evolving vocabulary of dying techniques (which she identifies as "animal, vegetable, and mineral"), embroidery ("I've experimented with making it look abstract, almost like scarring, or sometimes with glitter thread to play with the light."), and, more and more, intriguing cutting techniques. Inspired by film, travel, nature, and pure chance (anything, it seems, besides fashion itself), Sathal seems bent on doing away with

Photography Michelangelo di Battista Art direction Philippe El Koubi Makeup Christina Lutz Hair Carita/Jean Claude Gallon Imaging Richard Martha/Laboratoire Janvier Location Pin Up

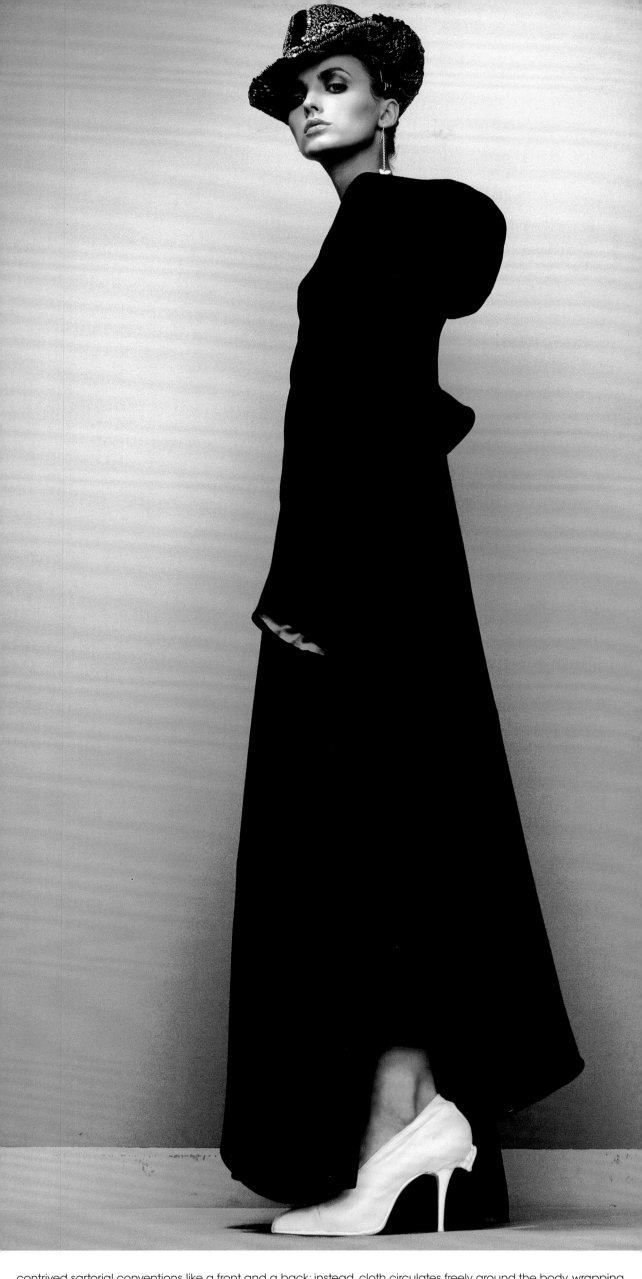

contrived sartorial conventions like a front and a back; instead, cloth circulates freely around the body, wrapping and encasing the wearer. (Surprisingly, she cites such classicists as Coco Chanel and Yves Saint Laurent as influences, "for their interest in androgyny, creating clothes that were masculine and ultra-feminine.") Ask Sathal to put what she does into words, and phrases like "urban nomad" and "sophisticated primitive" and "animal androg-yne" trip off her tongue without a trace of irony. Something of a nomad herself, Sathal is as far removed from fashion's obsession with global branding and diffusion lines as it's possible to get. Equally poetic—and somewhat mysterious—are the names she bestows on her collections, each of which tends to underscore her unusual interest in fusing organic forms with references to hyper-technology. There has been "Metamorphoses Articulees" (October '95), "Instinct Genetique" (October '97), "Anatomie Intuitive" (October '98), and "24 Degrees Celsius," her collection for the new millennium. This last one featured her favorite piece to date: a dress, she says, in a "wild and noble" red leather, fastened with a magnet covered in violet embroidery designed to read like a scar. —MH

FREDIE STEVENS

"I don't like nonfunctional shoes," says Fredie Stevens. "It's nice if they can be in a museum, but in the end it's better for people to be able to walk around in them." Many of Stevens's shoes would not be out of place in a museum. But unlike Meret Oppenheim's furry teacup or Marcel Duchamp's urinal, Stevens's little surrealist objects are designed for everyday use; people are indeed meant to walk around in them. Stevens has produced her own line of shoes independently, made shoes for the shows of Viktor & Rolf, and in 1999 signed on with the Italian shoe company Boccaccini to create a commercial line called Red. She grew up in southern Holland and graduated from the Arnhem Academy as part of the school's three-dimensional department, a program in industrial, furniture, and graphic design. The course in shoe-making at the academy is extremely technical and somewhat old-fashioned. The practice of making shoes by hand apparently has not changed all that much in hundreds of years. At one point Stevens found herself hand-sewing a piece of leather using a needle made from the hair of a Russian pig. "It was really like the Middle Ages," she says. But being able to make

Photography Greg Broom Styling Anna Levak

a shoe from the last up was liberating; the idea being that once you know the rules, you're free to walk all over them. Stevens likes to focus on one particular aspect of the shoe, exaggerating the toe, or the heel, or the upper, but never all of them at the same time. It often appears as if two shoes, or a shoe and something else entirely, like a pair of pants, had collided. Part couturier, part cobbler, Stevens makes three-dimensional models and even drapes material as in the making of a dress (she is often inspired by the techniques of clothing design itself, using such elements as pleats or cuffs). Boots with the proportion of a hoof bypass the ankle to connect the leg to the foot; these could also be described as a pair of cropped pants that have sprouted a little shoe. A squat white shoe with a gaping mouth brings to mind a teapot that has lost its spout. Black patent leather half-boots have been cut away to expose the inside of the leg and are attached just below the knee with a silver cuff. "It's really very limited," she says of her chosen medium. Seeing what she has done with it, though, one would be inclined to disagree. "The challenge is to change it. To see just how far I can go." —AB

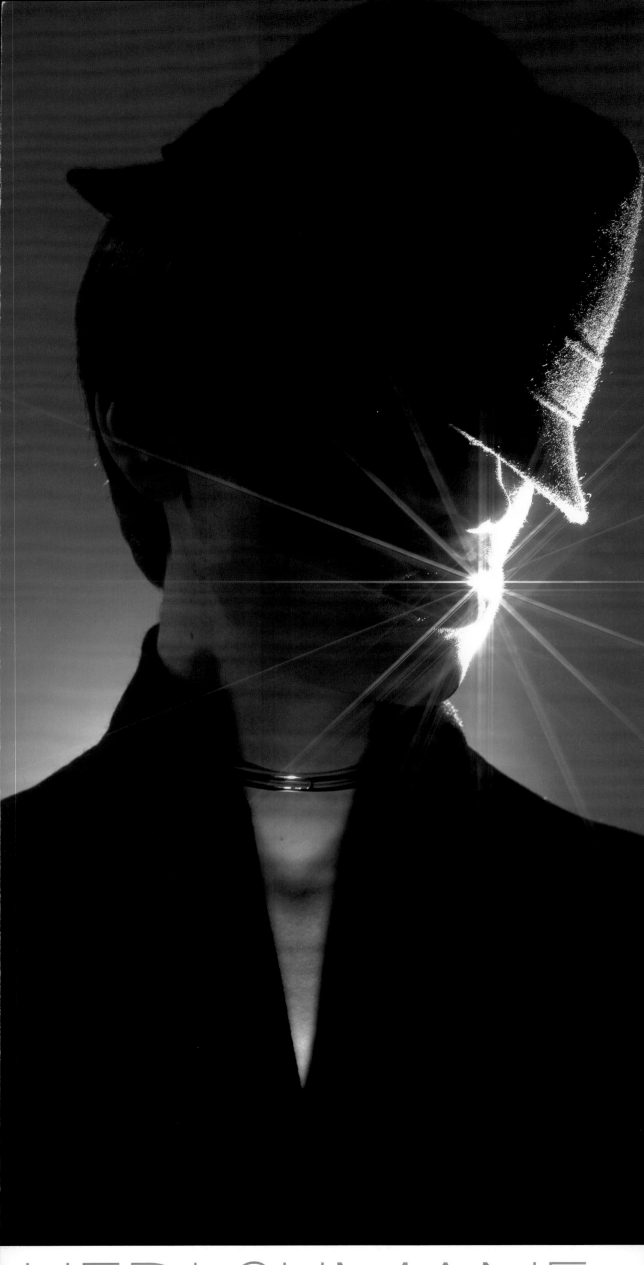

HEDI SLIMANE

Any young designer who is handed the reins of an established fashion house faces a difficult task: one is either accused of dabbling too freely in the archives and of being stuck in the house's past, or of having scant regard for its future—not to mention the tricky dilemma of how to make the house's signature style work in the here and now. One designer that has managed to negotiate all these problems successfully is Hedi Slimane, who designs Yves Saint Laurent Rive Gauche Homme. Slimane—who, at thirty-one, is only a year older than the label he designs—makes references to the styles of the late '60s and early '70s, but the results never look retro: slim black tuxedos reminiscent of Saint Laurent's classic *Smoking*; Left Bank leather shirts and jeans; subtle nods to safari chic with jackets and lace-front shirts; and tunics cut like djellabas and worn over lean pants. "I think that Rive Gauche has always had a certain mystique," says Slimane. "It seems to me that the foundations of the modern wardrobe were settled for good by Monsieur Saint Laurent in the late '60s. I would like what I'm doing to be a mix of Paris, of couture, and of elegance." Slimane's first memory of Saint Laurent was being deeply impressed by a retro-

Photography Sean Ellis Makeup and Hair David Mallet/Marie-France Photo assistance Giovanna+Olivier+Lynn Barca Artist Hank/Illusion

spective at the Musée des Arts Décoratifs in Paris. Slimane didn't study fashion; he went to the École du Louvre to study art history. After graduation, he went to work for José Levy in 1990, where he was Levy's art director for more than four years. He spent a brief spell at Jean-Jacques Picard and joined Saint Laurent in 1996. Slimane's success at the house is due in part to his keen understanding that Saint Laurent was the first designer to fuse authentic elements of street style (everything from the existentialist Beat look to the student garb of Paris '68) with a certain smoldering androgyny. Indeed, Slimane based his spring 1999 collection on photographs of Saint Laurent and Betty Catroux, his muse, who often dressed alike; certainly there are more than a few traces of that style in Slimane's wrap jackets that fasten with tie belts, his high-waisted trousers, and his narrow-shouldered coats. "Saint Laurent saw that the world was in transition in the late '60s," says Slimane, "and he invented clothes for women that responded to that world, that liberated them. Maybe, with men's fashion being so dominated in the late '90s by the clothes worn by ravers and skaters, I'm trying to create clothes that reflect that world." —MH

JEREMY SCOTT

When the young Jeremy Scott visited Paris for the first time, he was, quite frankly, disappointed. Scott was literally fresh off the farm; his most formative fashion moment to date had been a cat fight on *Dynasty* (full hair, full makeup, gowns, jewels, the works); what's more, he still believed in the glossy, glamorous magic of magazines like *Vogue*. So where were the ten-foot-tall glamazons in head-to-toe Thierry Mugler regalia? It has been Scott's personal mission to bring the excitement and the glamour—and perhaps a little bit of humor—back to fashion. Jeremy Scott was born in 1973 in Missouri. He always wanted to be famous. Shortly after he graduated from high school, he entered a shoe design competition. He didn't win, but he had discovered a passion and a potential claim to fame. He moved to New York and enrolled at Pratt. (F.I.T., legend has it, turned him down, saying that he lacked creativity and originality). Scott studied Balenciaga, Norel, Cardin. He got himself an internship with Marc Jacobs. And in the summer of 1995, he returned to Paris as a designer. Scott created his first collection with virtually no money: a series of surgically inspired pieces made from paper hospital gowns.

Photography Marcus Mâm Styling Claire Dupont Makeup Karim Rhaman/Callisté Hair Laurent Philippon/bumble+bumble Location Studio Zero Model Shanna Shank/City

Intricately cut and pleated, these frocks were in theory more decadent than any couture gown: they could be worn only once. He called them "prêt-à-jeter." His first formal runway presentation he called "Rich White Women": the all-white garments lacked sleeves or legs, or had humps or flying shoulders. This time, instead of paper or plastic, there was leather and fur. Scott, perceiving before him the leading edge of fashion that he had been searching for, was so moved by the sight of the models collected on the runway at the end that he cried out, "Vive l'avant-garde!" The phrase stuck, and has become his battle cry. The spring of 1999 brought the rosy "Establishment": pink pouf dresses, pink bows, a pink poodle. Scott introduced himself to his audience in a voice-over: "Hi. I'm the designer. And I'm proud to be in the world of fashion." This was the first time Scott offered a real pant, with two legs. "I want to go down in history," Scott says. "I want people to open up books and see an outfit and say, 'Oh my God, who made that? What year was that?'" The year is 2001. And the designer is Jeremy Scott. —AB

JEREMY SCOTT

> Photography Marcus Mām

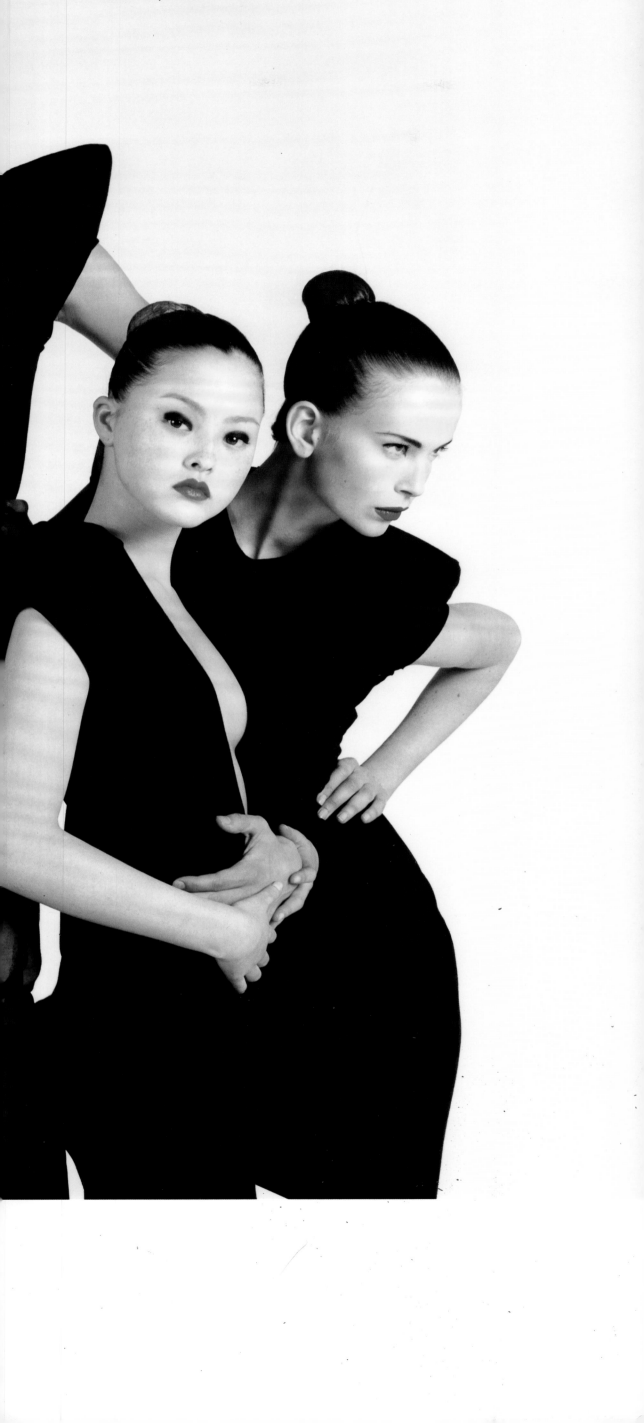

JESSICA OGDEN

While mainstream fashion has been pushing a glossy, premillennial update of *Tess of the D'Urbervilles*, and words like "pastoral," "rural," and "innocent" have entered its vocabulary, Jessica Ogden has been quietly pioneering her own sweet yet subversive take on it all. You can find Ogden's clothes nestling between the hard-edged experiments emanating from European fashion schools that line the rails of the London boutique The Pineal Eye. Her clothes are easy to spot among the convention-defying tailoring and razored leather: a simple dress cut from a blue floral fabric that looks like it started life as a tablecloth, the skirt falling in sharp knife pleats; or an antique kimono padded and appliquéd with odd strips of "found" fabrics. Stylist Anna Cockburn (who, along with Neneh Cherry and Tori Amos, is an ardent admirer of Ogden's work) has called them "clothes with soul." Certainly, they abandon the veneer of perfection that fashion loves, opting instead for a more vulnerable and outwardly naive (though in reality ultra-sophisticated) approach to design. "They are," Cockburn has said, "a new form of luxury." "My clothes are made with love," muses Ogden. "One of the things that I want to hold on to as my label grows is

Photography Amber Rowlands Styling Soraya Dayani Hair Anna Lewis-Owen Model Sacha Knight

the idea that the clothes I make are on a journey—that they have a life, one that will continue once I've sold them. I'm all for people patching other pieces of fabric onto them, personalizing them in some way." Ogden—who was born in Jamaica—came to fashion after a period spent at the Byam Shaw Art School in north London. While her interest in fashion stems back to her childhood, when she would watch her mother sew, it was fine art she chose to study. "I realized that I'd gone off on a tangent into something that was cold and conceptually driven. After I finished college, I went straight out and bought a sewing machine. I wanted to make clothes." Five years later, her vision of fashion is one that's difficult to pin labels onto. Deconstruction seems too clinical a description; there's a huge amount of gentle warmth, of raw humanity in Ogden's work. Her pieces are made from fabrics given to her by friends, or from those she sources at antique fairs or from secondhand stores. "I never throw anything away," she says. "Personally, I'm much happier in clothes that are really old. It seems that people's interest in clothes that are low-key—that aren't driven by status—is going to last. That makes me very happy." —MH

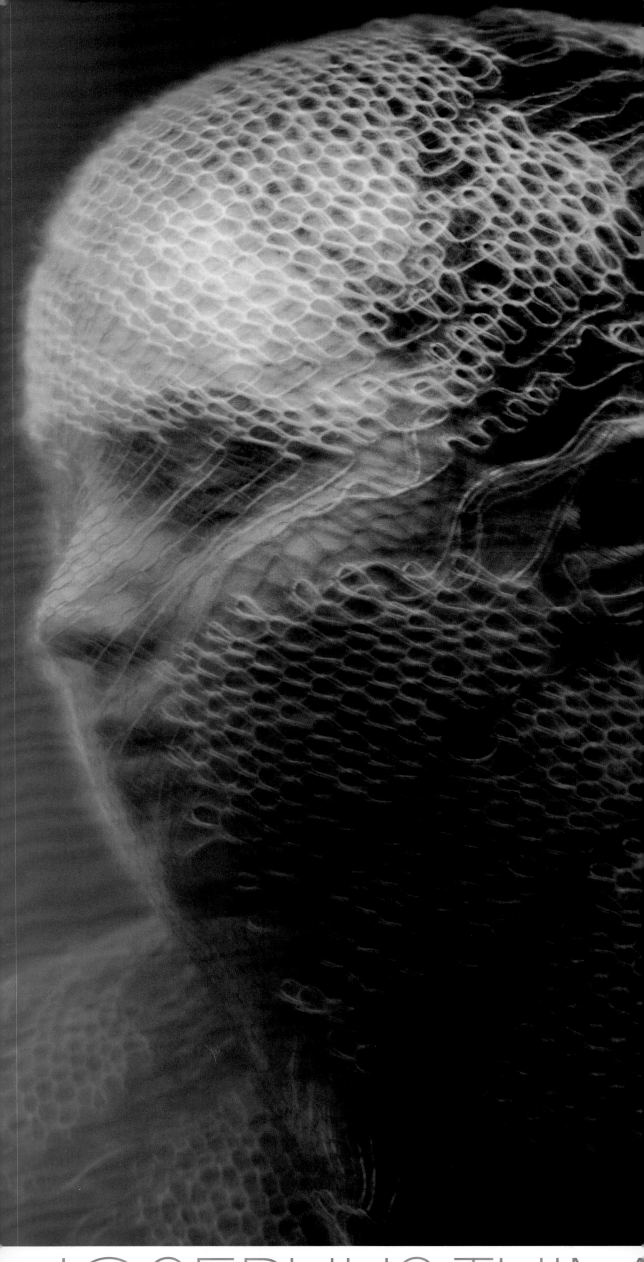

JOSEPHUS THIM

Depending on the season, the rumors of the death of French haute couture may or may not be greatly exaggerated, but if the increasing number of new names on the couture schedule is any indication, a new generation is setting out to revive it. Not just by breathing fresh air into the dusty old houses, but by starting up their own labels on their own uncompromising terms. Josephus Melchior Thimister has a genuine respect for the couture craft, but since he started his Thimister collection in Paris in 1997 he has worked to redefine its parameters, to show that it is possible to be grounded in tradition but still be forward-thinking—that it is possible to admire the work of both Yves Saint Laurent and Rei Kawakubo. Thimister's background is mixed: he is Russian, French, Belgian, Orthodox, and Catholic—a mix he bluntly calls "garbage." He grew up in Holland and England and studied fine arts at Antwerp's Royal Academy of Art, graduating summa cum laude in 1987. Thimister freelanced for Karl Lagerfeld in Paris as an assistant on the men's ready-to-wear collection and later worked in the couture atelier of Jean Patou. In a case of "Nice work, shame about the industry," Thimister, disgusted (for the

Photography Michelangelo di Battista Styling Aleksandra Woroniecka Makeup Topolino Hair Yannick D'Ys Photo assistance Orlando dos Santos Location Pin Up No 1 Model Natalia Ivanova

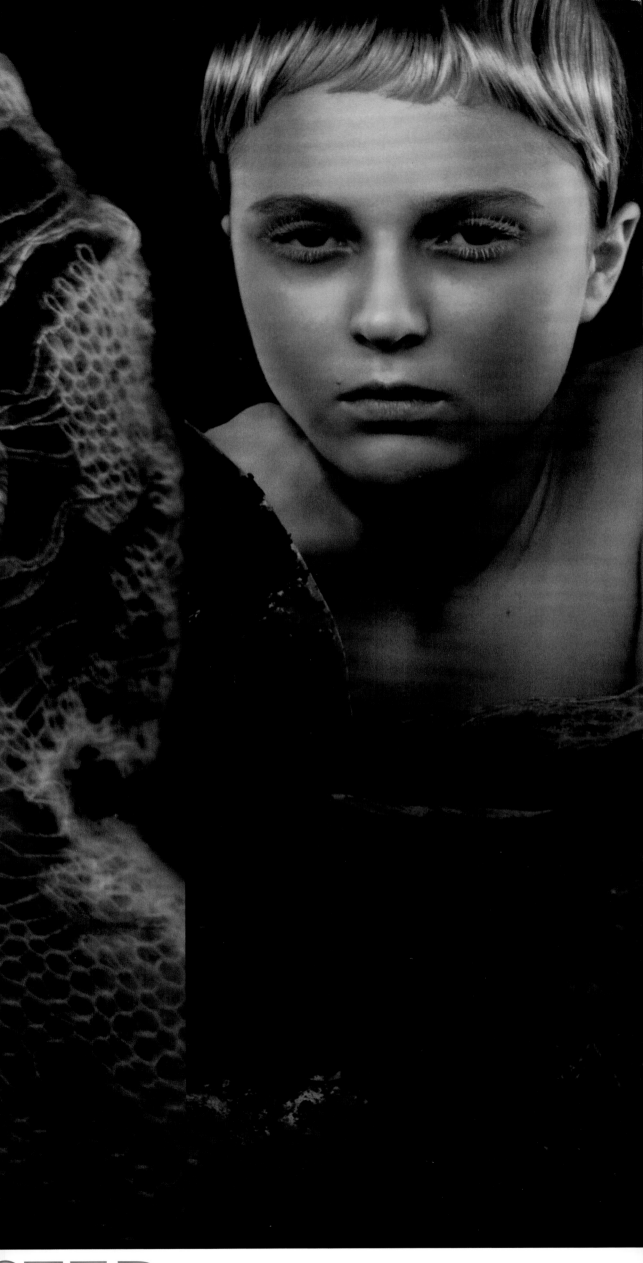

STER

moment, anyway) with fashion, made a hasty retreat into interior design and might very well have stayed there had a friend not tipped him off to the fact that the house of Balenciaga was shopping for a new designer. "I didn't even know Balenciaga still existed," Thimister recalls. It was said at the time that with his pure, succinctly modernist vision, Thimister was a natural successor to the architectural designer. But after five and a half years there, he began to feel like he was losing time and energy. He left to start his own collection in 1997 and took most of his Balenciaga team with him. Thimister's evening gowns are a departure from the old couture form in substance and in spirit. A dress may be made of five layers of chiffon interspersed with plastic or cotton gauze spray-painted and heated and then crumpled to look like paper. The skill and craftsmanship is there, but they are invested in such pieces with the goal of making them appear unrefined rather than finished, and therefore lighter—and more contemporary—in spirit. "To really make something authentic is the toughest way to go," Thimister says. "If things are too perfect today, they lose their sense." —AB

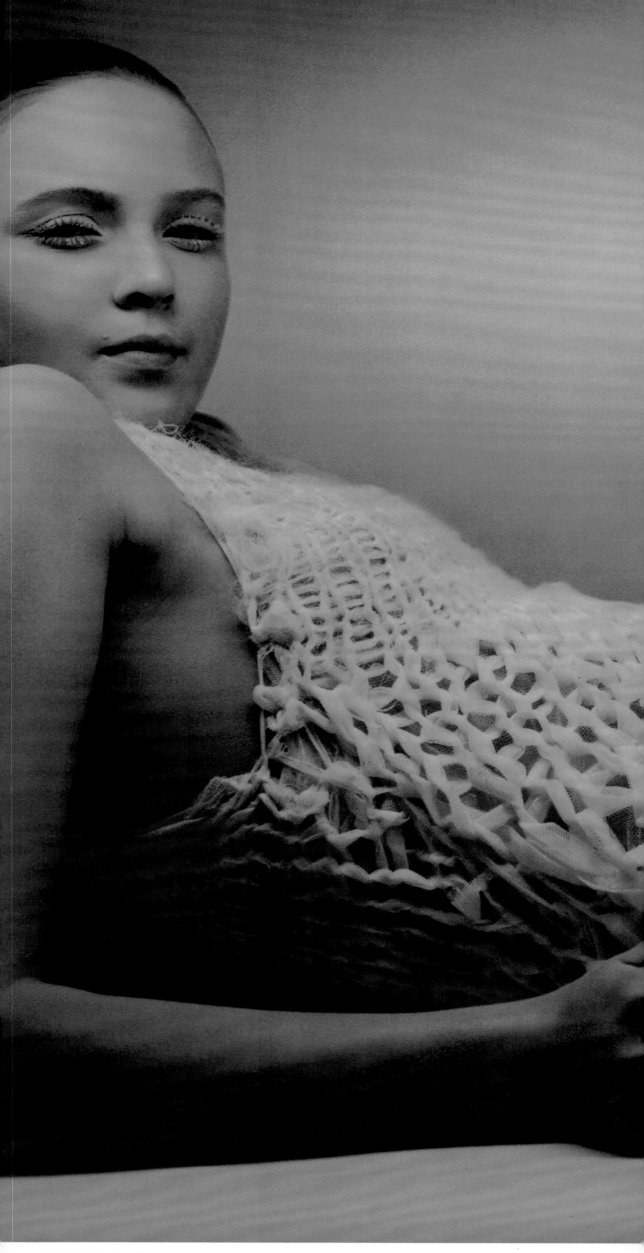

JOSEPHUS THIMISTER

> Photography Michelangelo di Battista Styling Rolando Beauchamp Makeup Topolino Hair Yannick D'Ys Photo assistance Orlando dos Santos Location Pin Up No 1

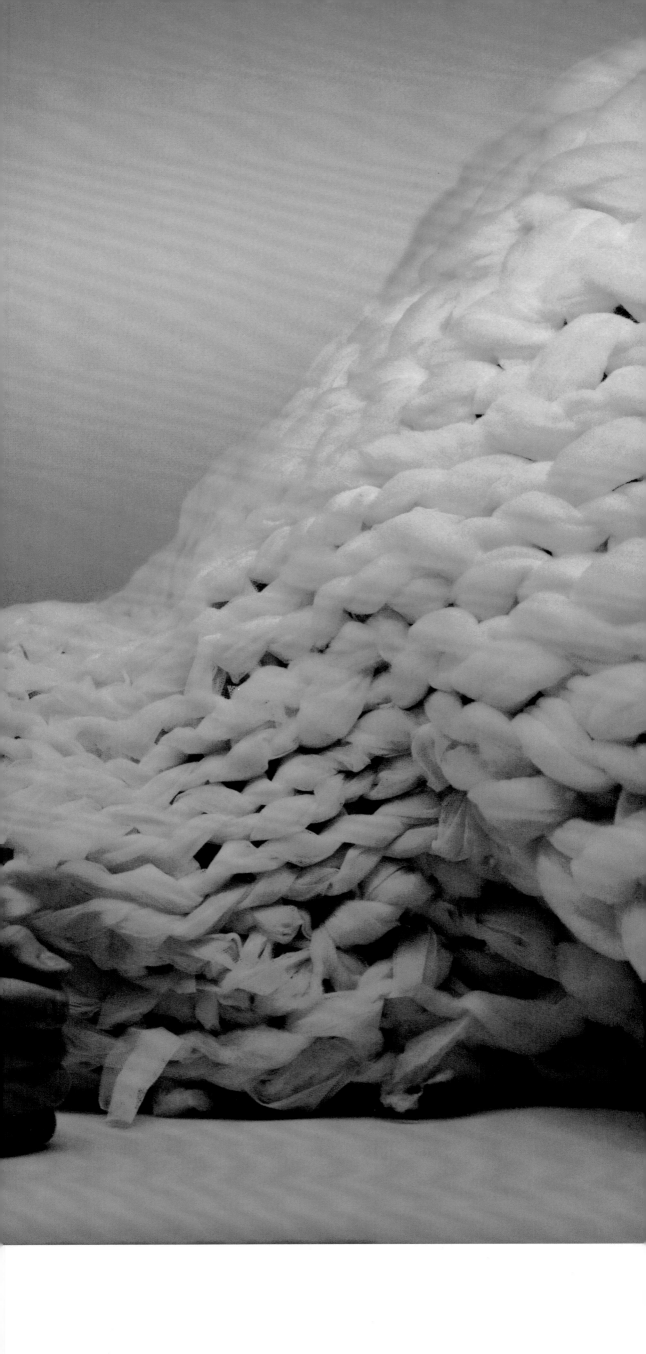

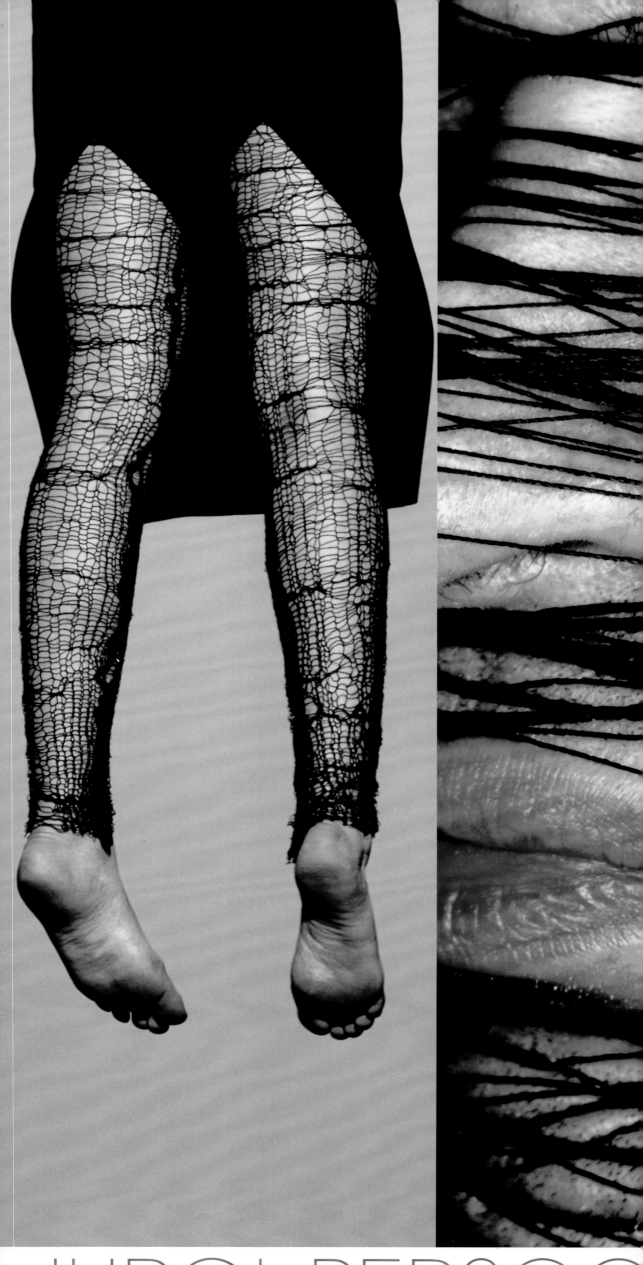

The printed invitation to Jurgi Persoons's fall '99 collection would have made nice opening credits for a horror film, or even a ransom note. This was the Belgian designer's seventh collection but only his second presentation (the first was in the form of a short film called "I Know What You'll Wear Next Summer"). He showed without permission on a random underpass along Paris's Quai d'Austerlitz. A convoy of fashion editors arrived at the eerie drive-by spectacle in their chauffeur-driven Mercedes and tentatively rolled down their windows. Uniformed security guards, accessorized with muzzled rottweilers on tight leashes patrolled the area. Models dressed in unintelligible pieces of mutilated clothing layered over thick black catsuits and muddied, graffitied motocross boots stood unblinking, their faces obscured by strands of shredded chiffon, their arms frozen to their sides and encased in Perspex boxes like specimens in a laboratory. As the hour approached midnight, the dark waters of the Seine flowed ominously behind the roadway. Persoons, who grew up in Belgium and graduated from Antwerp's Royal Academy of Art in 1992, stands in near-brutal opposition to the conventional. "I start with classic

Photography Ronald Stoops Styling Olivier Rizzo (left image only) Makeup Inge Grognard Hair Rudi Cremers (right image only) Model Sofie (left image only)

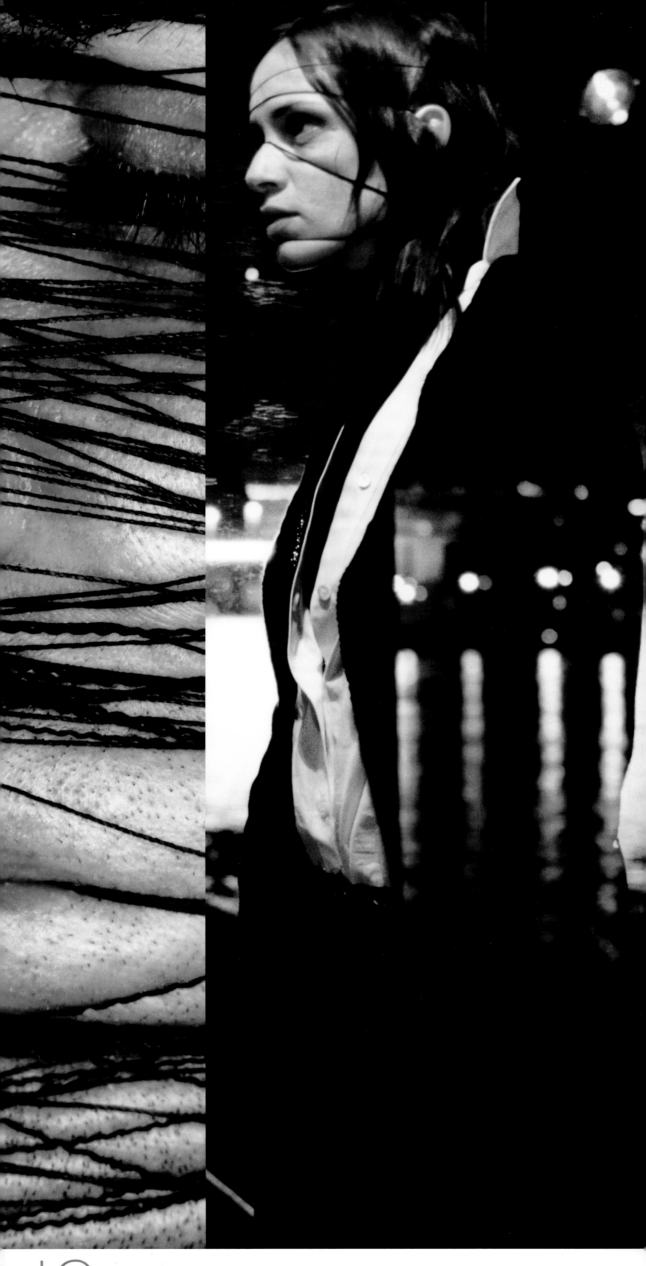

clothes, then deform them," says the designer, admitting that as a student at the Academy he was already disfiguring such sartorial icons as Burberry's jackets (his early collections have names such as "Escada Trauma, Working Girl's Nightmare" and "Resurrection of Eighties Ungaro Tramps out of Their Graves"). Persoons begins with housedresses, classic white shirts, and ordinary knee-length skirts. These clothes come fully formed into his studio, then he sets to work on them. A white shirt ends up with its sleeves and collar pulled archly behind or thrown off balance to one side. A dress in a cheery print fabric has its neckline ripped out. Sweaters have scratched-out sleeves, with lace crudely sewn on in patches. A black coat is lined in strips of shredded white chiffon, the stitchwork exposed on the outside. A man's jacket is split down the center, its insides pulled out. A lace dress has its sides cut out and reattached with a tangle of red thread. And to think that when Persoons first put needle and thread to fabric some eight years ago he was the one who was scared. "When I started I was afraid," says the designer. "I was thinking about how to sell, who will buy it, the prices. Now the less I care the easier it goes." —AB

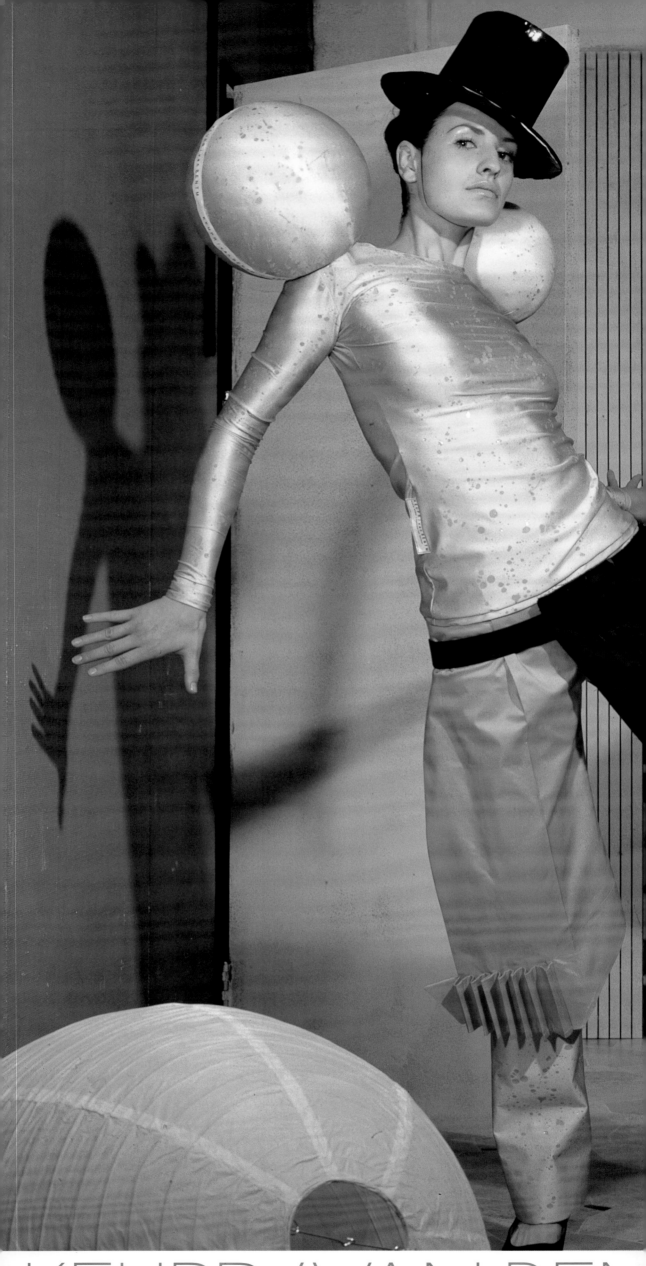

In January of 1999, during the Paris Haute Couture, Michiel Keuper and Francisco Van Benthum, the designers behind Keupr/Van Bentm, put on a fashion show. The program notes describe the runway looks: Black Hole (3 1/2 meters squared of black polyesteripleslash, cut and folded on the backseam, which is to be worn over a double-breasted twisterpantyhose); Chemical Insult (One-piece doublesided slap of grasshoppergreen poly-morph-lush); Tribute to Leigh Bowery (Green on blue polka-dotted 2/3 pantalonium, attached to a paper-folded skeleton, standing about 1.90 meters measured from the shoulder. Light, multi-colored foam-stuffed back-piece, completed with eleven meters of rhinestone trimmings.). If all of this sounds incredible, that was the point. Invitations were sent out the day after the show was to take place. The show never happened. "It enabled us to do the impossible," they explain. Keuper and Van Benthum both graduated from the fashion department of the Arnhem Institute for the Arts, Keuper in 1993 and Van Benthum in 1996. They shared a studio space and soon discovered that they also shared a sense of the absurd. They made their debut as Keupr/Van Bentm in 1997. In

Photography Michiel Keuper/Francisco van Benthum Makeup and Hair Sil/House of Orange Models Pet/Name Petra/Touché

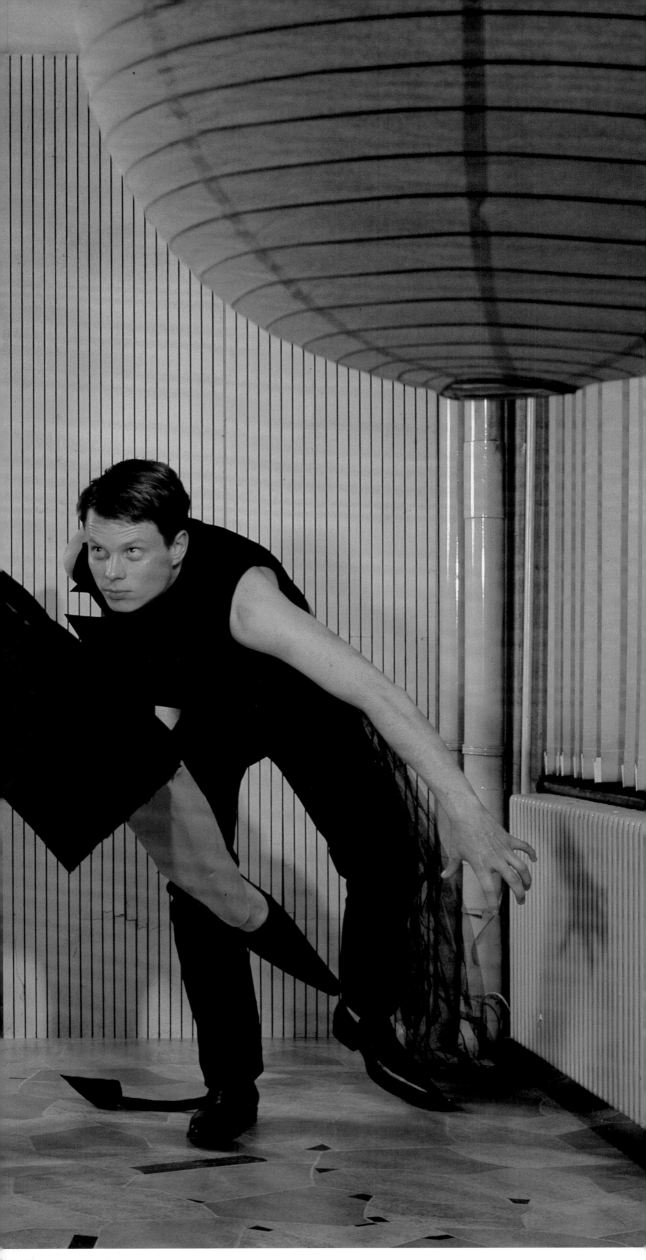

their work, wearable elements are broken down into bits and then thrown together again seemingly at random, a sartorial puzzle whose pieces don't quite fit. Keuper and Van Benthum refer to their presentations—the ones they actually produce as well as the imaginary ones—quite accurately as "Parades": shoulders sprout spheres and explode out of holes in the backs of jackets; pants change their minds midstream and become skirts; corsets have collisions with coats; a ludicrously baroque man's suit is composed from shards of a kilt, trousers, a scarf, and a house plant. Then there are the accessories: opera-length kitchen mits, donkey masks, capes, top hats, tulle tutus, and a "pressing-egg" covered in rhinestones. They use their system of fragmentation and montage to turn garments on their ear and, they say, to do the same to our comprehension. "The viewer is confronted with what he or she already knows or can refer to, but this image is only the first layer. As soon as the model turns, garments are not what they seem to be," they wrote in the notes to their 1998 collection, "Evil Wrapped in Beauty." "It's very hard to do something new these days," they say. "We never want to take things for granted." —AB

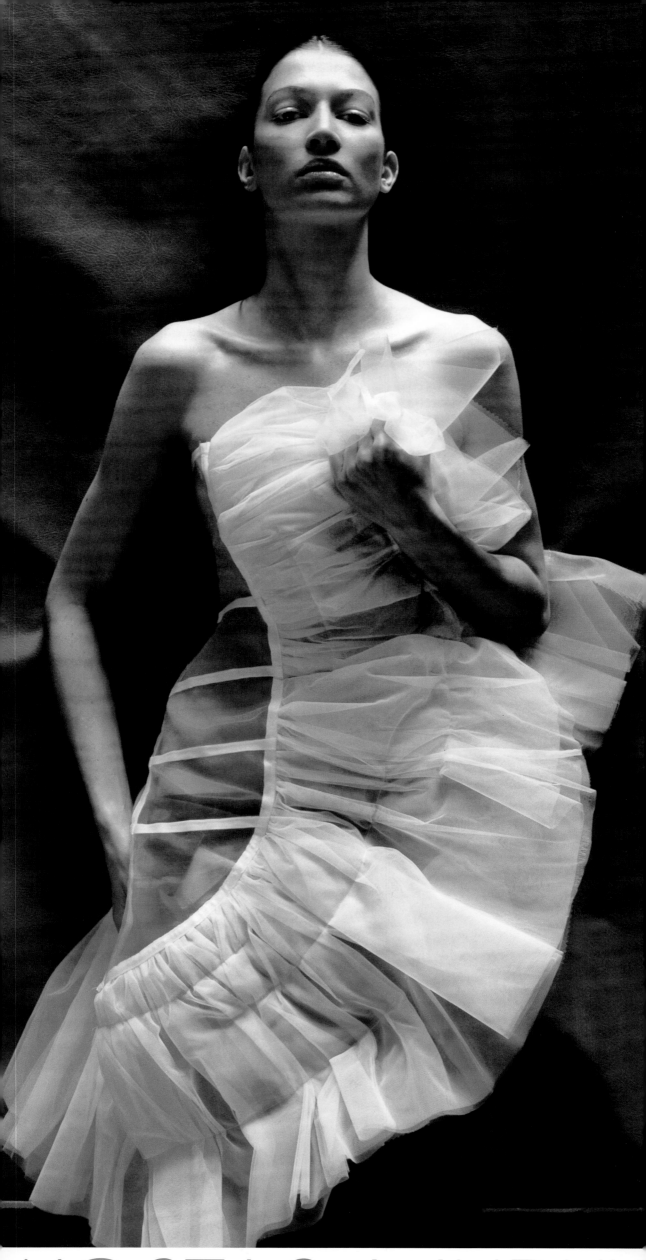

KOSTAS MURKU

For a young designer just starting out, it is both a blessing and a curse to have worked for somebody well known. While it is no guarantee of talent, the "assistant to" factor can draw the attention of store buyers and press that might not otherwise take a chance on an unknown figure. On the other hand, the expectations—and consequently the readiness to criticize the young protégé's work as derivative—are escalated. It has been Kostas Murkudis's particular blessing and curse to have worked with designer Helmut Lang for nearly seven years. So when Murkudis finally decided to go out on his own in 1994, it was not without a certain amount of trepidation. As if to stake his ground as far away from Lang territory as possible, Murkudis presented a first collection filled with colorful, long silhouettes inspired by his own Greek heritage. Now, with six seasons behind him, the designer seems to have settled into an aesthetic completely his own. Murkudis grew up in East Germany, a place he describes in retrospect as a prison. "I didn't have television. I didn't know Paris existed. It meant nothing to me," he says. "It was okay; I was a little child. I didn't know any differently." To please his parents, Murkudis took up his

Photography James White Styling Darryl Rodrigues Makeup Topolino Hair Laurent Philippon Special thanks Lionel Peralta

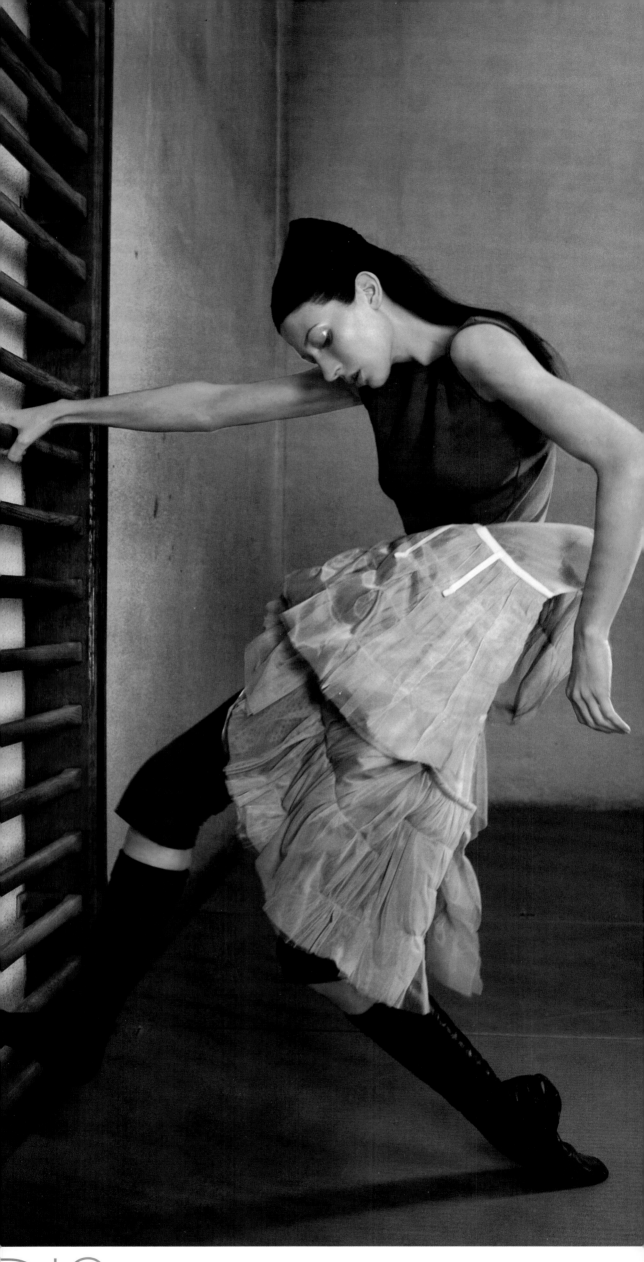

studies in chemistry but abandoned them two years later to go to fashion school in Berlin. He worked one season for Wolfgang Joop and then met Helmut Lang, who was preparing his very first show in Munich. Like Lang, Murkudis is fundamentally utilitarian and works primarily within a vocabulary of men's tailored suits and simple shift dresses. But Murkudis never comes off as cool or standoffish. He draws from a panoply of references, so his collections can be surprisingly eclectic—mixing, say, flightsuits and pilot coats with ribbon dresses straight out of Greek folklore. His fall '99/'00 collection began with a picture he found of the Russian Ballet. The point of departure was from behind-the-scenes, featuring reversible pants in jersey and nylon with rehearsal tutus worn over them and dresses crafted from tulle and nylon, or lace and tissue-thin plastic. "I tried to please women with this collection more than in any collection before," Murkudis says, adding that this collection was a turning point for him in more ways than one. "We used really beautiful fabrics. In the beginning you can't afford them. I had to buy cheap—fabrics for five francs, linings and things. It's a real challenge." —AB

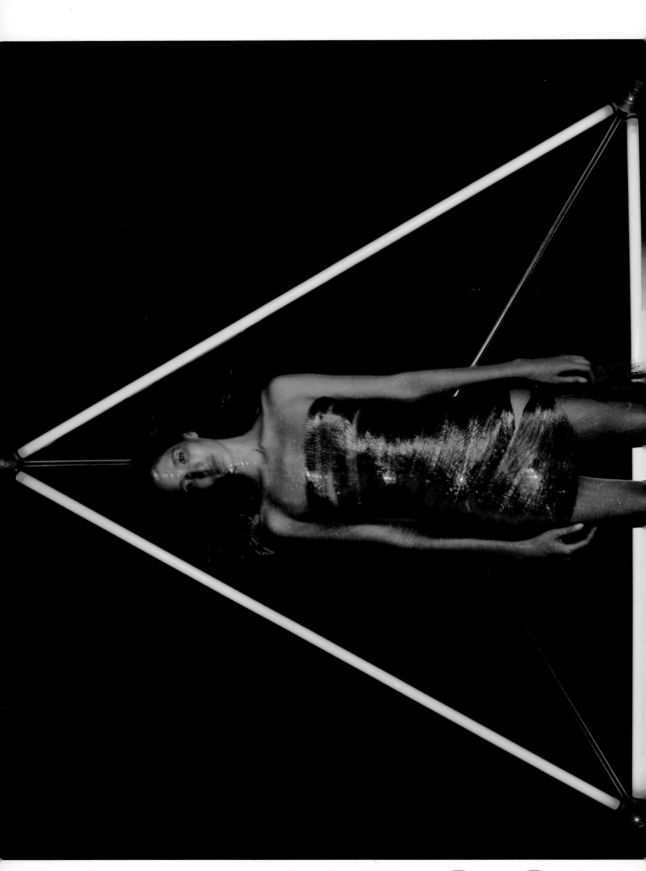

LAINEY KEOGH

Lainey Keogh is not a new designer, for she has been creating sensual and stunningly innovative knitwear in her native Ireland since the mid-'80s. But it was not until 1996 that the fashion world became aware of her wild genius when, with the assistance of stylist Isabella Blow, she brought her collection to London. That first British show was a true fashion moment, as supermodels (Naomi, Helena), super-sized models (Sophie Dahl in her runway debut), and stars (Marianne Faithfull) shimmied seductively in knitted cobwebs. The international style community has clamored for Keogh's fanciful creations ever since. A gown by Lainey Keogh can snake seductively around the body like a fragile boa constrictor, or it can drape and train like something out of Queen Guinevere's walk-in closets at Camelot. A chenille bathrobe, a crocheted frock: the commonplace and the homey become magical and precious under Keogh's care. "Every fiber has its own alchemy, its own language," she says enigmatically. "I like very much the architecture of metals when used as components in yarns that we then handweave or handknit or crochet. The metal element can change the look in marvelous ways." To create her

Photography Warren du Preez Styling Lainey Keogh Makeup Wendy Rowe/Blunt Management Hair Earl Simms/Debbie Walters Photo assistance Giles Price Laser artist Chris Levine Printing Howard and

labor-intensive and often fantastical creations (for fall/winter 1999, there were gold-plated copper gowns bejeweled by hand with crystals), Keogh works with a team of twelve in her Dublin studio and another twenty or so craftspeople in the Irish countryside (which she knows well, having grown up on a farm). She sees her production process as collaborative; the craftspeople are gifted technicians who have deepened her appreciation of the essential techniques that underlay the work. "Through their profound knowledge, I work to understand new fibers and stitches," she says. "In that journey from the beginning of work with a new fiber to the thrilling final result, anything can happen." The organic nature of the production process reflects Keogh's deep appreciation of the wider natural world. Her fall/winter 1999 collection portrayed "the cycle of life here on earth, starting with red, the fire creation, and then moving to green, which makes life, and then to purple, which is a color of love, to black, which is death, and finally to red again." She even defines the appeal of her work in evolutionary terms. "There's something transformative about beautiful things. My clothes have an energy that is all about becoming." —SS

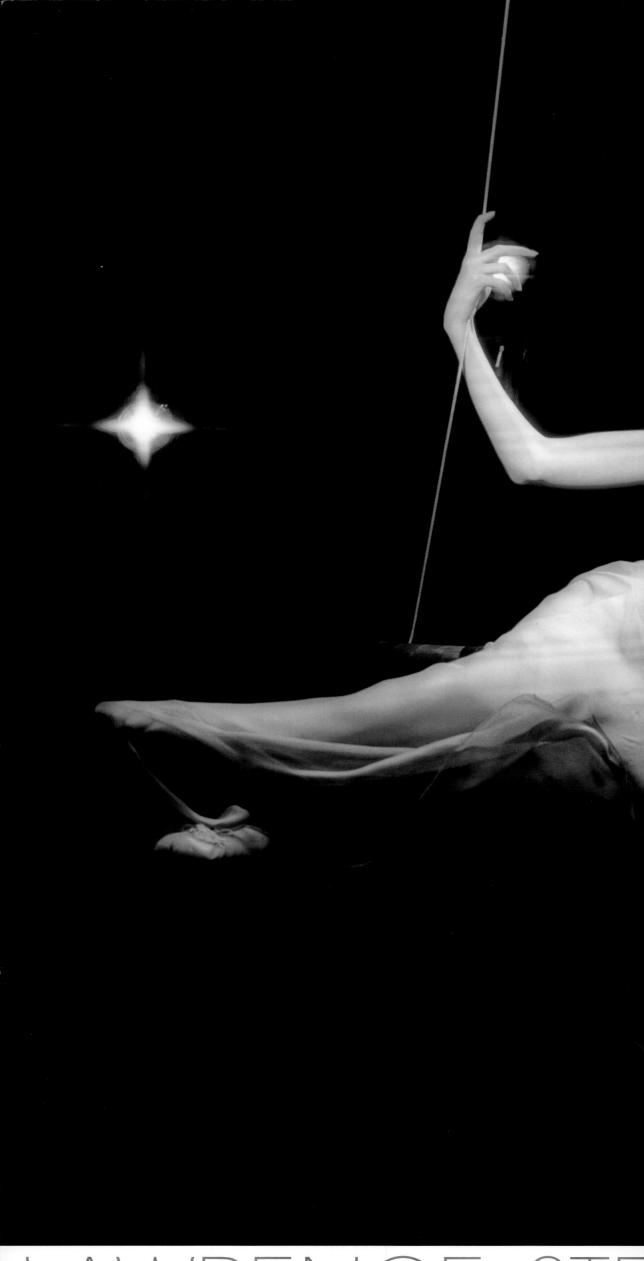

LAWRENCE STE

To welcome 2000, Lawrence Steele is moving his collection from Milan to New York. "In the next century, I am going to have to start thinking about the industrial process, and how to render hyper-feminine designs via an industrial process," he says. "New York is the city most forward-thinking about such matters; it is a mecca for movement and direction." The need to create garments that are luxurious, frivolous, and deliberately raw or knowingly imperfect in an industrial setting has long concerned Steele, a young Illinois native who has devoted his fashion career to encouraging the traditionally inclined factories and mills of his adopted Italy to expand their design vocabularies—with Franco Moschino in the '80s, a goofily gregarious wit infused Steele's classic tailoring; under Miuccia Prada, hyper-modern cutting met classically gorgeous double-faced cashmere. With his own line—or lines, as the case may be, for he has just embarked on a secondary sport collection—Steele continues to explore the nature of industrial luxury. For fall/winter 1999, he offered down padding under cashmere in a narrow parka and he zipped up silk taffeta separates; a wide belt was shown on the catwalk in stainless steel; and stretch materials in

Photography Miles Aldridge for the 1998 Biennale di Firenze

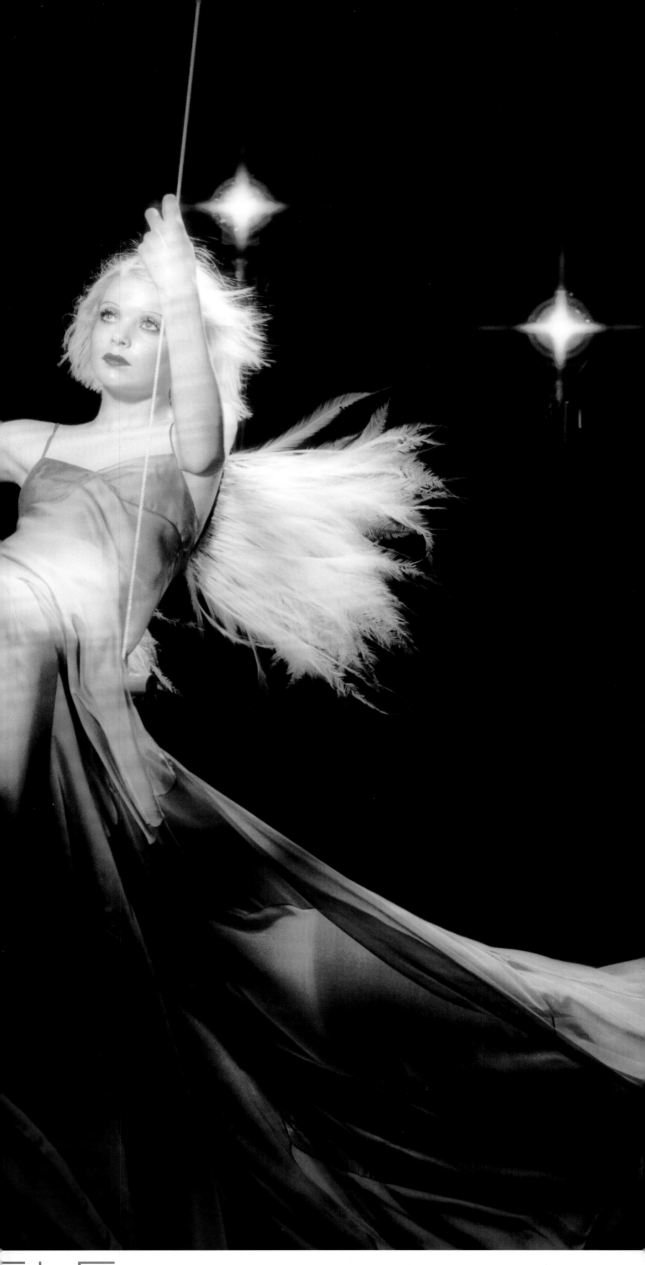

icy shades of silver and frost became slick pencil skirts and skinny dresses. Steele's silhouette is body-conscious and often evokes a rather old-fashioned elegance. "I want my clothes to express a vulnerability but to be in fact quite studied and very constructed," says the designer. "Even though the results are modern, I always have an eye on the allure of fashion that comes from the past, whether it be Chanel's obsession with the cardigan jacket or the perfection of Saint Laurent's tailoring. I think that in the future," he says, "there will be more need for individuality. To do that through glamour may be cliché, but we all need beauty in our lives." Steele marries a singular point of view with real commercial canniness. Even in his sport line, he never sacrifices his slinky-cool design vision to the crasser concerns of easy-wear separates: his parkas and ski pants are cut with a precision that is pure, unadulterated "fashion." Yet Steele does not pay lip service to the notion that high style should only be for the precious few, hand-tooled to within an inch of its sartorial life. Practical yet fanciful, Steele is a pure product of the Midwest, and the American design community should be delighted that he has finally decided to come home. —SS

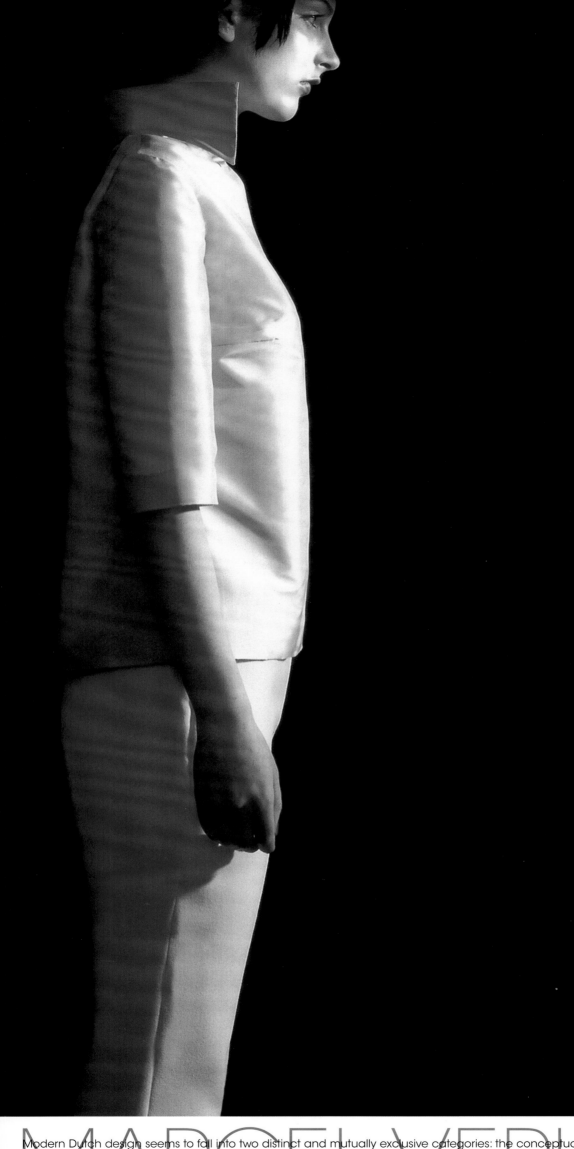

MARCEL VERHIJE

Modern Dutch design seems to fall into two distinct and mutually exclusive categories: the conceptual and the technical. The conceptualists hang their collections on an idea; the more abstract the better. The technicians take a decidedly more hands-on approach, building their collections piece by piece from the ground up. In another life this latter group might have been designing furniture or office buildings instead of jackets. Marcel Verheijen, who hails from southern Holland, is pure technician. After graduating from the Arnhem Academy of Art's four-year fashion program in 1992, Verheijen participated in Paris presentations with Le Cri Néerlandais and collaborated on the "Défilé sans public," with fellow alumni Viktor & Rolf and Saskia Van Drimmelen. He also served a six-month stint with Martin Margiela. Before any of this, however, he had been on the career path to becoming an electrician. It's not much of a stretch. Verheijen is obsessed with the way things are made and how they work, be it an electrical appliance or a pair of pants. "I start with a body, then I think about the fabric, and I think about how to put the fabric on the body," he says. The investigative process always starts at the point of construction, in

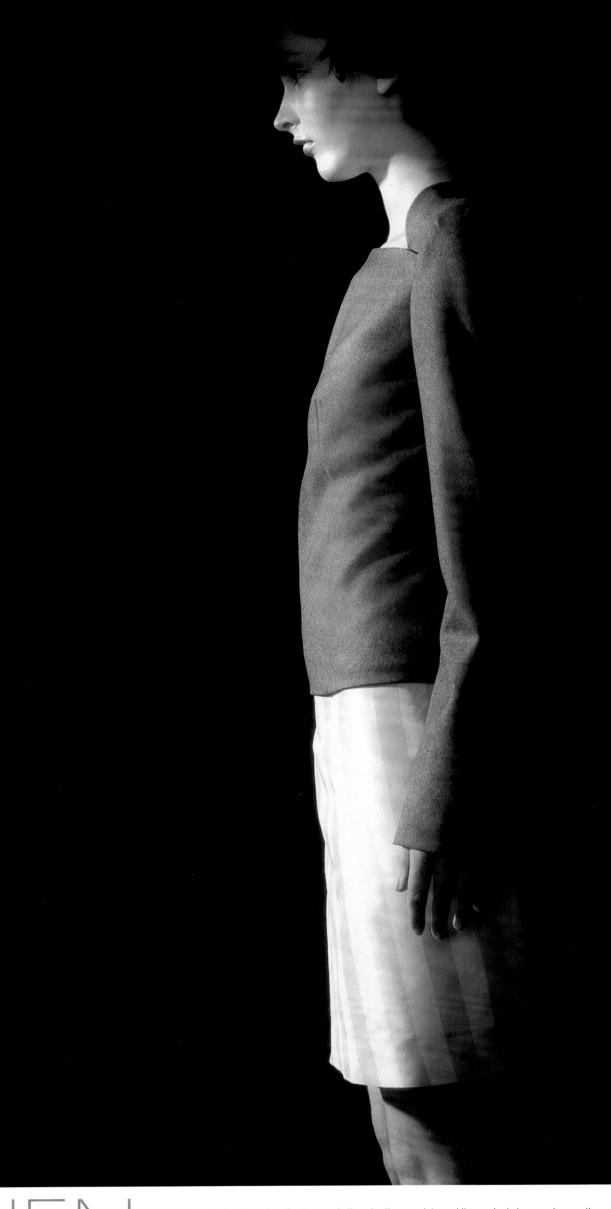

three dimensions (not on paper), and ends when he finds a solution to the problem. His materials can be quite classic—100-percent cotton poplin, silk, or wool—or, as he describes them, "quite freaky," such as an industrial fabric stiffened by aluminum. Most pieces of minimalist design look very simple but have a complicated internal construction; in contrast, Verheijen's clothes appear at first glance to be quite complicated but are actually the result of a very simple design process—simple in his own mind at least. "I start with a basic pattern, turn it inside out, and then turn it back around into a garment," he says. When his pieces are sent out for production, they are accompanied by step-by-step instructions worthy of an engineering project. It amused Verheijen to see another designer try to copy a box skirt he had devised. "It was nothing more than a square of fabric with four seams," he says. This person had created an entire internal structure to achieve a similar effect without much luck. "In school people told me I should have been in the three-dimensional program," Verheijen says. "And sometimes I look at something I've done and say, yeah, that could be a table, or maybe a chair." —AB

2/28 ' I 8
VERY FINE
"CROCHE

BACK C

MARIA CHEN

Fashion can be a means of covering up the past, a promising cloak we don to transform ourselves into some-body else. Or as in the case of designer Maria Chen, clothing can be a means of rediscovering, and ultimately coming to terms with it. Chen, who works out of London, was born in America but grew up in Taiwan, where she was raised by her grandparents. A friend of her mother's who owned a boutique encouraged her to draw, and Chen came to New York City to study photography and fashion, working variously for designer Isabel Toledo and photographer Steven Klein and as a freelance photo assistant for the *Chicago Sun Times*. "I was where I wanted to be aesthetically but not in the work sense," says Chen. She relocated to Paris where she studied the history of fashion, from illustration to corsetry, and then completed her M.A. at Saint Martins in London, finishing in 1998. Her graduation collection, inspired by the work of photographer Cindy Sherman, was optimistic and cartoon-like, buoyed by brightly colored chiffon layered over muslin linings. The organically formed silhouettes, such as a bubbly double skirt that reinvents itself as a dress, offered up the shapes of collections to come. "I've

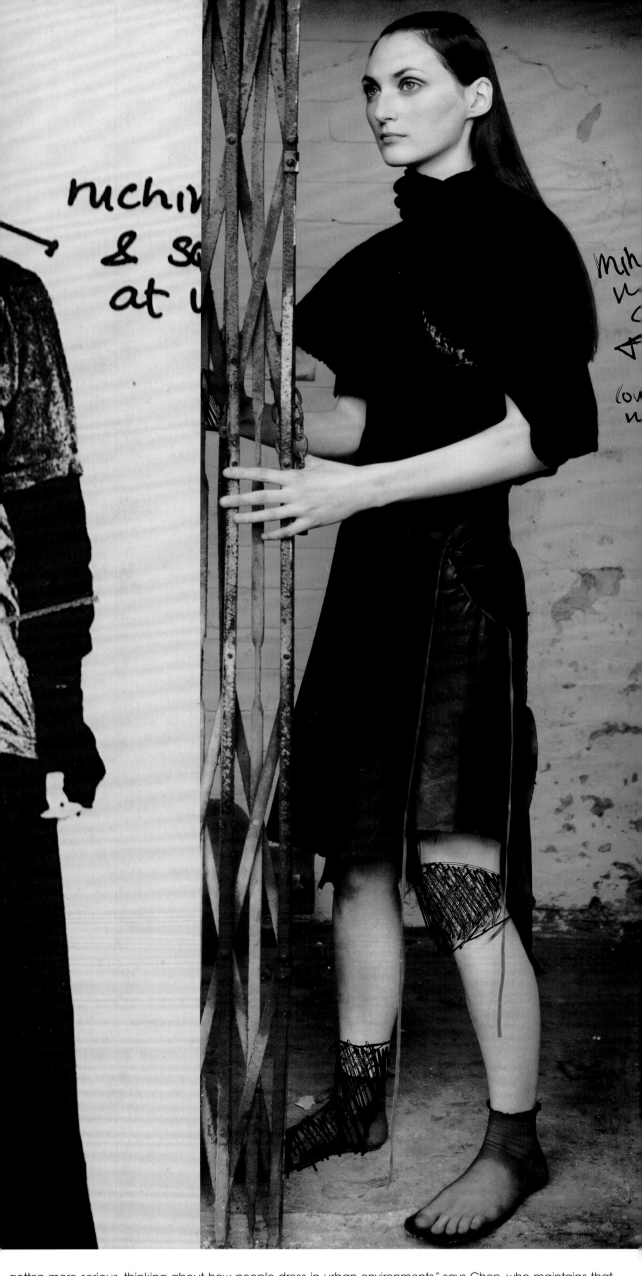

ruchi
& so
at t

min
u
c
t
lov
u

gotten more serious, thinking about how people dress in urban environments," says Chen, who maintains that
there are more similarities between Times Square and Taipei than differences. More significantly, this less exuber-
ant, more honed aesthetic has brought her back full circle to her childhood. Chen studies old photographs of
working-class people and wanders the markets of London looking for the small but significant details other
people simply don't see. There is a lot of handwork that goes into her clothes and Chen's fingerprints are evi-
dent everywhere. Fabrics are dyed or overbleached or rigorously washed, their finishes stripped away to create
the effect of having been softened by hard work and the wear and tear of everyday life. Her soft, sculptural
pieces willingly mold themselves to the body of the wearer, but the memories inherent in such garments are
Chen's own. "Not growing up with a lot of resources, we had to make the most out of everything. We'd always
push something further, use it again," she says. "My father has things he's had for years; he never threw anything
away and he really drilled it into me. At the time I don't think I appreciated it. Now it's a big part of what I do." —AB

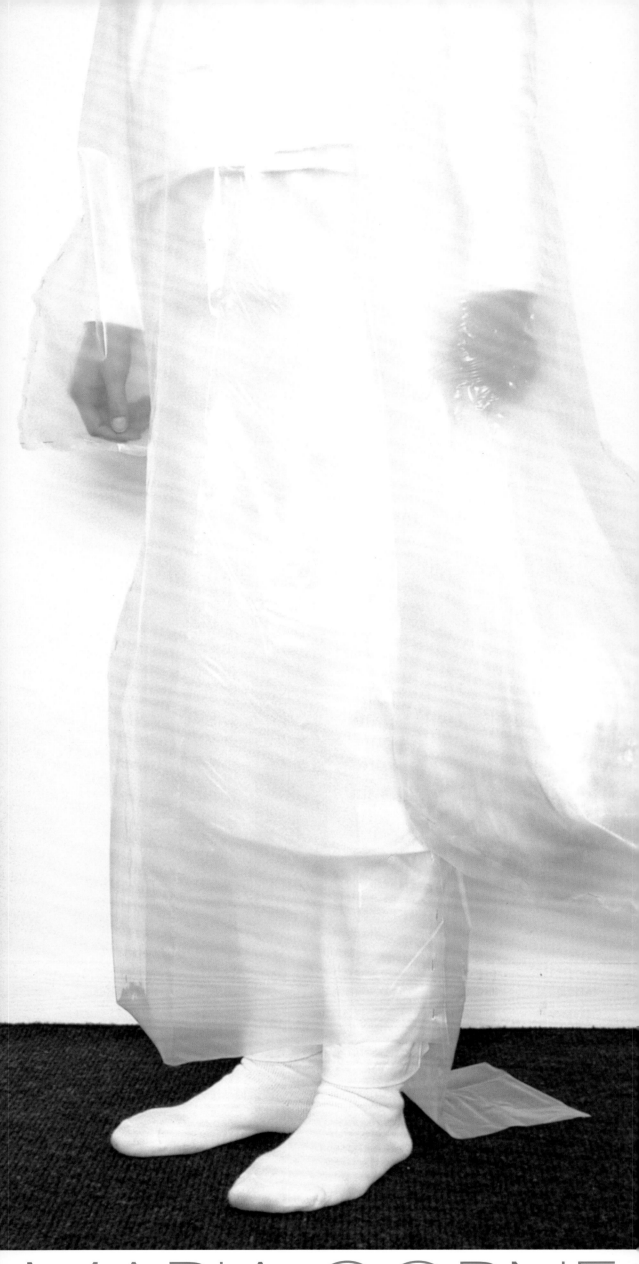

MARIA CORNE

For a new generation of young designers, the '80s are a vital point of reference. Maria Cornejo, however, would just as soon forget them. "I had had twenty stores open in Japan in a single day," she recalls. She was twenty-three years old. Only a few seasons out of London's Ravensbourne fashion school, Cornejo and her then-partner John Richmond seemed to have it all: big runway productions, a cultlike following of club kids. But having it all is never quite what it's cracked up to be, and Cornejo and Richmond split, both as a couple and as a business. Afterward, Cornejo tried to go it alone in Paris with an Italian backer for a few seasons but it wasn't long before she found herself under all too familiar circumstances. "I was so fed up with the way the system worked, I thought I'd crack if I didn't get out," Cornejo says. "I wanted to get my identity back." In 1998, Cornejo started all over again from zero (whence the name of her new company). She set up shop in a former garage space in Manhattan's Lower East Side and started to make clothes again, this time on her own terms. The significance of Zero, appropriately enough, is to be found both in what it is and what it isn't. What Zero is: elegantly utilitarian

Photography Mark Borthwick

shapes that are based on simple geometric principles, quietly intriguing and designed for everyday use. A square of fabric with three holes cut into it becomes a top. A tube with a slit on one side for an arm reveals itself as a dress. Two triangles meet up to make a skirt. "I create the things that I want," Cornejo says. "I don't have the time to get intellectual about the process, so the clothes have to be a lot more practical." What Zero isn't: everything that Cornejo left behind. Pretensions, advertising hype, runway hoopla. Zero doesn't follow any of the artificial rhythms of the fashion industry; Cornejo's abiding philosophy is that something that is well made and designed with a degree of integrity will stand on its own and that "clothes don't become pieces of shit because six months have passed." Cornejo produces the clothes in a small atelier in the back of the shop and puts them on sale out front when they're ready. Her reputation is based on word-of-mouth, and that seems to be enough. "People come into the store with their own intelligence, people who understand the clothes," Cornejo says. "All the cool girls are wearing the clothes anyway. And they're not wearing them because someone told them to." —AB

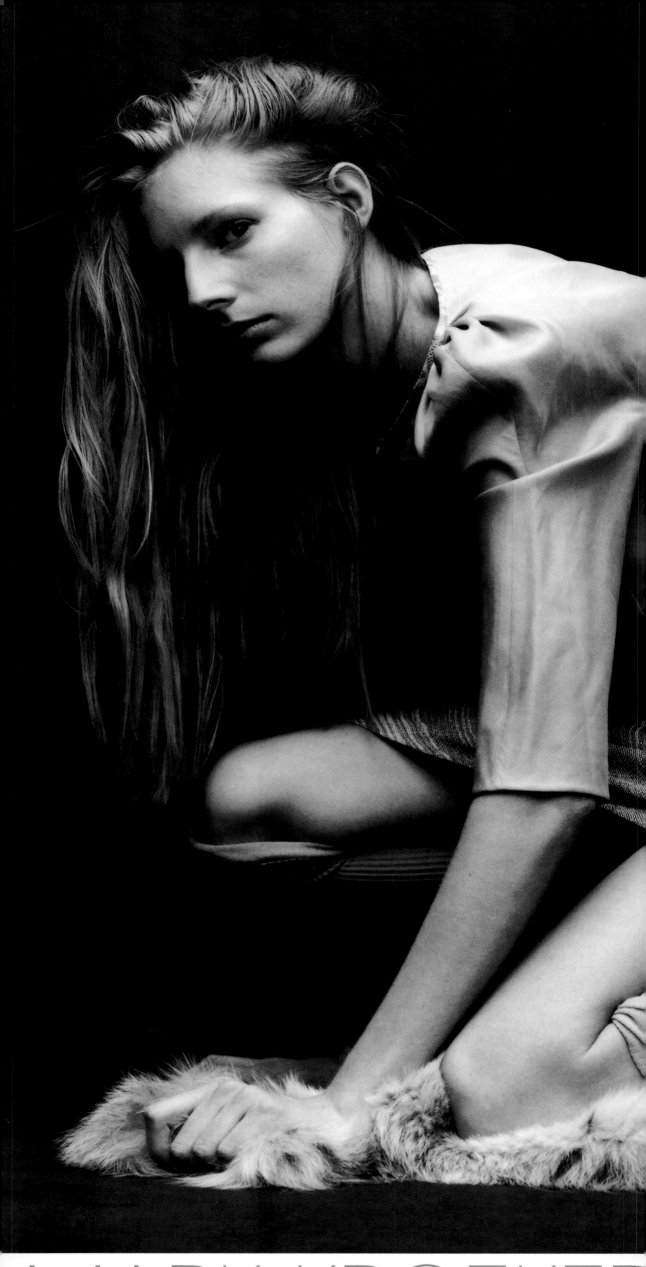

MARK KROEKER

As a small boy living in Istanbul and Tehran, Mark Kroeker spoke Turkish and Persian. He lost these languages when his parents (who were teachers) returned to the United States, but some oriental remnants are still discernable in his designs. He works only by draping, and his silhouettes—long, lean, and elegantly feminine—swathe their wearers in ways suggestive of the harem and the souk. He has wrapped long aprons over skinny trousers, covered ankles in burnished metal cuffs, and veiled the torso in fluttery layers of silk chiffon. For fall/winter 1999, he clad wrists in "dowry" bracelets: a series of skinny tension wires that spun around the arm and culminated in a dangling gold coin that the wearer concealed in her palm. A floor-length skirt, split thigh-high on each side, was rendered in Arabic cutwork lace. In the same collection, however, New York–based Kroeker also took inspiration from his other childhood homes in Oklahoma and Texas. He called his fifteen looks "prairie alien" garb, and in the sweetly tucked and ruffled necklines and prim, body-skimming nightgownish frocks of stony blue-grey, one sees the possibility of a thoroughly modern Laura Ingalls. Acid-etched silks, designed in collaboration with textile artist Aviva

Photography Thomas Schenk Styling Jon Moore Makeup Ferida Hair Michael Boadi/Art Department Studio The Space Model Grace Kelsey/IMG

Stanoff, marvelously evoked the geology of the American desert—the rock strata, the whorls of sand and stone. "As I get more comfortable with myself, everything I create becomes more comfortable," says Kroeker, who graduated from Parsons with a serious attraction to the "shiny." But there is a complexity of design in his work which belies the simple ease of the garments. Kroeker is ingenious at finding graceful solutions to perplexing problems of construction. His cobra sleeve, for example, has a series of small tucks across the shoulder instead of a seam; his single-seam sheath folds back on itself to create a sleek and unobtrusive lining. Kroeker's problem-solving skills extend, by necessity, to financing and production. By day, he does research and development work for architecture firms and takes only a month off before fashion shows. In order to share ideas and maximize creative energy, he has formed a "lost collective" with fellow artists Isabel Encinias (jewelry) and Aviva Stanoff and Rose Ailongian (textile design). He says of his work with Stanoff, "We can create fabrics that are worth $200 a yard. We can do so much more than if I had a huge budget. The challenge is to find ways to make intriguing things with no money." —SS

As fashion director of *Details* in the early '90s, Mark Whitaker worked with David LaChapelle to create highly contrived, highly stylized, and super-sassy pictures. When he stopped making images and started making clothes, he nonetheless continued to produce highly dramatic designs. "Fashion styling is about creating an image on a page; you could almost say that I wanted to take the concept further and produce an image from my clothes." His all-black collection was based on origami and shown only on black models; his "print" collection played with orchids and—conceptual leap—aspired to be "modern sushi"; and when he chose to work in pastels, he acted like a confectioner of enormous petit fours—voluminous padded gowns in fondant hues and velvet clown trousers in soft fuchsia. Whitaker's initial collections (there have been five) were astounding, exuberant and—most important—marvelously crafted. Working as a stylist gave the young Yorkshireman with a fashion degree from Newcastle the opportunity to scrutinize the fabric and production quality of much of what's for sale in the designer market. This information became invaluable when he finally launched his own line, which he shows in galleries

and small presentations. "If you only produce for the runway," he says, "you can never get across the details and allow your audience to feel the cloth, enjoy the cut, see the seaming, and notice that the pockets are as beautiful on the inside as on the outside." In his recent work the exquisite tailoring and handfinishing is still important, but Whitaker has moved away from high drama. "I need to feel very close to the person that I'm designing for," he says. "Now that I've started doing menswear, my womenswear is becoming more realistic. I was always playing with fabrics which had to be drycleaned. But at the end of the day I tend to wear a T-shirt and jeans or chinos." A small line of sundresses in easy-care, easy-wear Liberty print cottons has proved his most commercially successful offering to date. And so for fall/winter 1999, alongside tailored pieces in ethnic-inspired prints (woodcuts and batiks), Whitaker has added a number of denim pieces such as a Queen Mother coat. "I'm never going to compete with the Gap, but I do have something to say about that type of dress. Blending all of the things I've done in the past with a much more sensible outlook means that my best collections are yet to come." —SS

MATTHEW WILL

Matthew Williamson stands in sweet relief to his British compatriots, who seem intent on shocking the world with sartorial wizardry and runway pyrotechnics. But by the same token, he delivers far more to the imagination than designers who are content to offer up a cardigan and a slip and call it a day. Inspired, by and large, by his extensive travels in India, Williamson's collections turn on simple shapes, bright color, beading, embroidery, and just enough sexual innuendo. "Good things come from bad choices," he once told *Elle Decor*. "Life would be very dull if we all conformed to the same ideas of good and bad taste." Growing up in Manchester, Williamson showed an early aptitude for art. Whenever he was given a project to work on in school, he somehow turned it into a fashion project. "I knew I wasn't a mathematician," he says. "I never really had a decision to make." Having narrowed his focus to art and textiles, Williamson set off for London with his portfolio under his arm to try to find "this famous fashion college he had heard about." While completing a four-year program at Saint Martins, Williamson made his first trip to India, spending a year there working for a textiles company. It was a defining experience. "There is

Photography Pascal Demeester *Styling Samantha Adam Makeup and Hair Marina Buka Photo assistance Frédéric Bourgois Styling assistance Stephanie Mogenet*

an amazing variety of skills and craftspeople there," he says. "And the smells and colors are completely different. Anyone who is creative would be hard-pressed not to be inspired." Williamson graduated in 1994 and freelanced for various companies, including Marni and Georgina von Etzdorf, returning frequently to India all the while. When he started his own company in 1996, it was with a collection based on his experiences there. Williamson presented his first runway show in the fall of 1997. "Electric Angels" featured bias-cut dresses in clashing acid colors, offset by sharp black tailored pieces and soft cashmere knits and tied together with dragonfly and butterfly embroidery. This was followed by "Future Heirloom" ("what I would think people would consider a vintage garment in years to come"); "Disco Zen 2000" (simple, sharp silhouettes, deftly embellished with a nod to hedonism); and "Glomad" (inspired by the image of Indian women working in the barren landscape but dressed in luminous saris). "It's not my aim to produce clothes that shock or horrify," he says. "On the other side, I don't want to be stuck doing pretty slip dresses for the rest of my life. I'm trying to find a middle ground." —AB

Digital Imaging Pier 59 Digital Evolution/Pier 59 Studios Location Studio Ed Albers Model Mayuko/Elite

MORTEZA SAIFI

With so many designers feeling compelled to hang their clothes on a specific point of inspiration (anything, really, for a good story), it is unusual to come across a young designer who simply puts fabric to form and designs. Morteza Saifi, in fact, doesn't seem to like to talk very much about his clothes; instead he stands back and lets his work speak for itself. With a deft hand, Morteza cuts, wraps, drapes, and manipulates gravity-bound materials like shearling and double-faced wool into gravity-defying apparitions cloaked in mystery. In his first collection, which he presented in New York in the spring of 1999, a ropy, hand-knit coat corkscrews its way around the body. On a wool dress, one sleeve loops around and attaches to the back while the other dips down and meets up with the hemline in a single fluid and seemingly perpetual motion. He based a jacket on the idea of setting a sleeve upside-down and backwards. In his "jointed suit," the hem of the skirt doubles back up and becomes a scarf. At first glance, some of the pieces appear to be tricky, but, surprisingly, none of them are overly complicated. Morteza grew up in Iran, where his uncle manufactured clothing, and came to New York in

Photography John Minh Nguyen Models Olga and Jodi

the late '80s. He enrolled in some classes at New York's Fashion Institute of Technology and attended Parsons School of Design but didn't finish the program there. "It was a bad marriage for me," he says. "I wasn't interested in what they had to offer and they weren't interested in what I had to offer." Saifi worked as an illustrator for Gap and Old Navy, choosing to freelance in this way purposely to avoid coming under the influence of other designers. "I tried in the beginning to unlearn everything I had been taught," he says. "To start blank." Saifi, it should be noted, is not without his heroes: he cites the work of "several dead couturiers" and Japanese designer Rei Kawakubo as inspiration. And while he comes across as disciplined, he is not methodical, preferring to employ a more laissez-faire, one-thing-leads-to-another process of discovery. Pieces go through a lot of transformations before they are declared finished. He knows something is done only when he has nothing more to give it. "For me it's a matter of keeping myself in the same frame of mind," he says. Saifi, however, has no desire to reveal what that frame of mind is. Like his secretive, capelike clothes, he keeps his motivations concealed. —AB

NICOLAS GHES

When Balenciaga appointed Nicolas Ghesquière as its head designer in 1997, there was little of the hype that ordinarily attends the handing over of a traditional house to a mere twenty-five-year-old. However, the choice of the Frenchman from Loudon, whose CV includes stints at Trussardi, Thierry Mugler, and Jean-Paul Gaultier and who previously designed for Balenciaga's licensees, has proven to be the boldest statement yet by a classic French house in favor of true millennial design. Ghesquière's sensibility—rigidly architectural and hard-core cool—is forward-thinking without the slightest hint of kitsch. His long belted dresses may have a touch of Princess Leia about them (and he does cite her as an inspiration) but with their skin-tight leather detached sleeves and sleek, narrow lines they transcend that type of easy pop-culture referentialism. Ghesquière's spring/summer 1999 silhouette—the long A-line wrap skirt and narrow peasant top—also shook off the ghost of the '70s through truly innovative detailing: fitted, padded cuffs from elbow to wrist which dramatically elongate the arm; shirts with slashed sides and semi-attached puffed narrow sleeves. His preferred trouser shape is extra-long and skinny-

Photography Inez van Lamsweerde and Vinoodh Matadin Styling Marie-Amelie Sauvé Makeup Lisa Butler/Streeters Hair Eugene Souleiman/Streeters Photo assistance Jodokus Driessen

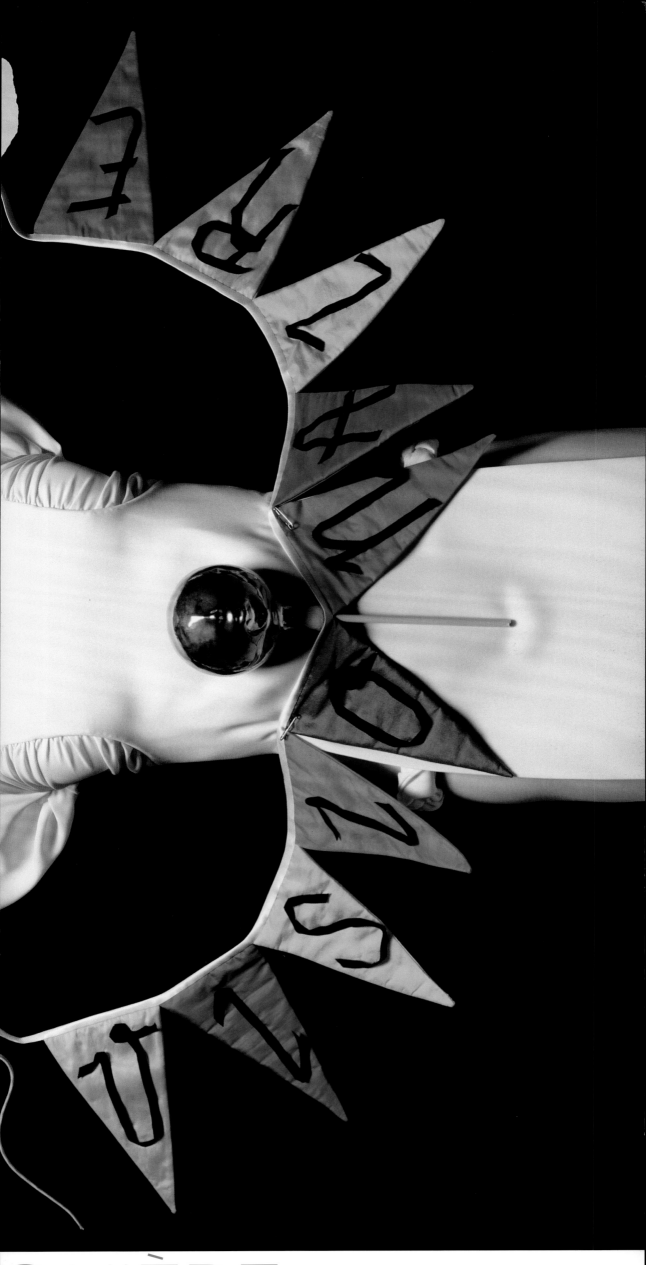

legged with a waistband that lies flat across the hipbones. These he has paired with square- and circle-front tunics to create an exaggerated and super-sexy T-frame without resorting to shoulder pads. There is a Gothic quality to Ghesquière's dark palette and unrevealing, controlled silhouettes, but this is tempered by an unerring Gallic sense of chic. He makes culottes to rival the Saint Laurent classics and cuts slim, V-neck tops out of the thinnest chocolate leather. He has tried, he says, to give the feeling of new lines and configurations and likes the idea of it being a perverse trick, restricting at first glance but actually very giving. For clothes that reveal so little skin, the effect is startlingly sexy: a mix of Talitha Pol, Bianca Jagger, and, perhaps, a little Princess Leia. And the shoes that Ghesquière pairs with his looks only heightens the frisson: vertiginous heels that have reduced seasoned models to tears after a trip or two around the catwalk. True fashion, some might argue, always requires sacrifice. The wearer of Ghesquière's Balenciaga is not looking for comfort—if so, why wear a leather sleeve that fits like a Band-Aid?—but for elegance that stands defiantly at the opposite pole of reactionary. —SS

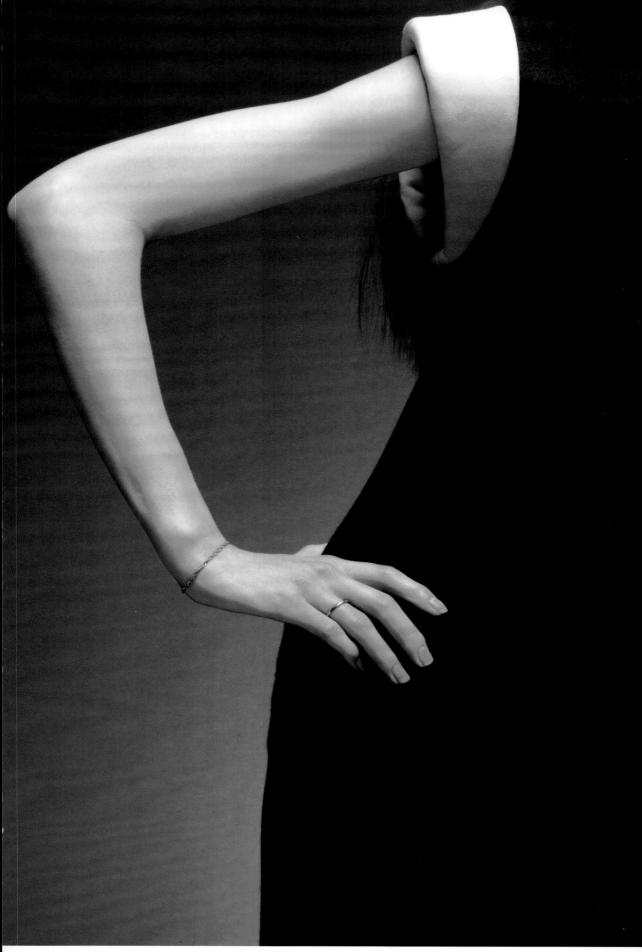

NICOLAS GHESQUIÈRE

> Photography Inez van Lamswerde and Vinoodh Matadin Makeup Lisa Butler/Streeters Hair Eugene Souleiman/Streeters Styling Nancy Rhode/Streeters Photo assistance Jodokus Driessen

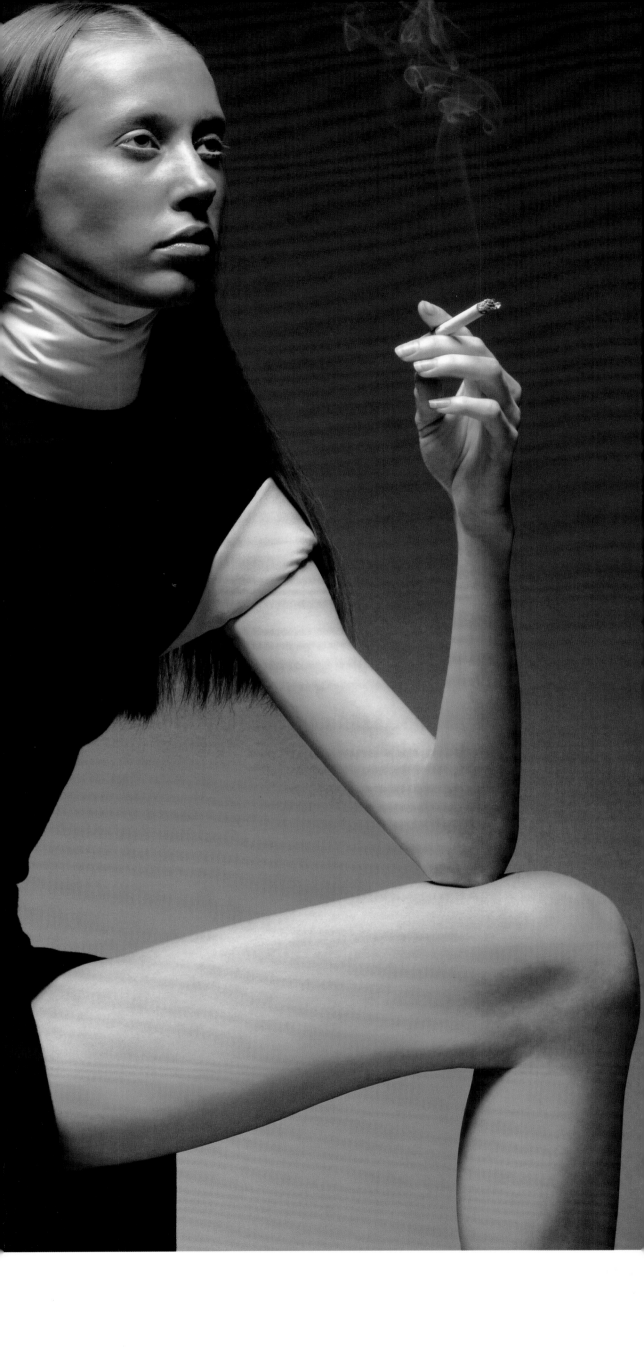

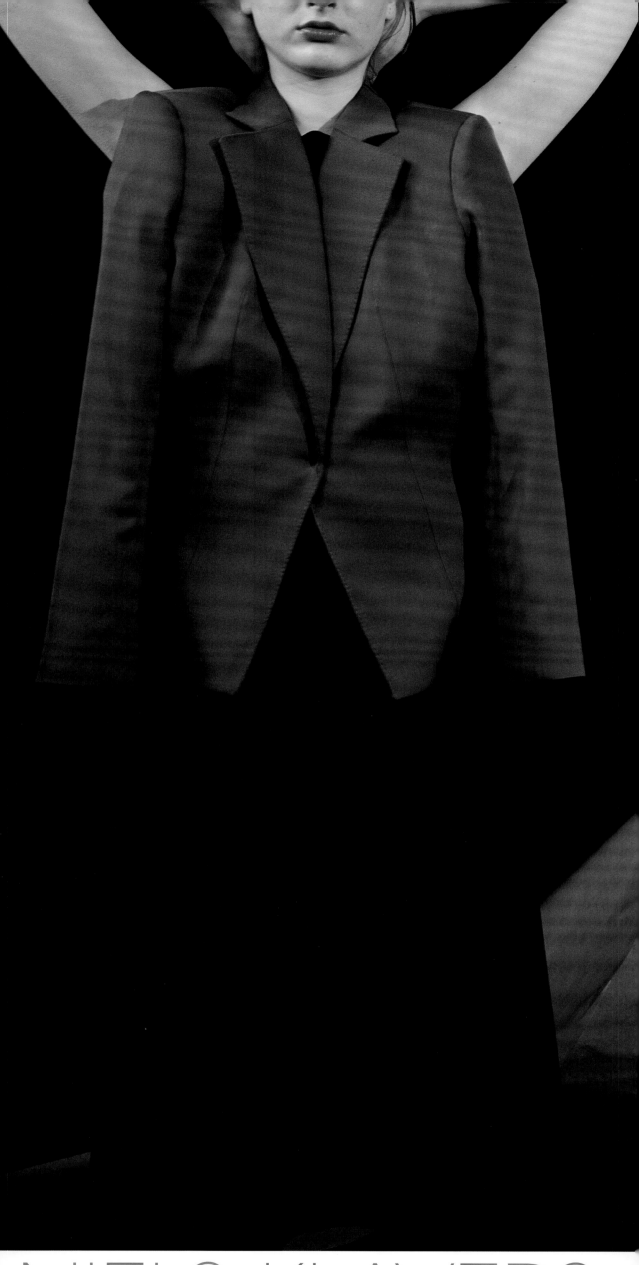

NIELS KLAVERS

Fashion has gone to such extremes at the end of the millennium that designing something truly shocking practically requires an electrical socket and a bucket of water. In all the hoopla, the three-armed jacket stands out as the biggest fashion joke of them all, the most obvious example of the lengths to which some designers will go to make us sit up and take notice. Dutch designer Niels Klavers has created a jacket with multiple sleeves—his had four. He has also made three-legged pants, a four-armed sweater, and a coatdress colonized front and back by two identical coatdresses. And Klavers has done these things in all sincerity, with a straight face. "I do this work very seriously," he says. "I don't laugh about it. I'm not making fun with it." Klavers's modus operandi is to take a side of clothing we already know, to which we have already become blinded by complete and utter familiarity, and add another dimension. His first collection, "Show Me Your Second Face," used what he calls "feature doubling," or the annexation of duplicates to this effect. A pair of ordinary trousers suddenly became less ordinary when it had five pairs of the same trousers trailing behind it. In his second

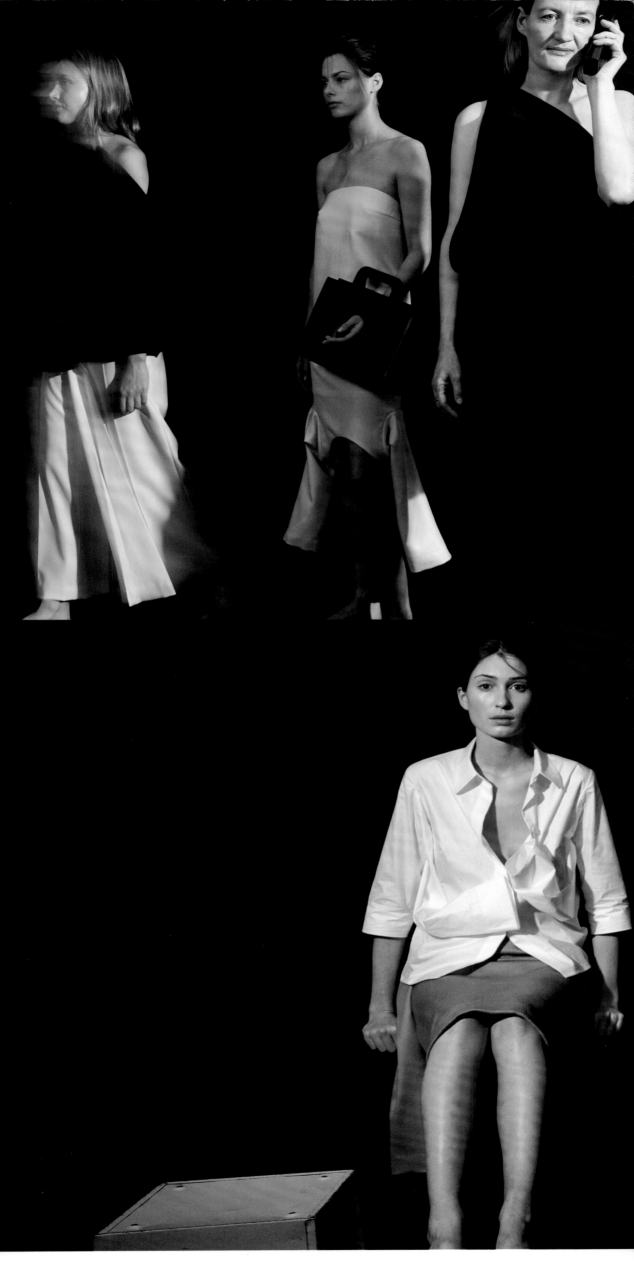

collection, which was presented in Paris as part of a group showing of the Fashion Institute Arnhem in the spring of 1999, Klavers took this idea and twisted it slightly. A jacket shifted ninety degrees on its axis, the arms protruding from the chest and back; a skirt sprouted shoulders and sleeves; a garment that may have started as a pair of pants morphed into a skirt. The models who walked the runway had their hair combed into their faces; there was no telling if they were coming or going. "We aren't used to a top as a skirt," Klavers says. Indeed we are not. These pieces are more subtle than they may sound, which makes them all the more unnerving. Klavers always begins with an ordinary pattern, and there is nothing unusual about the fabrics and colors he chooses, which range from the banal to the classic. "In a pink color, the skirt is like a toy," Klavers says of his armed and shouldered mutation. "In camel, it's a decent skirt." Relatively speaking. In Klavers's hands, the familiar still has the power to shock, or at the very least to make us do a double-take. "On the one hand the pieces are very normal," he admits. "But there is also something very wrong." —AB

OLIVIER THEYSKE

Belgian designer Olivier Theyskens is an art-school drop-out. While a student at La Cambre in Brussels, Theyskens reasoned that the creative laissez-faire attitude could not prepare him for the realities of the fashion world, where a collection needed to be created every six months whether the spirit moved you or not (sound logic for someone only twenty-two years old). He took the collection that would have served as his senior thesis and presented it on the runway in Germany. Shortly thereafter, he was catapulted, sort of, to fame, when Madonna appeared in one of Theyskens's dramatic black satin coats at the Academy Awards. Sort of, because none of the 87 million viewers at home had any idea who Theyskens was and because the coat Madonna was wearing was alternatively misattributed to both Gaultier and Versace. Even as the rest of the world struggles with the pronunciation of his name, Theyskens has attracted the likes of goth rocker Marilyn Manson and Hole's Melissa Auf der Maur with his gothic ball gowns (now his trademark), split at the seams and refastened with industrial-looking hooks-and-eyes salvaged from his grandmother's attic, as well as his black leather corsets and bizarre

Photography Les Cyclopes *Styling Laetitia Cranay and Olivier Theyskens Makeup Max Delorme Hair Stéphane Lancien Photo assistance Alek Location Studio Zero*

jumpsuits. If there is humor in Theyskens's collections, it's of the dark variety. His choice of venue is a vacant parking garage with glaring neon lights flickering madly overhead. He has created a Hitchcockian dress that is a frenzy of attacking birds, and another smothered in funereal black flowers. He has made jackets with strands of real hair streaming down the back; ball gowns made from cheerful gingham or chintzy toile de jouy, the top and bottom halves slashed apart and reconnected by a disturbing cage-like contraption; and a catsuit made of fur Theyskens stitched together with blood-red thread. Couture, the young designer concedes, can be too serious—too, well, couture. He prefers to take this idea of what is chic and trash it up. Plastic and fur? Why not? All of his medieval antics aside, however, Theyskens turns serious when it comes to the way things are made, turning out extremely technical, impeccably crafted pieces on his own Singer sewing machine at home in Brussels. A little Christian Dior, a little Dr. Frankenstein, Theyskens has created an elegantly raw brand of couture, breaking apart the old rules of etiquette and putting them back together again in his own image. —AB

OLIVIER THEYSKENS

> **Photography Les Cyclopes** Styling Laetitia Crahay and Olivier Theyskens Makeup Max Delorme Hair Stéphane Lancien Photo assistance Alek

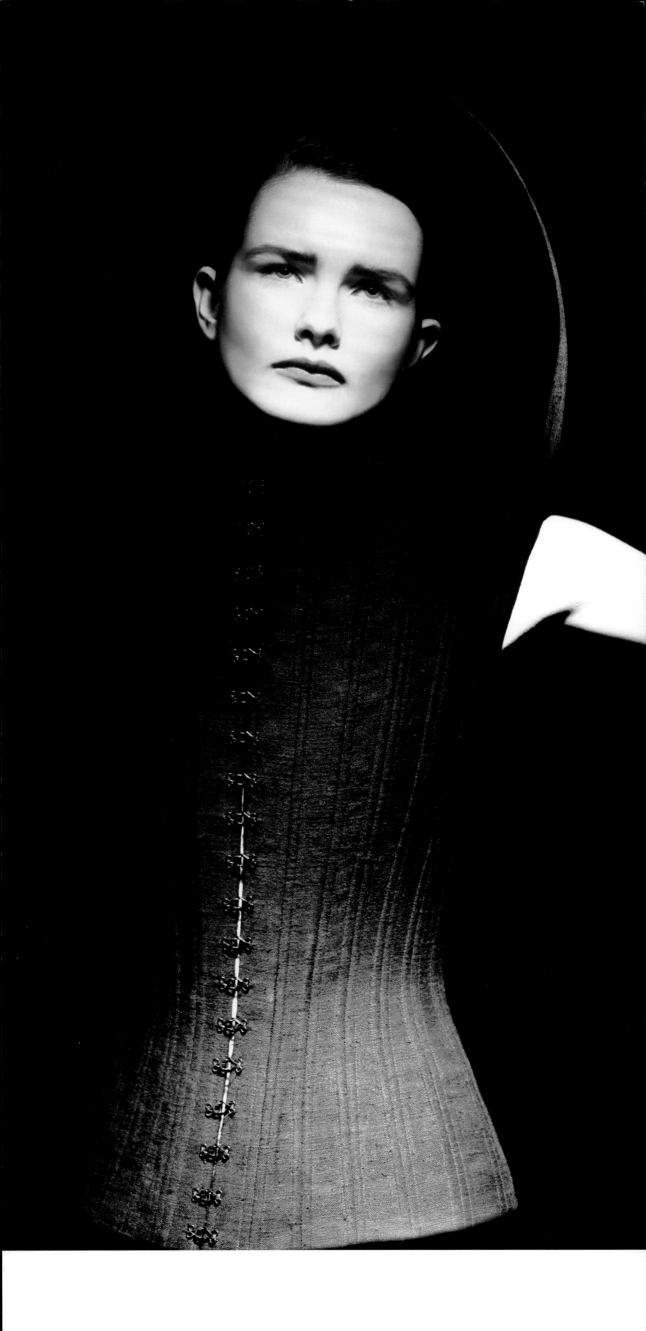

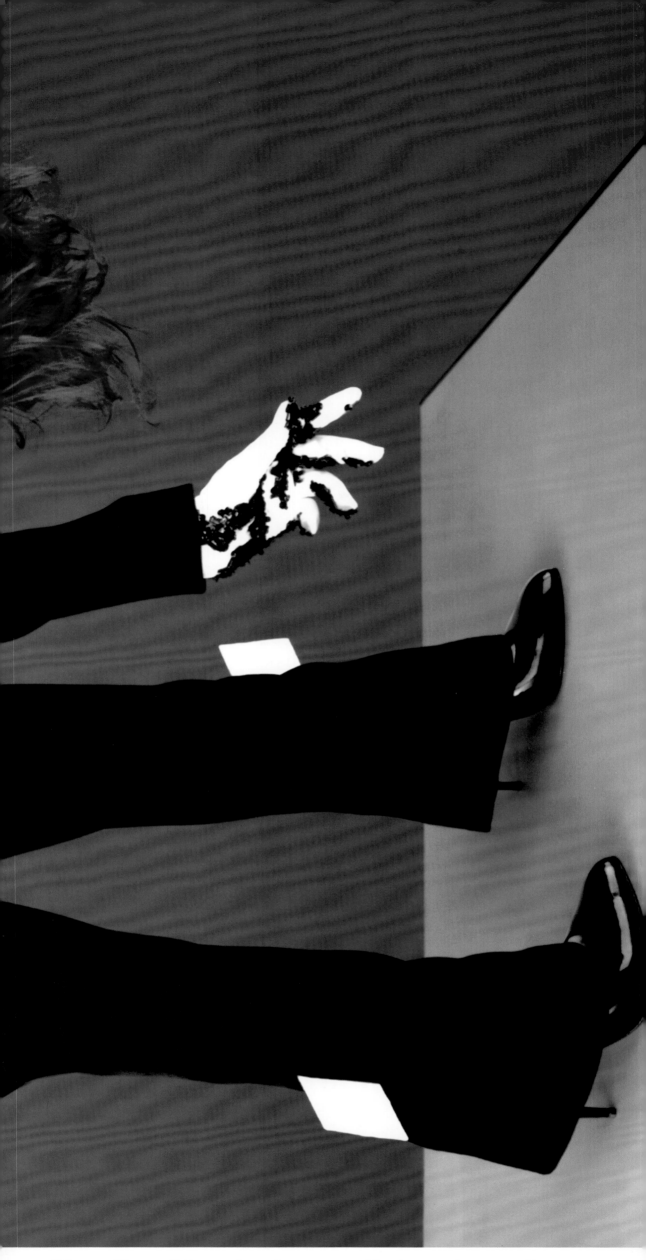

OSCAR SULEYM

Oscar Raaijmakers and Süleyman Demir, the design team behind Oscar Suleyman, stitch their hearts prominently on their sleeves. Both are graduates from the Arnhem Institute for the Arts and the newly established Fashion Institute Arnhem. Raaijmakers, who is from Arnhem, has worked for Veronique Leroy. Demir, who is originally from Turkey and came to Holland at the age of fifteen, has worked with Dice Kayak and Vivienne Westwood. After mixing their respective graduation projects and restyling them as a single collection, the two joined their names—and their creative forces—officially in 1996. In the tradition of increasingly well-known Dutch design duo Viktor & Rolf, the work of Oscar Suleyman is both highly conceptual and highly personal. One of their earliest efforts, "L'Adolescence d'Oscar Suleyman," was an intimate metaphor for their experience as young designers wanting to participate in the real fashion world but not quite feeling ready. A pre-invitation they sent out shows a picture of a little girl playing with a hula hoop. On the invitation that followed, the girl appears as a grown woman. Her hula hoop is a pair of hoop earrings. Staged on a very chic playground, the collection featured satin dresses tied

Photography Maurice Scheltens *Makeup and Hair Fedde/House of Orange* Model Maaike/Bookers

up in ruffles and ribbon like big ball gowns altered to fit a small body; a sweet lopsided blouse in white eyelet (one sleeve pouffed up, the other deflated) covered in a splattering of black paillettes, as if the girl who had been wearing it had muddied her Sunday best. "We are constantly questioning the definitions of beauty and aesthetics," Oscar Suleyman say ambitiously. "Each collection is an attempt to redefine these clichés. We try to push back the boundaries between superabundance and simplicity, perfection and imperfection, and the so-called good and bad tastes." But when they presented their third collection in the spring of 1999, Oscar Suleyman was still not quite ready to put away childish things. Titled "Paper Cut-Out Dolls/The Oscar Suleyman Series," it consisted of flat-tened pieces in leather, fur, and black satin outfitted with paper-doll tabs; arms came fixed into a jaunty on-the-hip pose or thrust overhead in a permanent state of surrender. The clothes were clever and cute, simultaneously dressing their wearers up and stripping them of their defenses. It will be interesting to see what becomes of this promising duo when they turn their gaze outward and take the big bad fashion world head on. —AB

For PASCAL HUMBERT, form follows form. And the form in which he is most interested is the human one. Humbert, who works purely on a made-to-measure basis, cuts anatomy into a garment. Often it is the anatomy of the specific woman for whom the garment is intended; sometimes it is the anatomy of his imagination. Humbert was born in Alsace and studied painting and fine arts at Mulhouse in eastern France. In the early 1980s he opened a boutique in Paris, Plus Que Jamais, for which he and his two sisters made a line of clothes. From there, Humbert moved to London, where he worked in theater costume design. Then, after dressing the windows at Barbara Bui's Paris store, Humbert became her assistant. Since he went out on his own, he has presented only one collection a year. His shows often allude to his background in the theater, inviting the collaboration of artists, filmmakers, and people in the music industry. His 1995 "Chrysalis into Butterflies," was essentially a performance, as were his 1997 super-eight film, *Straight Jacket*, and the 1998, "20 costumes pour 20 personalités," which consisted of twenty individual looks made for and shown on twenty different people. "20 for 20" was a sort of tribute

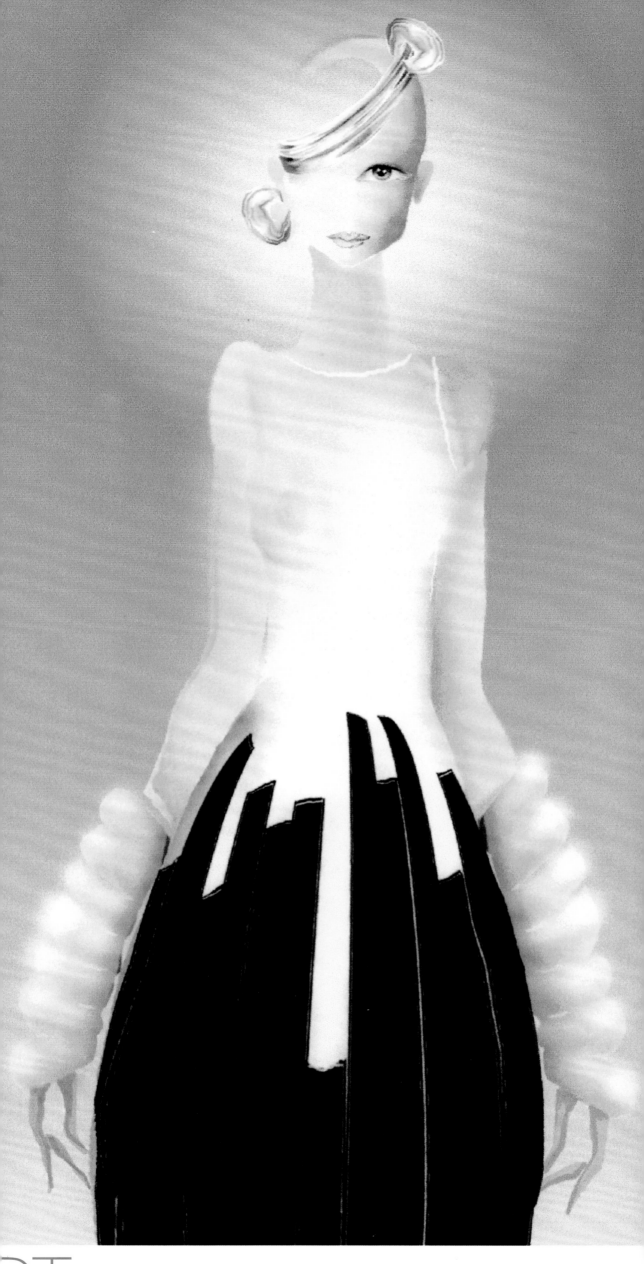

to *le smoking*, the iconic pantsuit of the 1970s, re-cut with an inventive architecture Yves Saint Laurent could not have foreseen. The suits were not tailored to fit the body, but rather to expose and accentuate certain parts of it. A cut-away jacket was thrust open by a "pigeon-throat" blouse. Scalelike pleating down the back of another suit drew attention to the spinal column; still another was slit open down the back to reveal a dorsal fin. On others the arms were slit open or cut off altogether. Humbert's idea of fit is inspired: in "Couture sur mesure," oversized white shirts spilled into dresses, as if a young girl were wearing the clothes of her mother; tiny, glovelike jackets gripped the torso as if the girl's mother had tried to squeeze into her daughter's clothes. Still, Humbert is careful not to refer to what he does as couture, using instead the more humble term made-to-measure. He does not, he points out, have an atelier full of craftspeople (his clothes don't rely on embellishment to achieve the desired effect anyway); he merely thrives on the rigors and the intimacy of custom work: the human contact between designer and client, and the process of making perfect clothes by hand. —AB

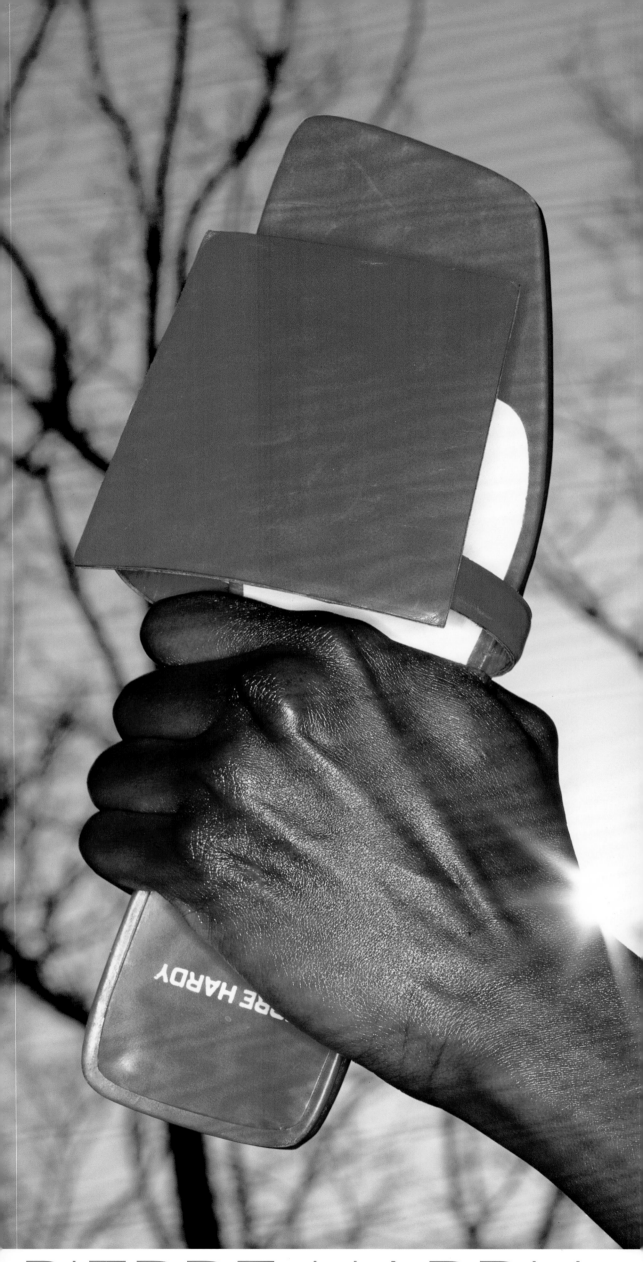

PIERRE HARDY

For some time, Pierre Hardy drew shoes for himself for fun. In school, he studied art, architecture, and painting, and while he seemed to have a natural proclivity for fashion, he "was not aware that it was an option," he says. Hardy procured a job as an illustrator for a fashion consulting office and spent his days drawing other people's designs. Soon he found himself at Christian Dior under Gianfranco Ferré, designing shoes not just for fun but for real. Steeped in the tradition of legendary shoe man Roger Vivier, Dior's approach to footwear was very feminine and often exceedingly decorative. The interest lay primarily on the surface, in how much lace or beadwork you could apply. From Dior, Hardy was courted to develop a shoe line for Hermès. "They had a heritage too," Hardy says, "but not in fashion." Working within the sole parameter of luxe luxe luxe, Hardy gave form to the Hermès foot with shoes ranging from a flat "H" sandal to a handmade leather sneaker. Still, somewhere in the back of his mind, Hardy continued to design shoes for himself, for fun, and after nine years of working for others, executing ideas that didn't always quite fit his vision, in 1998 Hardy launched his own line. He began by

Photography Greg Broom *Styling* Anna Levak

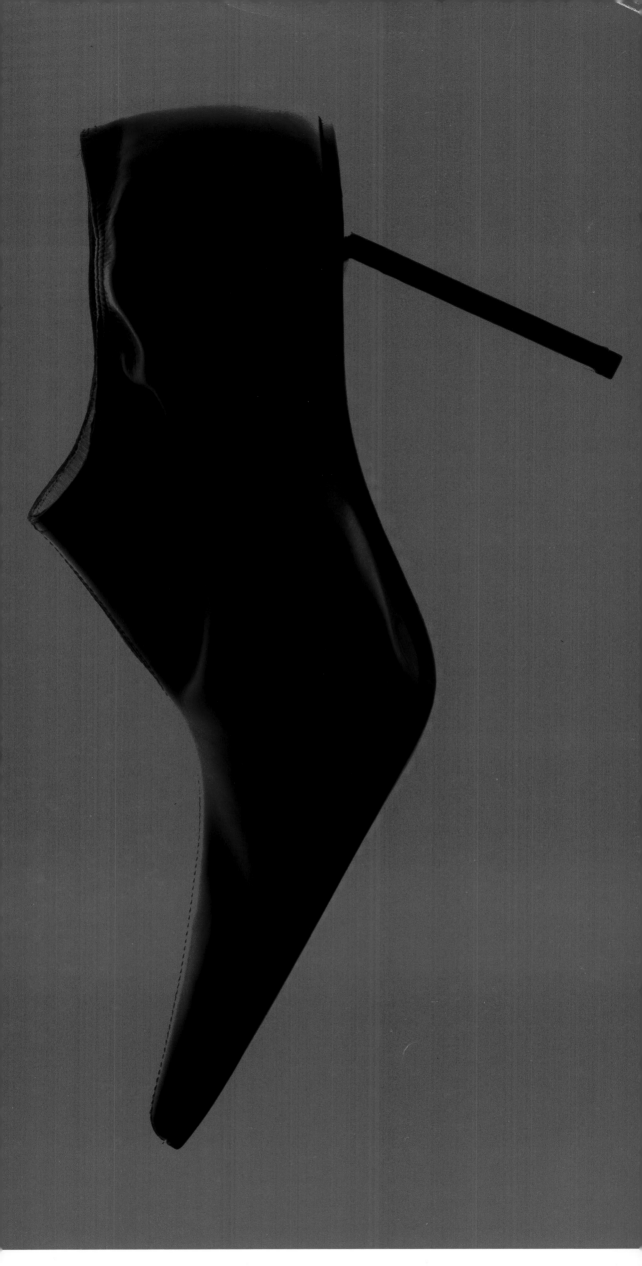

rethinking the fundamental shape of a shoe, from the ground up. "I wanted to do sophisticated shoes in a modern way," Hardy says. "Everything around me was narrative, nostalgic." Unlike the shoes he made for Dior, his first collection of starkly architectural shoes lack any surface detail whatsoever. And unlike the shoes he designed for Hermès, they exude a hard-edged sexuality. A shoe with a fiercely pointy toe he set upon a bladelike heel, impossibly pin-thin from the side, as if it were resting on nothing. It's feminine but very aggressive, a stiletto minus the curves. "I tried to simplify the design to an essence," he says. "A shoe can be about emptiness." A shoe, apparently, can also have a sense of humor. His second collection included ballet flats with the same sliver of heel screwed into them. Boots with bulbous toe boxes relied on strips of elastic to give them a quirky, puckered shape. He designed a wedge so that you can't tell where the shoe or, for that matter, the foot ends and the heel begins. To this day, Hardy still does not know how to actually make a shoe, and he has no desire to learn. "It's better not to know how," he concedes. "It's a form of self-censure. It stops you before you even start." —AB

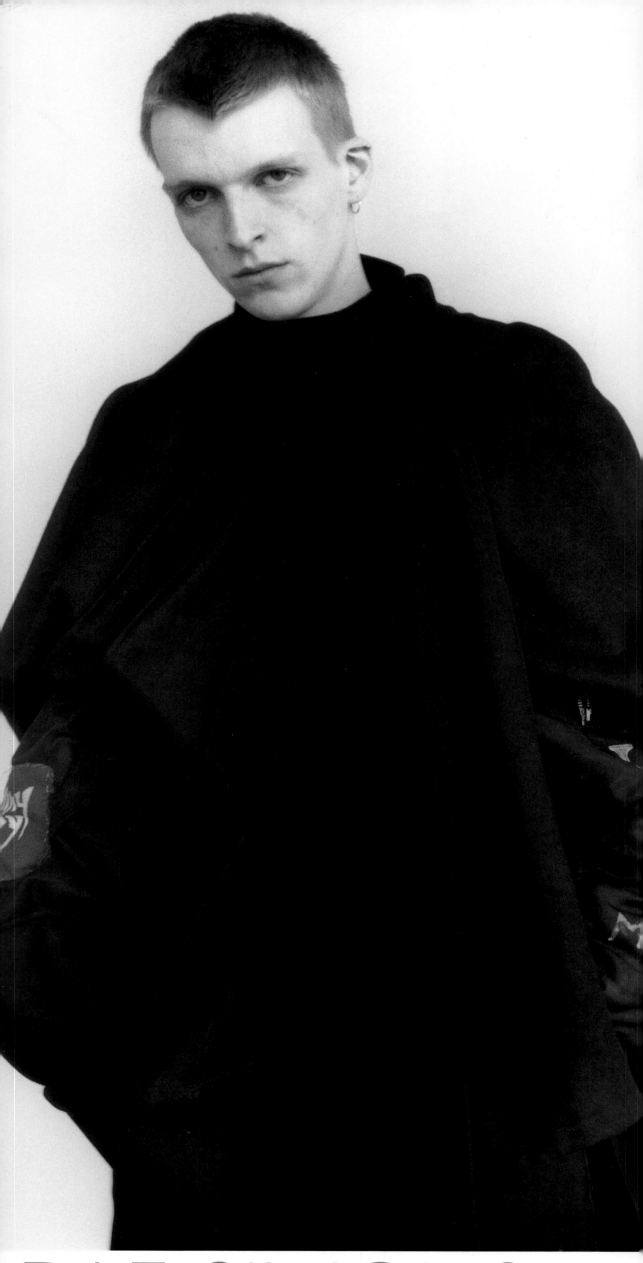

RAF SIMONS

With the same measured concentration he applies to everything he has done over the past five years, extremely shy and extremely exacting Belgian designer Raf Simons has built a reputation and a company by making impeccably crafted, classically inspired clothes for a young generation that is not inherently attracted to fashion. Simons's sleeveless jackets, drag-on-the-ground trousers in traditional menswear fabrics, collegiate duffel coats, leather blousons, and narrow coats with his now signature zip-lapels are the precise incarnation of his belief that the extreme is in very small things and that fashion is found not in clothes, but in the attitude of the person wearing them. The direct references to schoolboy uniforms, and to punk and new wave, point to the simultaneous yearnings to fit in and to stand against. The social aspect of his work is very important, says Simons, drawing on his own adolescence. "I saw things but couldn't really reach them. I always had a feeling of not being at home." Simons grew up outside of Antwerp in Neerpelt, close to the borders of Holland and Germany. He studied industrial design in school but followed fashion from afar; when it came time for him to apply for an

Photography Willy Vanderperre Styling Olivier Rizzo Makeup Peter Philips Model Robbie

internship he sent a letter to designer Walter Van Beirendonck. Working in Paris with Van Beirendonck, Simons was exposed to the work of Martin Margiela and Jean-Paul Gaultier. Something clicked. But it was several years before he would act on it. He saved to move to Antwerp, where he met Linda Loppa, the head of the fashion department at the Royal Academy of Art. "Raf was already so determined," Loppa says. "I was afraid after four years here we would destroy his identity." She introduced Simons to her father, a prominent Belgian tailor, and Simons locked himself in his house; several months later he emerged with his first collection. His intricately chore-ographed shows play out the ongoing themes of belonging and not belonging, order and disorder. In "Kinetic Youth," an army of rail-thin boys, all cast from the street and, notably, in Simons's own likeness, descended with mathematical precision from an elevated catwalk in a parade of white turtlenecks, checkerboard sneakers, and primary-colored trousers. A Rubik's cube. "On the one side I think the individual is the priority, but I'm obsessed with repetition," he says. "Visually, that is the most beautiful thing there is. Individuality is in your mind." —AB

RAF SIMONS

> **Photography Willy Vanderperre** Styling Olivier Rizzo Makeup Peter Philips Model Robbie

RICHARD JAME

It's best to cast aside stereotypical notions of the Savile Row tailor when you're confronted with the work of Richard James. His shop—salon is too effete a description, atelier too precious—is adjacent to Anderson & Shepard (Alexander McQueen learned to wield a pair of scissors here, leaving his mark by scrawling obscenities in tailor's chalk onto suit linings) and sits directly opposite Hardy Amies, the last arbiter of aristocratic England's dress codes. James's shop is in sharp contrast to the other tailors that line the street. Their window displays feature bolts of cloth that, it's safe to assume, aren't style statements of Zen-like simplicity. James, on the other hand, might showcase an immaculately tailored suit cut from indigo denim, or one suitable for an urban guerrilla, the jacket and trousers swirled with a camouflage print. The visual shocks don't stop there. Enter his shop and you're confronted with a display of color verging on the psychedelic: rows and rows of shirts (a James trademark) in magenta, orange, and turquoise; silk ties lined up in a riot of yellow, scarlet, and emerald green. "I'm based in the most classical street of classical tailors in the world," says James, "but I try to distance myself from that. We're not

Concept/Direction Chris Stevenson and Murray Partridge

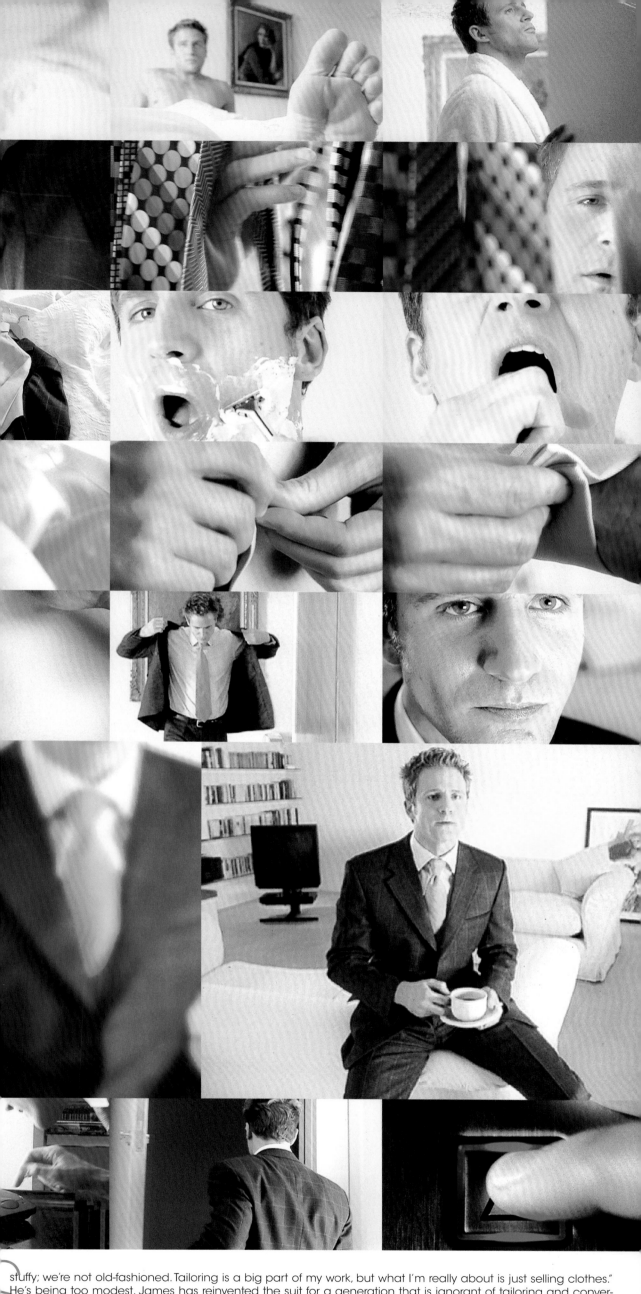

stuffy; we're not old-fashioned. Tailoring is a big part of my work, but what I'm really about is just selling clothes." He's being too modest. James has reinvented the suit for a generation that is ignorant of tailoring and conversant only with fashion's language of labels and logos. Furthermore, he understood a curious contradiction: as menswear designers strived for a global presence, working with a classic three-button suit as a mainstay was probably the most radical thing they could do. "My tailoring has all the elements of a beautiful English suit," he says, "but I try to make it modern, to make it accessible to a wider range of people. It goes in and out of fashion, but I think a suit is still the most flattering thing you can wear." James established his operation just over seven years ago, after a stint as a menswear buyer for the London boutique Browns. "I traveled the world looking for clothes," he says, "and it got to the point where there was nowhere else to look. Also, it was the '80s. You'd want a simple cashmere blazer, and all you could find was a designer version. It was so much about, 'You're wearing Gaultier—you look fantastic.' It's better now. People just say, 'That's a great suit—who is it by?'" —MM

RICK OWENS

It is entirely possible to count the fashion designers Los Angeles has produced over the years on one hand, and most of the fingers will be allocated to designers who specialize in the glitzy stuff. Accordingly, the odds of finding a designer like Rick Owens in Los Angeles should be approximately zero. And the odds of Rick Owens actually thriving there? Worse still. "People will ask me who am I dressing for the Oscars," Owens says. "Who the fuck would want to wear my clothes to the Oscars? My stuff is not about status. It's all grayish-beige and beigish gray." And yet, oddly enough, after nearly ten years in business, Rick Owens likes it there. Owens grew up in northern California and moved south to study painting at Otis Parsons. He learned how to cut patterns at a local technical school and procured a job in the L.A. garment district with a company that made designer knock-offs. "They would only let you look at the Versace jacket for half an hour before they returned it to the store," Owens recalls. "It was the most amazing training, though. It made you really accurate and really fast." Before long he was making his own designer originals. Points of inspiration run the gamut from monsters to mummies to Tristan and

Isolde to the work of Francis Bacon. "He was more tortured than Picasso," Owens says of the artist. "His paintings distorted people but you could still see a figure you recognized. It's not playful; it's gloomy." If there is a glimmer of Hollywood screen glamour in Owens's fur jackets and bias-cut dresses, it is of the faded variety. His is an aesthetic patched together from washed-out and second-hand materials, combining intricate cutting techniques of the '30s and '40s with the nomadic and world-weary outlook of the young punks who hang around his neighborhood. ("My stuff looks kind of vintage," Owens says, "but from what planet?") And while finding people skilled enough to do his production work is often a problem, it only makes him work around it and Scotch-tape something else together. Owens, for example, has circumnavigated the need for clumsy zippers by attaching knit pieces to bias pieces to create an evening gown that skims the body unencumbered by closures. "There are people on Hollywood Boulevard who devote their lives to shining the stars on the walk of fame and think they have an elevated purpose," Owens says. "My elevated purpose is making gowns." —AB

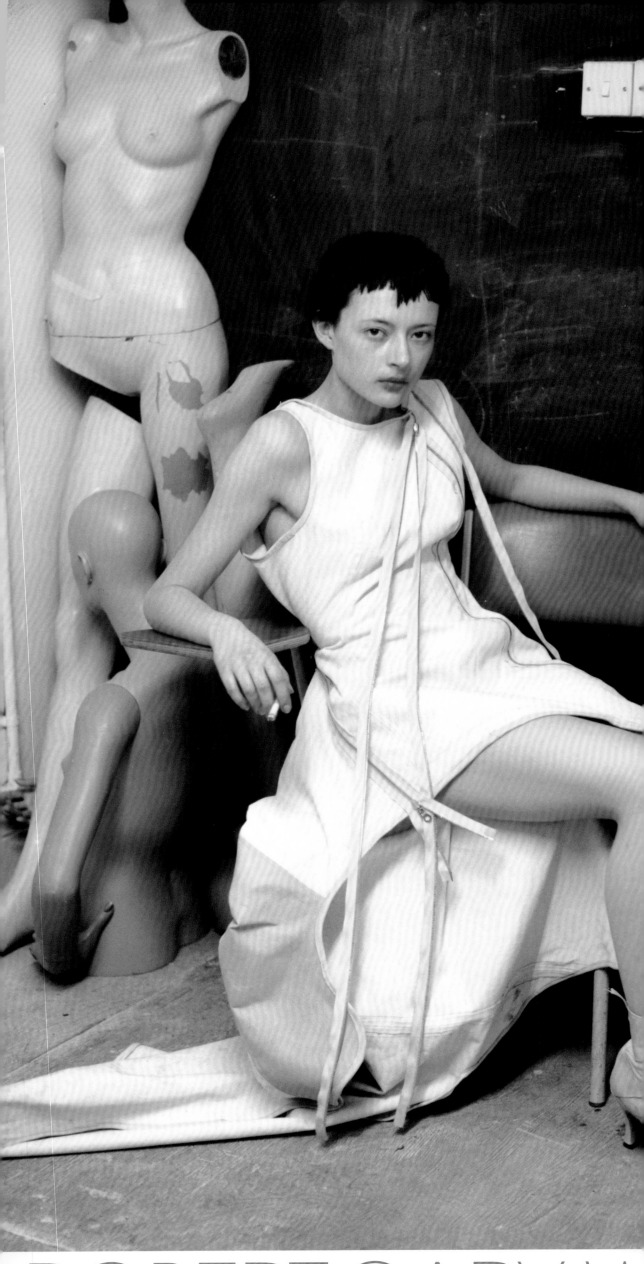

ROBERT CARY-W

Robert Cary-Williams makes no compromises. His fall '99 show—titled "Victorian Carcrash"—offered up not only a disturbing subtext to his designs, but a thick, chalky atmosphere that had his audience rushing from the venue choking and gasping for air. In person, however, Cary-Williams is mild-mannered and unassuming, discussing his work in quiet, measured tones. "The inspiration for this collection was a woman from the Victorian era who somehow ends up in the present day," he explains. "She's run over by a car. She survives, but the clothes get damaged." All of this resulted in a show of arresting, even macabre, images: latex or leather jackets, dresses, and full skirts cut to fall off the body; zips that trailed the floor; and shoes that looked like they were in the process of morphing into hooves. In many ways, the designer is still trying to make sense of it himself. "I was speaking to a friend of mine today—she's in her mid-fifties—and she felt that the clothes were incredibly sexual," he says. "I hadn't thought of them in that way. To me, they had a feeling of freshness about them. I wanted people to look at them and feel that they were seeing something they hadn't seen before." It seems that Cary-Williams is just coming to

grips with the need to flex his design muscles and test his limits. Certainly, he's self-reflective enough to know when something has—or hasn't—worked. "I'm constantly learning," he says. "Ideas are always springing up, and I tend to go with them. I think that I'll probably look back to this time and think, 'That's why I did that.' It's like therapy, really." Cary-Williams—who graduated from Saint Martins in 1998—has had an unconventional career path (he left school to join the army). While he is uncomfortable—or perhaps just bored of—talking about it, he acknowledges that the three years he spent in the military gave him a chance to travel. (He represented his regiment at Nordic skiing, visiting St. Moritz, Austria, and Germany.) Having nursed an ambition to attend art school, he ended up studying fashion. He did both his degree and postgraduate degree at Saint Martins, spending a couple of intervening years in Paris, "soaking up the atmosphere." He returns to the subject of the feelings his clothes can induce. "I think," he says finally, "that I'd like a woman to feel that they are taking her somewhere different, that she has to dare herself to wear them." —MH

RODOLPHE ME

Rodolphe Menudier has his head far up in the clouds and his feet firmly planted on the ground—which, for a shoe designer is an ideal situation. "If I remember well, the first shoes I designed were without a heel and looked like a shell," says the designer, who leaves no stone, no star, no shell unturned in the quest for creative stimulation. "Every new shoe is a challenge that encourages me to find inspiration among all that I see, from planets to the smallest particle on the earth." Menudier was born in St. Emilion and lived in Bordeaux in the southwest of France until the age of twenty-four. He studied mathematics and electronics in school and eventually took his first steps toward the shoe world in 1986, making his way to Paris's prestigious AFPIC shoe academy and then working under designer Michel Perry. Some five years later, Karl Lagerfeld, a divining rod for young talent, commissioned Menudier to create shoes for his Chloé collection. Menudier started to design under his own name two years later. "It was the height of grunge fashion," he says of the time. "At this moment, I brought some new shoes, very sexy, very bitchy, and kitschy, and it was exactly what the girls were waiting for." If there were ever

shoes designed to make the young girls give up their pole-climbing boots, they were Menudier's high-heeled mary-janes in flaming orange or mesmerizing psychedelic hologram plastic. "Designing shoes requires a lot of precision, but at the same time it is very important to express the spirit, to join the useful and the utile," says Menudier who is technically obsessed, paying keen attention to the comfort of his highest shoes and working with a chiropodist to study the physiognomy of the feet. "If I design shoes, this is not to see them in magazines, but to see them on." The useful and the utile play off one another in archly feminine pale mink lucite wedges that seem to balance on nothing, or in Menudier's wildly futuristic but ultimately practical duo-heeled millennial shoe. "These shoes come from a will to create a new way of life, to be applied to the future generation. I look optimistically at all the perspectives of the future, respecting at the same time all qualities of the past," explains the designer. He seems entirely content to teeter on the brink between fantasy and function. "For me it's not a balance," he says. "It's a thread in front of me on which I have to walk every day." —AB

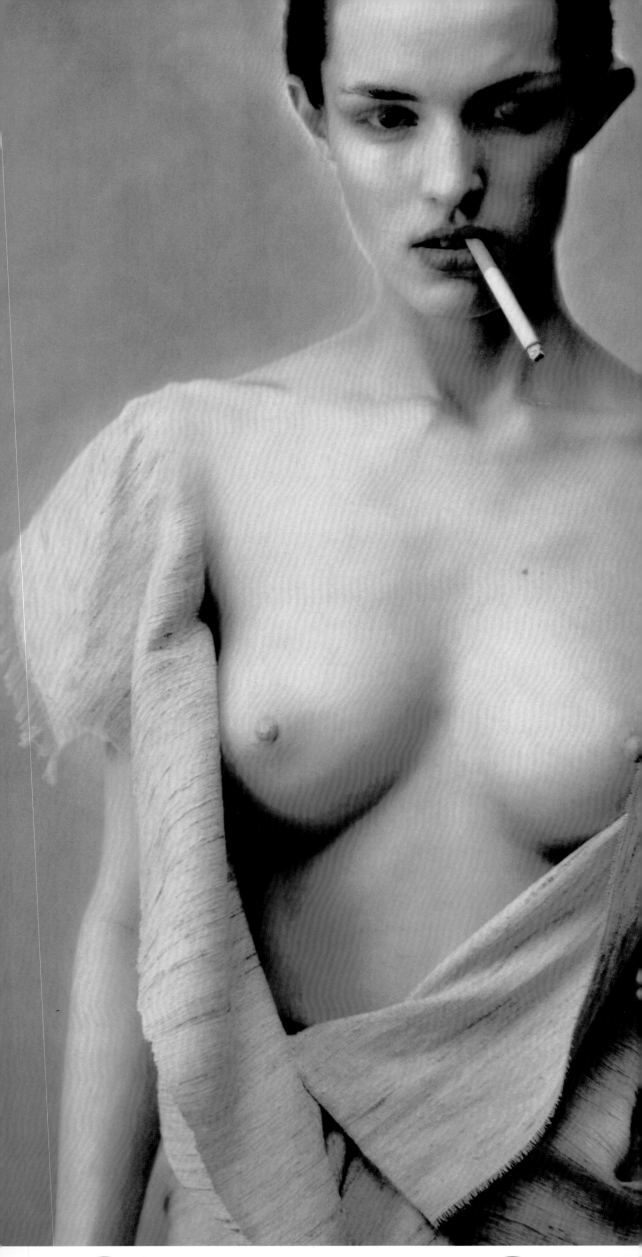

ROLAND MOURE

What does it take to make a memorable show? In the case of Roland Mouret, a mere thirteen dresses. Mouret—French-born, London-based—showed his small but perfectly formed collection to a select audience (read that as a number in the low double digits) that broke away from the loop of London's Fashion Week schedule to marvel at Mouret's way with fabric-cutting. To a solo violin accompaniment, the models meandered out while toying with a polished apple or a tumbledown chair, dressed in Mouret's dresses that twisted, tied, and tucked around the body, each one exuding the elegance of an Irving Penn image: a single kimono sleeve falling from a dress cut from rough beige hopsack, another in gray wool with a neckline that spins around the shoulders. That was late September 1998. Mouret didn't show the following season: his work doesn't follow that biannual rhythm. What interests him is creating something that has a sense of longevity. "Showing those clothes was about making a moment," says Mouret. "It was an attempt to put a little reality into fashion. I think everyone's bored of movements, of trends, of simply selling a product . . . and it felt like I was working through a lot of my fears with

Photography Zanna Makeup Sharon Dowsett Hair Alain Pichon

this collection." Such as? "You're always judged by who you are and what you are," he elaborates. "Sometimes you just want to be yourself." Mouret's resume so far reads as follows: a spell as a model after being discovered by Jean-Paul Gaultier in the mid-80s; art director for Robert Clergerie; stylist for French *Glamour*; a move to London to set up the Freedom Cafe in the early '90s; and then founding People Corporation, a label that turned out the kind of hip, street-oriented clothes to wear to "Freedom." Now Mouret works from a room in his apartment that's dominated by a carved wooden angel rescued from a German church; he's designing to order for women like Katy England, Samantha Gainsbury (Alexander McQueen's show producer), and the photographer Zanna. His way of working is naked, direct, instinctive and occasionally poetic—taking fabric and cutting it on the body, watching how it drapes and falls. "I love the reaction of fabric with a woman's body and her skin," says Mouret. "When I talk to a client about a dress, I watch how she moves, I learn what she does and doesn't want to show. My clothes are a vision of women for women."

—MH

SARAH HARMA

I'm so sick of people using easy tags to describe what I do. All that people level at me is that I'm a bondage queen. I'm tired of people saying that my work is fetishistic, that it's aggressive." Sarah Harmarnee is on a roll— both verbally (a vocal delivery that is as feisty as her talent) and professionally (in addition to designing her own provocative line, she works with Alexander McQueen on his signature and Givenchy collections). Like many young, renegade designers working today, her work doesn't slot neatly into any traditional category. "Jewelry" doesn't begin to convey how radical and startling her work can be (take, for example, her bold, exquisite references to equestrian sports in the form of riding crops, saddle buckles, and stirrups). And "accessories," that vague catchall, doesn't convey the more precious elements of her designs (the amazing filigree corset she created for a Givenchy couture collection). But Harmarnee prefers that her work not be so easily categorized. "I think we're just not used to seeing the kinds of things I do," she says. "I studied sculpture, and there is a lot of that in my work. I love pure form, I love elegance, I love sweeping images. I like to challenge things on all sorts of levels.

Photography Donna Trope

RNEE

My work is about body adornment—but not in that sad, wearable-art sort of way." From a purely aesthetic perspective, Harmarnee's work is distinguished by the interface between the organic and the mechanic, the rigid and the fluid. It's an approach that also functions on a conceptual level. While she hates anything that smacks of a precious attitude to jewelry ("Who gives a fuck about a ring?" Harmarnee would like to know), she's keen that her work is seen as having longevity, that it doesn't follow the ebb and flow of fashion. "One of my favorite pieces is a buckled silver cuff I did years ago," she says. "I'm still doing it." Harmarnee came to her current metier via a sculpture course she took in Australia. She takes pains to point out, however, that she's not a native of the country of what she calls "bland mediocrity." She moved there from England as a child. "I was obsessed with fashion but wanted to use my sculpture in some way. I didn't really want to become a jeweler. I hated jewelry—in fact I still do—but it is an area that allowed me to use my training." Couture is another story entirely. "Everything in that world is perfection, the best it can be," she says. "I hate cheap more than anything else."　　　—MH

Saskia Van Drimmelen was born in Zwijndrecht in the Netherlands. She graduated from the Arnhem Academy in 1993 and presented her first collection in Paris in 1994 as part of Le Cri Néerlandais at the Institut Néerlandais. Quiet, concentrated, and intensely disciplined, Van Drimmelen is consumed by construction. In this way, she stands out from the new generation of Dutch designers, many of whom approach clothing as an exercise in conceptuality. Not that Van Drimmelen is lacking ideas. It is just that even while she often begins in the abstract, she always finds her way to the concrete. The pieces that make up Van Drimmelen's body of work are finely engineered; each contains its own internal logic. Their design merits stand on their own, not relying on a body to give them form. "They give wide berth to the individual," Van Drimmelen says, both figuratively and literally. Patterns are blueprints to be worked and reworked and, if necessary, reworked again. A single skirt may have been constructed from sixteen parts. Alternately, one pattern may eventually yield an entire collection. Names of collections are determined based on the design process, not some theme or far-flung source of inspiration. "Inner

Photography Jérôme Esch *Styling Elle Hagen Makeup Honda Remita Hair Taco/Ada Paris Model Kim Iglinsky/City Paris*

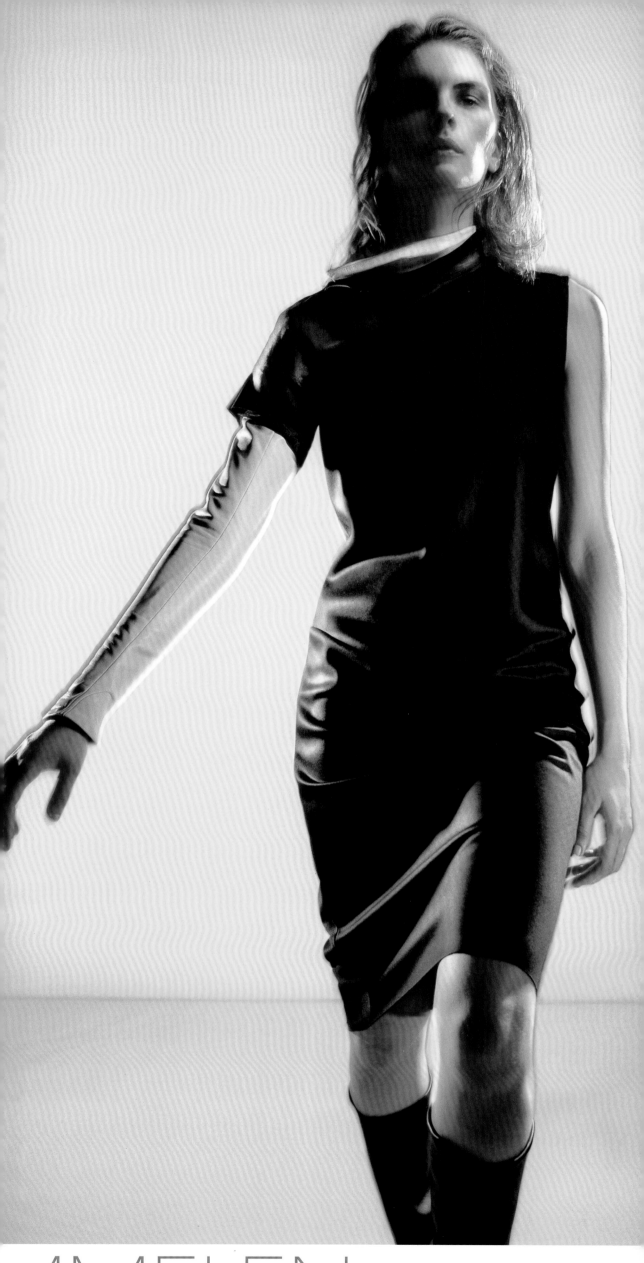

VMMELEN

Pieces' was a collection of reversible garments, each with a counterpart and a supplementary piece to fit into. "Inside/Outside" worked on the idea of double-sidedness using multiple layers and shadow pieces layered under white. "Paper Wrapper" included clean-cut dresses and tops closed by a single back-seam. "Tuning" explored the idea of wearable sculpture balanced on a single seam. "Doubles/Twins" was a study in duplication, addition, and mirroring. Van Drimmelen works with stiff fabrics in an uncompromising palette that only occasionally strays from gray, black, or white. It is impossible to imagine her using a print or, for that matter, a button or a zipper just to achieve a special effect. Van Drimmelen eschews the homemade, preferring things that can be made industri-ally. She'd rather glue a hem than sew it by hand. "I always want to know why a detail is there," says Van Drimmelen. "I don't agree that it should be there just because you like it." While many designers have dabbled in minimalism only to abandon it later for being too limiting, Van Drimmelen finds comfort in the restrictions she has set for her-self. "Sometimes I think I would like to make something really extravagant," she says. "But I just can't." —AB

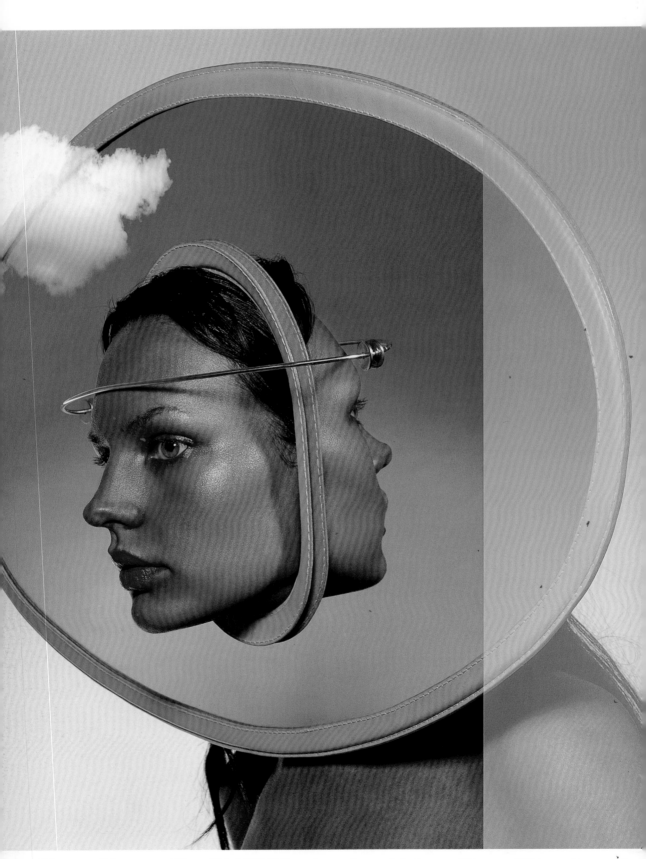

SCOTT WILSON

"Sometimes I wonder if my interest is in fashion or if it's in other things," says Scott Wilson. But anyone who has ever seen Wilson's discomfiting headpieces, or his bizarre Perspex eyepieces, or even his more commercially inspired plastic cuffs and mirrored chokers, would no doubt lean toward the latter. Initially Wilson was bent on a career in fashion, but he lacked a talent for drawing and ended up studying jewelry instead. "Everything I made was sculptural," Wilson says. "Like a meter-high body thing that was supposed to sit on the head. Visually it was quite amazing, but it couldn't be worn." Wilson, who is from the northeast of England, was completing his masters degree at London's Royal College of Art when talent scout Karl Lagerfeld commissioned him to create cyberistic body pieces in wire and metal mesh for his spring/summer 1996 signature collection. This was to be the first of a series of joint ventures in which Wilson's weirdly elegant accessories played a central role, elevating clothes to the level of, well, other things. The collaborative process has been a two-way street for Wilson, who is determined not to be a mere technician of other people's ideas and looks at the limelight with a certain amount

Photography Donna Trope Makeup Christopher Ardoff Model Natasha/IMG

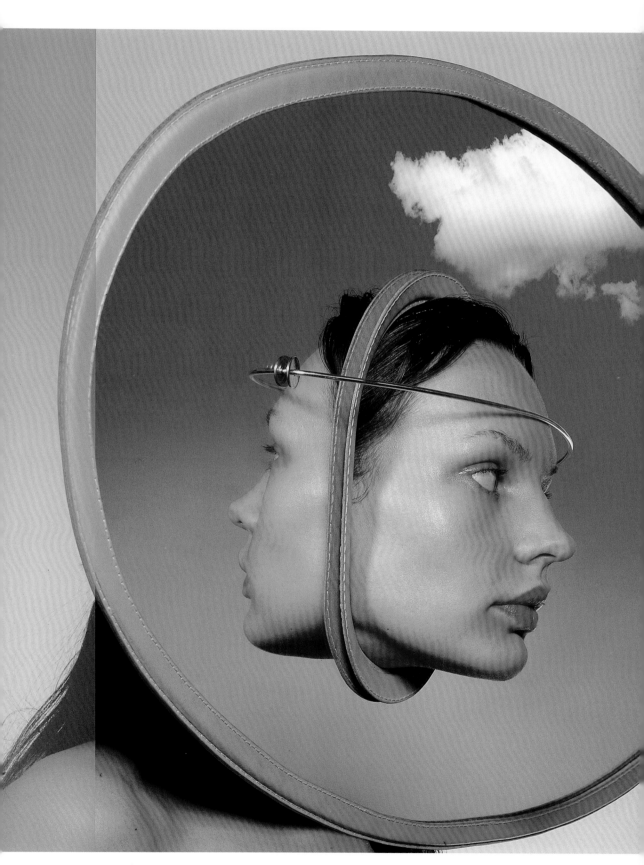

of ambivalence. Antonio Berardi, for whom Wilson has created surreal beaded eyepieces in flesh-colored Perspex (inspired by opera glasses), semi-mirrored breastplates, and huge glass rings, encouraged him to consider other materials and other parts of the body. "I always liked Perspex but never really used it," Wilson says of his now signature medium. Just out of college and working with limited space and resources, Wilson made the first Perspex pieces in his oven at home. His technique has become more sophisticated over time, and Wilson uses plastic the way other designers use metal, cutting, filing, polishing, and applying heat to mold it to the contours of his imagination. But even when he works in leather or stainless steel, the shapes set him apart—in particular, the pieces he has created for the cerebral Hussein Chalayan. "We talked about girls being faceless, about restriction," says Wilson, who took this to mean large Perspex headpieces designed to entrap the cranium and erase any semblance of individuality. The conical shape was spawned by the idea of slotting pieces into place. "The object is to give people something else, not always the most amazing thing, just not what they expect." —AB

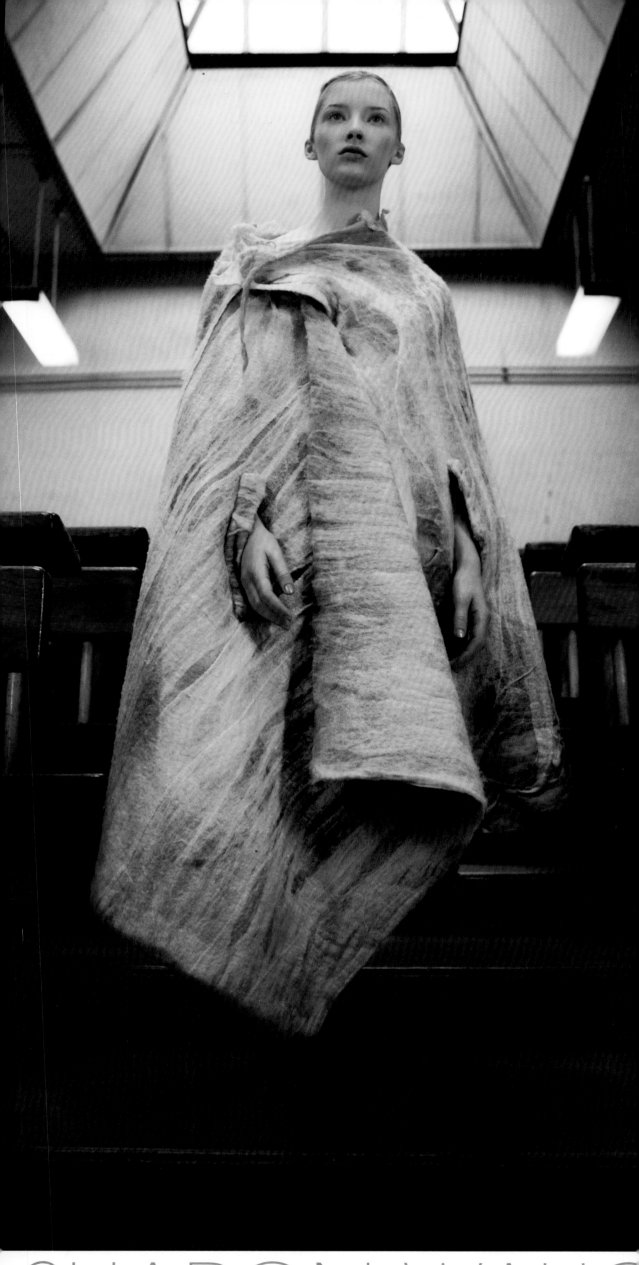

SHARON WAUC

While American in Paris Marc Jacobs basks in the limelight at the house of Louis Vuitton, another Vuitton employee has been working quietly in the shadows. In the spring of 1999, Irish-born, Saint Martins–educated Sharon Wauchob presented her own quiet, concept-driven collection directly after Jacobs's super-sleek runway show for the esteemed luxury goods conglomerate, and managed to attract a healthy percentage of the fashion world's heavy-hitters in her own right. Wauchob showed her third collection in the neo-classic splendor of one of the halls of the Bourse, the Parisian equivalent of Wall Street. The setting was a cool, circular room with a high domed ceiling that allowed the natural light to flood down the walls to the floor. The scene was stripped of artifice—no set dressing, no pyrotechnics (guests were invited to perch on plain plywood benches). What remained was the opportunity to concentrate on Wauchob's clothes in their own equally stripped-down, artifice-free state. Models appeared from a spiral staircase submerged in the floor, walking in rapid, tightly choreographed circular motions, and then quickly darted out of view. There was enough time—just—to attune your eye

Photography James White Styling Darryl Rodrigues Makeup Topolino Hair Laurent Philippon Special thanks Lionel Peralta

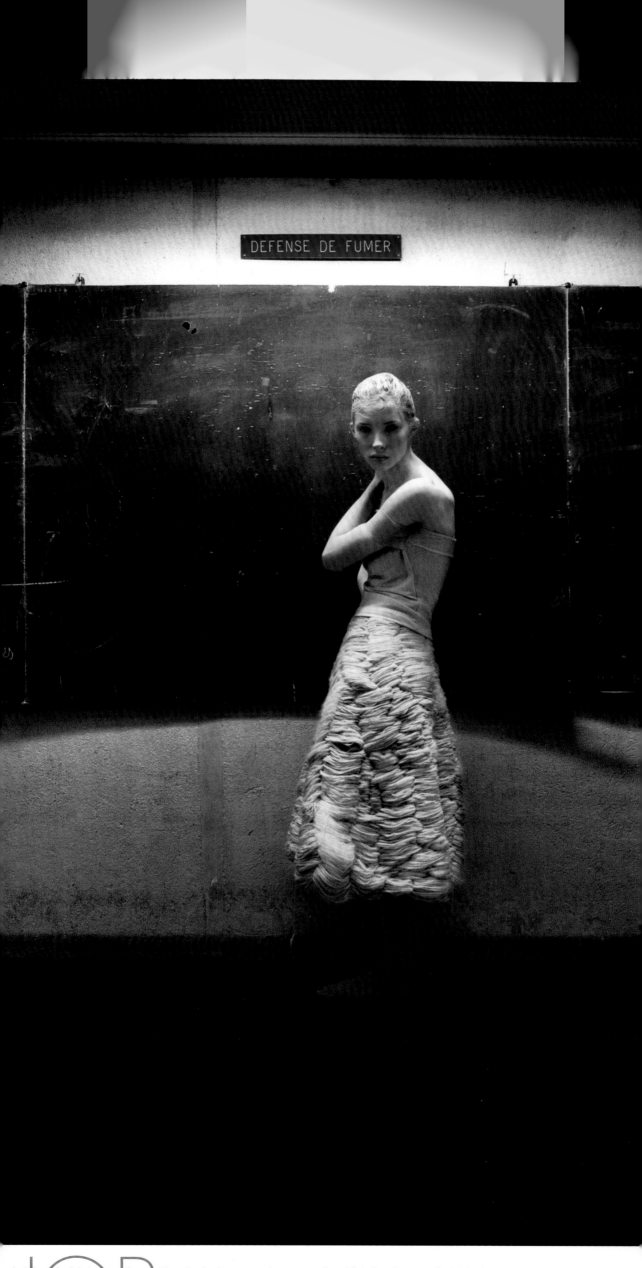

DEFENSE DE FUMER

to Wauchob's innovative cutting techniques and raw, unrefined fabrics (many of which she designs herself). Softly deconstructed dresses and skirts made from neutral-toned, felted blankets spiraled and wrapped around the body in odd harmony with their surroundings. There was an almost ethereal naiveté at work, a sense of innocence, and, refreshingly, an element of gentle romance. In fact, there is nothing arch or self-conscious about Wauchob's work; she is not a designer who strains for effect. "I like clothes to have a sense of ease," she says. It was Wauchob's second collection that got people's attention. Shown in a dusty, near-derelict, surprisingly light-flooded garage, the collection featured paneled suede skirts outfitted with paper-thin leather hip bags, khaki apron tops paired with salmon pink skirts, and cotton dresses that twisted and turned around the body with trains left trailing on the dirty ground. The designer herself is not easily unraveled, content to let her clothes do all of the talking for her. "I did the first collection because I had something to say," she says, "and the second because I still hadn't said it all." She could have said the same about the third—and whatever will come next. —MH

Shelley Fox has a way of making things work in her favor. While she was at Saint Martins, feverishly finishing her postgraduate degree collection in 1996, she scorched the yellow fabric she was working on. Rather than abandon it, Fox decided to go with it. "When something goes wrong, I tend to think that it has happened for a reason," says Fox. "The best ideas often come from mistakes. Anyway, that's what designing should be about—being open to going wherever it takes you." Since then, she has transformed surface texture, disturbing it with scarring, scorching, or—most recently—by adding Braille lettering. Yet it's easy to overstate the importance of mistakes to Fox's work. She is, after all, someone who rigorously researches in scientific libraries. (The idea for the Braille fabric came after a visit to the resource center of the pharmaceutical corporation Wellcome and a visit to an organization for the blind.) This spring, she used sound waves to scorch her clothes, though it's unlikely you'll find any of those pieces. "They were going to be horribly expensive to produce," she says. More successful were her twinsets—she attacked them with a blowtorch, adding singed and burnt lines. It's not just her approach to

Photography Jürgen Teller Styling Venetia Scott

fabrics that makes her work stand out. Her cutting is also inventive—in particular, her use of circular shapes, her desire to see what happens when they are placed on the body. It might sound gimmicky, but the results—an easy coat or a simple shift dress—are eminently wearable. Now Fox is gearing up for greater things. She won the Jerwood fashion prize, which gave her hard cash to build her business. Until then, Fox's experiences still sounded like the blueprint for most other aspiring British designers. "It's a huge financial relief to have won the prize," she says. "It means that I have the rent for my studio, that I can expand my orders without the fear of going bankrupt. Also, it gives me the luxury of having time to be creative." But time is something she may soon have less of than she thinks. Joseph Ettedgui—a retailer with a discerning eye—has asked Fox to design a range of clothes for his stores. He's not alone in his admiration. Alexander McQueen is a fan, as is Walter Van Beirendonck, who stocks Fox's collections at Walter, his Antwerp boutique. And Clarks—a stalwart of classic British shoes—have just asked her to work with them. "They want me to do all the stuff that I do," says Fox. "I think it's really exciting." —MH

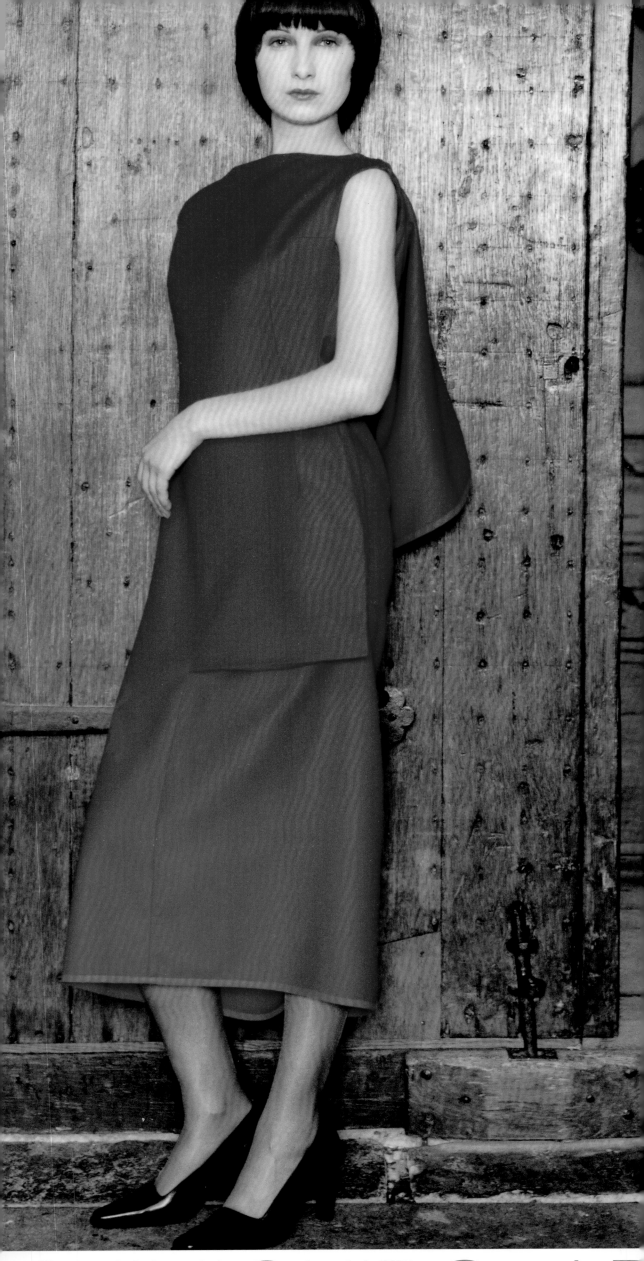

SHINICHIRO AR

Is fashion art? This is a question that is asked again and again at different times and in different contexts from both sides of the picture. Sometimes, to call fashion art is to pay it the highest compliment, to say that it has transcended its role as cut and sewn cloth that covers the body, that it affects us on an intellectual or emotional level. Other times the comparison comes across like a pretentious euphemism for over-the-top pieces that are both incomprehensible and completely unwearable. Japanese designer Shinichiro Arakawa has asked himself this question. And the answer is both yes and no. Arakawa is something of a self-starter. He attended art school in Tokyo and made the transition to fashion slowly over the years, never working in the ateliers of other designers. His father worked in a clothing factory, and when Arakawa was young, instead of going to the park with his friends he would often pass the time in the factory, playing alone among the bolts of fabric. The collection he presented in Paris in the spring of 1999 came with the following set of illustrated instructions: "Directions for wearing the clothing. The garment is encased in a frame like a painting. Pull the garment over your head and

Photography Elsbeth Struijk van Bergen Styling Wouter van der Tol Makeup and Hair Mylene Jansen/Angelique Hoorn Model Olga/Boekers

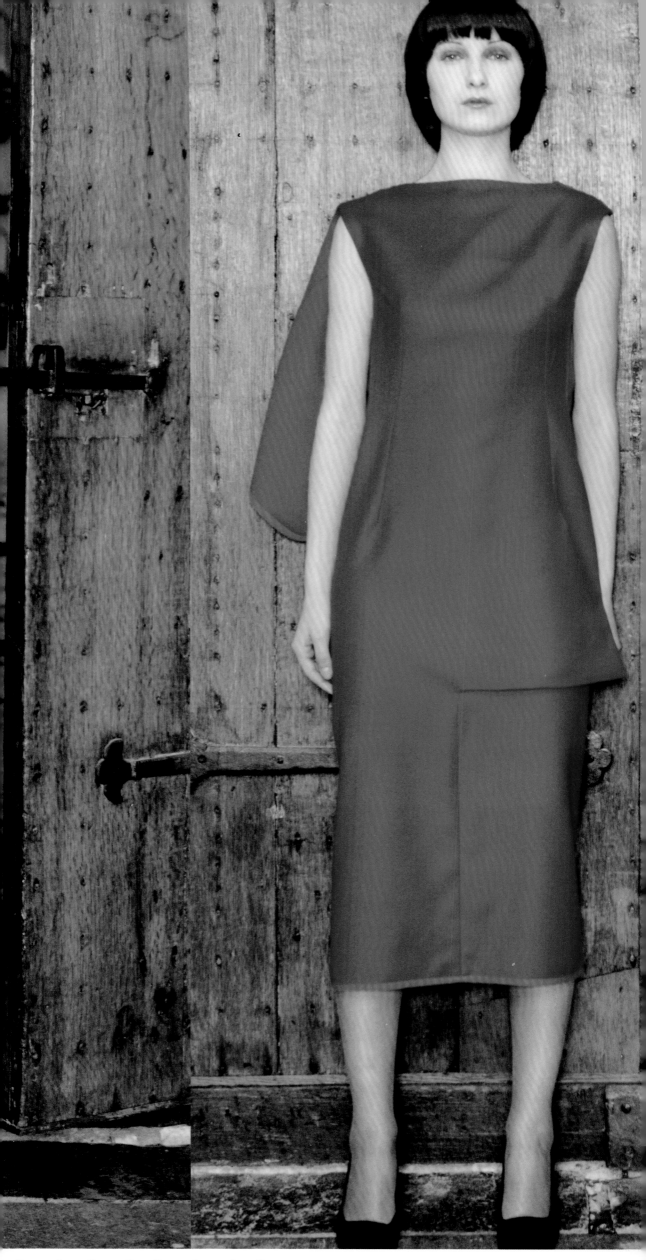

put your arms through the sleeves. Wrap the sides of the fabric behind you. You can then attach them together via zippers, buttons, or fabric ties. You have now completed the transformation. The framed garment is now ready to wear." "I decided to mix art and fashion," Arakawa says. "I wanted to pose the question." He presented this particular collection as the opening for an art exhibition, with the framed garments hung in singular tableaux throughout the stark gallery-like space. But here is the real irony: the clothes are, when it comes right down to it, more suited to hang on a live body than on a wall, so approachable—and, yes, wearable—are they in both shape and concept. A sweater, slit down the back and stretched out to fill the frame, looked as though it had been trapped in a spider's web. A black jacket appeared to have been steamrolled into a flat silhouette. A blouse was laid out like a bedsheet, its collar and sleeves trying to escape into their rightful three-dimensional shape. "I took the form of the clothes that exists already and broke it down," Arakawa explains. "Transformed them a little bit." Fashion, like art, is where you find it.

—AB

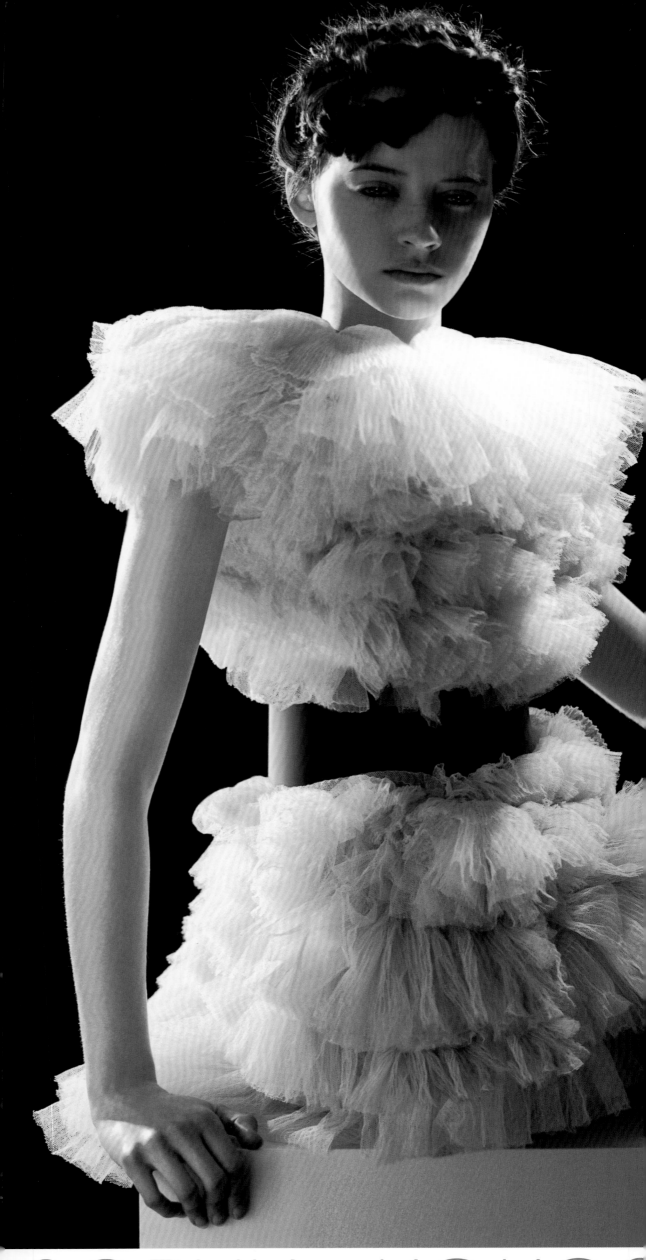

When Sophia Kokosalaki graduated from Saint Martins in London, the collection she presented for her thesis project was small, extremely focused, and made up of just a few pieces. One such piece, a jacket covered in miles of embroidered stream-of-consciousness text, took her six months to complete. Another, made from three meters of hand-smocked tulle, was finished in a relatively expeditious three months. If Kokosalaki learned anything at all in school, it may very well have been that she could not survive in the fashion world if she worked at an average rate of three garments a year, no matter how much she charged for them. But it is this interest in handwork and craftsmanship that continues to drive her work. Kokosalaki grew up in Athens. "I never thought that fashion would be a serious profession because that is the way it is in Greece. It is not something that is even taught in art school," explains the designer, who studied literature and received her primary fashion education through magazines. Artisanal crafts are another story altogether. By the age of six or seven, Kokosalaki had already learned to crochet and embroider from her grandmother. "It is something you do because you are

Photography Matt Alas & Marcus Piggott Hair Malcolm Edwards/Untitled Makeup Val Galard/Untitled Model Kiara/Select

ALAKI

bored," she says. Kokosalaki graduated from Saint Martins in 1998. After creating a small capsule collection "to keep herself busy," she presented her first runway show in February 1999. Described as a "retrospective look at the future," the collection included circular-cut skirts and Star Wars–style jumpsuits with excessive padding and lots of stitching, as well as leather riding trousers. Her full-blown labor-intensive arts-and-crafts projects dissolved into accents on a more manageable scale: touches of hand-embroidery, unfinished edges, ruffles, bits of cro-chet, and special notes to the wearer—hand-stitched verse legible only from the inside. "I cannot say what inspires me, because it's very abstract," Kokosalaki says. "One day I'll go for a walk and find an interesting fabric, another I'll open a book and see an interesting technique." But at the intersection of modernity and traditional craft techniques she has also found some sort of equilibrium; her clothes are memorable, but also wearable. "I try to keep things pure and refined," Kokosalaki says. Still, she willingly admits that her favorite pieces are always the ones that took the longest for her to make. "I love them especially," she says, "when they are done." —AB

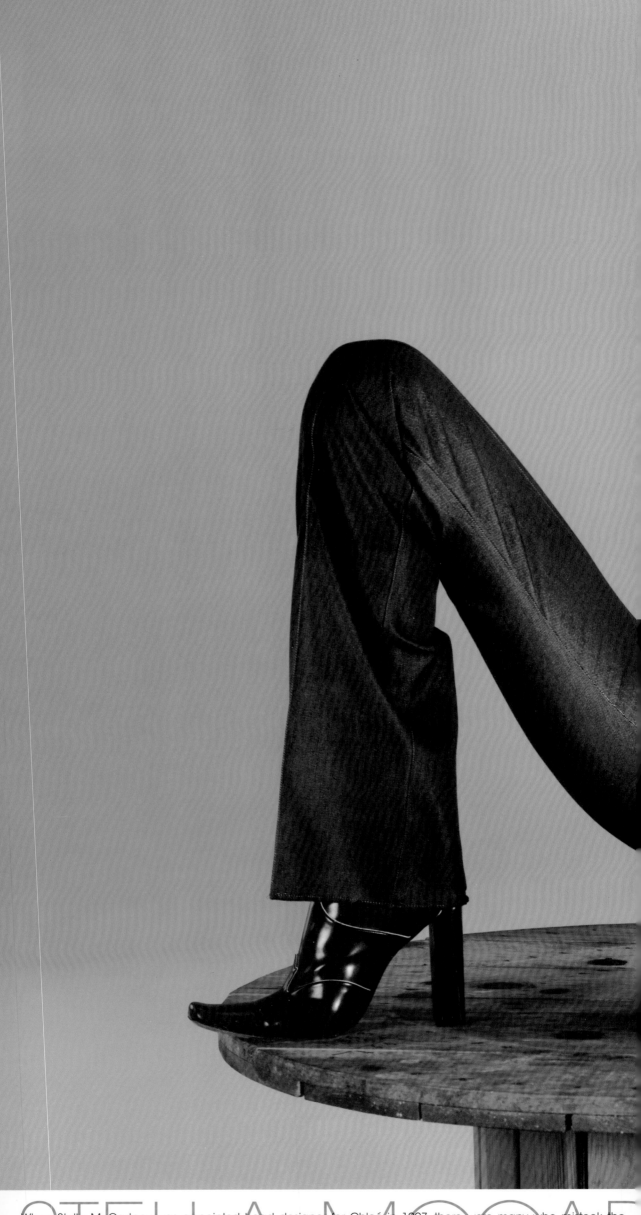

STELLA McCART

When Stella McCartney was appointed head designer for Chloé in 1997, there were many who mistook the hiring of a very young girl with a very celebrated surname as a top-class publicity stunt. It was, however, a canny move on the part of the classic French house, for McCartney's audacious, yet traditional and unapologetically feminine, sensibility is perfectly in tune with Chloé's history as a purveyor of flirty frocks. "I'm not interested in shock tactics," says McCartney. "As a woman, I realize we all want things to wear that enhance our sexuality." In the two years since her move to Paris, McCartney has repositioned the house to appeal to a younger customer and has brought a truly English sensibility to Continental fashion, perhaps more so than any of her fellow designing expats. Trained officially at Saint Martins and on Savile Row and unofficially on the streets of Notting Hill (where her own line was based in the years before Chloé), McCartney unites in her work smart tailoring and an appreciation of pure English fabrics (seersuckers, tweeds, woolens) with saucy bohemian styling. The effect is pure London: a Chloé outfit is one part grandmother's couture attic, one part seemingly secondhand kitsch. For fall/winter 1999,

Photography Marcus Mäm Styling Claire Dupont Makeup Karim Rhaman/Callisté Hair Laurent Philippon/bumble+bumble Location Studio Zero Model Evan/City

this translated into neat and tidy tweed suiting, granny-square ponchos, and the tightest stretch-silk disco jeans since the '70s' Sergio Valente. For spring/summer 1999, there were bias-cut '40s dresses in berry-hued silk, fluttering capelets, and bikinis and T-shirts with airbrushed sunsets straight off the sides of old Chevy vans. Her catwalk presentations for Chloé are deliberately eclectic; McCartney wants her customer to buy the collection in pieces rather than complete looks. "A realistic approach to dress is necessary as we go into the millennium," she advises. "Women need to get a little bit more confident. In fashion, what is modern now is inner freedom and confidence." Eventually McCartney would like to design under her own name again, but for now one line is enough. "Chloé," she explains, "has just evolved from my own label. When designing, I have never thought 'is this Chloé?'" Of course, her responsibility to her French bosses does bring with it a few newfound inhibitions: "I wouldn't do high humor for the house—a pair of knickers with a beaver or 'my pussy' on it. Editors wouldn't get it. If you do something a bit too London, or too pitched at my age group, it won't go over well." —SS

STEPHEN JONES

In a world where the most people wear on their heads is a pair of headphones, Stephen Jones is someone who has always understood the relevance of the hat. It's a gift that's widely appreciated. While Jones has been producing his own collections since 1980, one would be hard-pressed to come up with a designer with whom he hasn't collaborated at some point in his career. There are the likely suspects such as John Galliano, Thierry Mugler, and the houses of Christian Dior and Givenchy, but also the completely unexpected—Comme des Garçons, say; or Jil Sander or Walter van Beirendonck's W< line. Add to this his work with some of the more iconic pop stars of the last two decades (Madonna, Diana Ross, Grace Jones, Culture Club) and you're looking at someone who has come a long way since the days when he thought he might never be able to make a living as a milliner. Jones fell into his craft after he graduated from Saint Martins in 1979. It was a time when fashion was more about personal expression than wearing the right labels. Jones himself was deeply into his Ludwig of Bavaria mode as created by Visconti. Jones had first-hand experience of the more experimental end of millinery.

Photography: Matthew Stylian Green · Katie 1/2L at Language · Make up Nicolas Vesta/Greenex · Hair Fernando Torrent/Dublin · Model Sophie Rise/Select

making hats for the Blitz nightclub habitués Boy George, Steve Strange, and Spandau Ballet, who also happened to be his roommates at the infamous Warren Street squat in London. ("We'd wake up in the morning," Jones once said, "and the place would be surrounded by Japanese tourists.") In 1980, he opened his first shop cum salon in the basement of PX, the boutique where the eccentric hat-wearing denizens of the aforementioned Blitz outfitted themselves. A collection for Jasper Conran in 1981 sent Jones off on one long and rollicking head trip. Before long the '80s (hats for the film *Another Country*, a one-man show at the New York nightclub The Palladium, more hats for Boy George) gave way to the '90s (a slew of fashion exhibitions worldwide, still more hats for Boy George). Jones has offered up both the sublime and the salable, both serious couture quality and a near-surreal sense of humor—from fake zebra trillbies, feathered fedoras, and the fluttery confections that grace the ladies' heads at Ascot and English weddings to the heady flights of fantasy that come out of his numerous collaborations, including tropical palms, a black lace mantilla, and a jaunty pillbox hat made, perversely, from a rattlesnake's skeleton.　　—MH

FINEST SUMMER KID MOHAIR

TIMOTHY EVERE

It makes sense that Gilbert and George—men who have, in their own way, made a case for the importance of a well-cut suit—live only a few streets away from tailor Timothy Everest's shop. Everest's East End is not that of the neighboring media-hyped Hoxton, but somewhere quieter, quirkier, truly English. He is based in a converted house on Elder Street that belonged to the painter Mark Gertler in the 1920s. There are bare wooden floorboards, comfortable, aged leather armchairs, and a vintage copy of *Playboy* just beside *Arena*. Tracks from Air's *Moon Safari*, then a few edited highlights from the Tindersticks, murmur (blast would be too strident here) in the background. The entire house is given over to the Timothy Everest operation: from the basement, where the bespoke shoes are made, to the cutting and fitting rooms on the floors above, where Gertler once painted and penned paeons of love to Dora Carrington (unrequited, incidentally). "I suppose the obvious choice of location was Savile Row," says Everest, "but when I started eight years ago, I couldn't afford to be there. Anyway, I've always loved the places that you have to find—like those secret, hidden bars you have to seek out in London or New York." It's unlikely that

Photography Michelangelo di Battista Styling Aleksandra Woroniecka Makeup Alice Ghendrich/Lighthouse Artists Hair Rolando Beauchamp/ADA Photo assistance Orlando dos Santos

Everest's suits will have slipped by you: most noticeably they were on Tom Cruise in *Mission: Impossible*. He began his career eleven years ago, working for the tailor Tommy Nutter, whose commissions included matching white suits for John Lennon and Yoko Ono. What Everest received from Nutter was a brilliant training in tailoring; like Nutter, he knows when to be earnest and when to be irreverent. "We attract people who buy everything from Chester Barrie (the British Brooks Brothers) to Comme des Garçons here," says Everest. "I think that more people are coming back to bespoke; they don't want to wear labels head to toe." He picks up a beautifully cut and finished coat, which has taken several weeks of consultations and fittings. "I'm waiting for Damon of Fuel (hip graphic design team) to pick this up. He'll wear it with a pair of secondhand trousers and sneakers. When I meet with a client, of course I'll talk about what they want their suit to look like, but I'll also ask them about their favorite music, or the films they love. You have to learn what makes someone tick." He fingers the lapel of the coat. "Getting something made to measure is an addictive process. And best of all, the clothes only get better with age." —MH

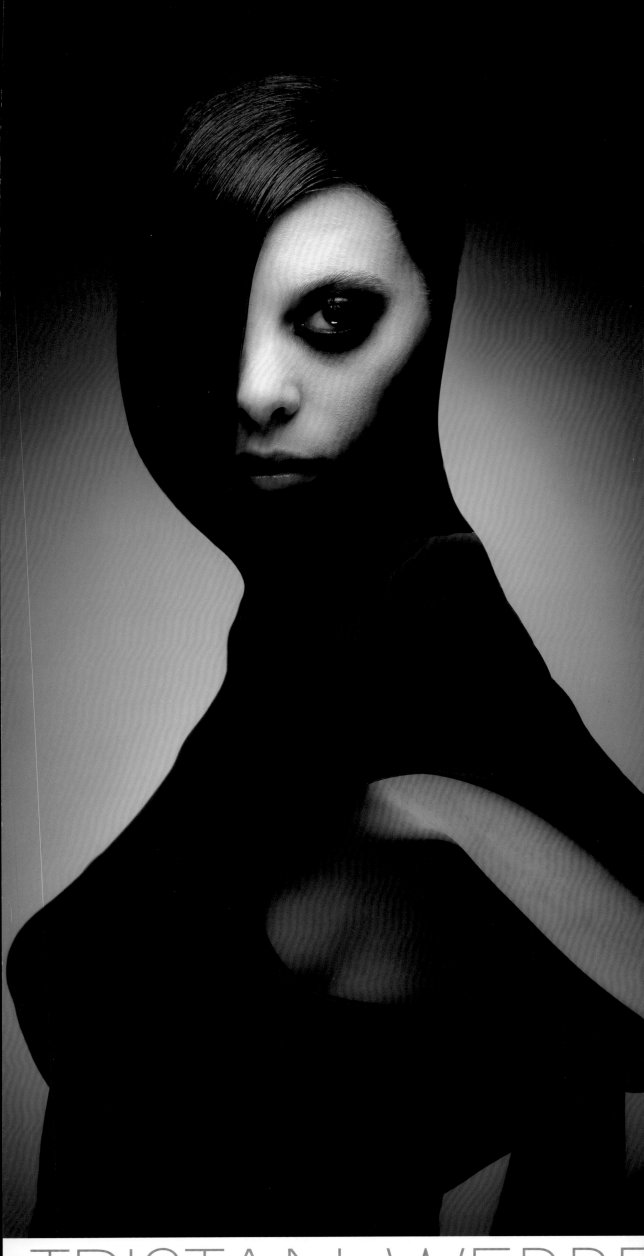

TRISTAN WEBBE

After abandoning the idea of becoming a lawyer and then an architect, Tristan Webber took an interest in fashion. He started looking at magazines and advertising images, noticing not so much the clothes themselves, but the way in which the people in them were physically altered, and the various cut-and-paste methods that had been applied to elevate ordinary people into semi-gods. Webber, who is from outside of London, completed a two-year course at Saint Martins. "I'm always looking for lateral ways to present it, of using information and twisting it," he says. He presented his first collection in 1997. Called "Genus Orchidaon Daemonix," (pseudo-Latin for "Orchid Devils, A Super Breed"), it explored the idea of survival of the fittest, a concept with which the young designer was already becoming all too familiar. Taking inspiration from the complex genetic structures of orchids, the subtle and not so subtle variations within species, and how through diversity and change the plants have been able to survive even the most extreme conditions, Webber attempted to apply this information to women and clothes. And you can bet there was a lot of twisting involved: the seaming on a "dissection jacket"

Photography Sean Ellis Styling Tristan Webber Makeup Lisa Butler/Streeters Hair Neil Moodie/Premier Photo Assistants Gio/Chris Barco artist Hank/Illusion Production Kate Ellis

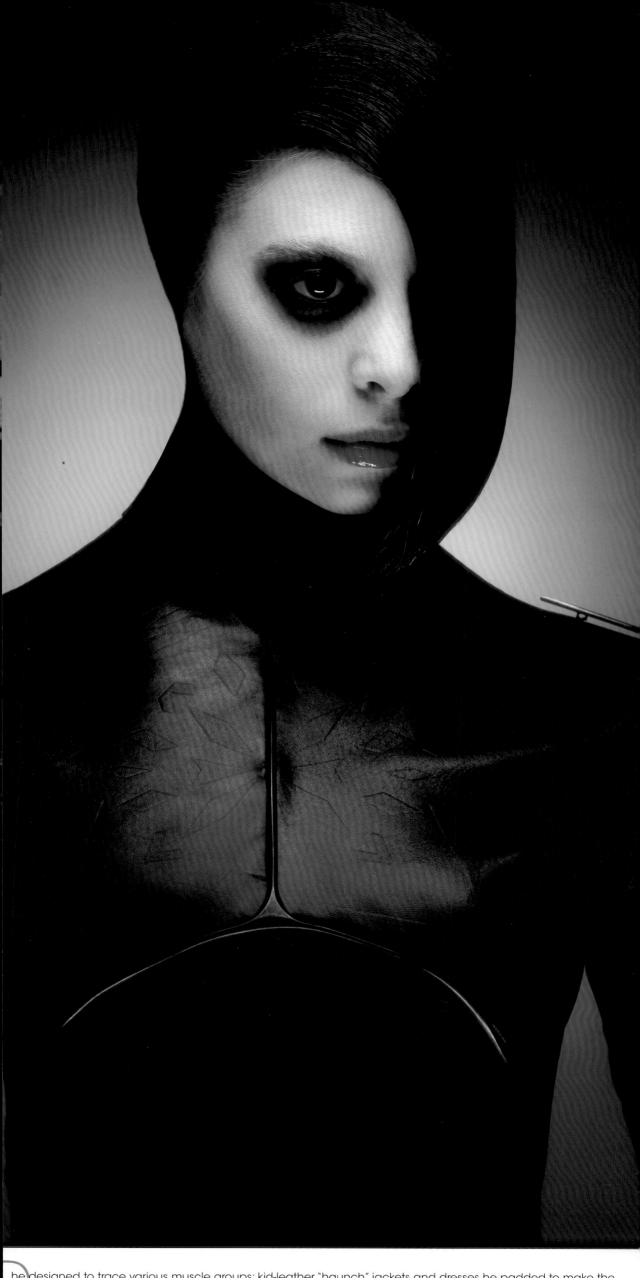

he designed to trace various muscle groups; kid-leather "haunch" jackets and dresses he padded to make the shoulders disturbingly animal-like; sheets of latex he manipulated into contoured body maps; metal was rubbed into certain garments to alter their shape. Since then, each collection has become more technologically involved, his design studio evolving into a science lab. These days, Webber is more likely to have his nose buried in a textbook than in the pages of *Harper's Bazaar*. With "The Orchid Engineer," Webber drew on alchemy and the field of genetic engineering to forge metal into botanical shapes and create a series of amphibian-like leather coats and skirts. When you lay a particular piece down flat, it looks like a botanical dissection, an orchid that goes from three-dimensional to two and is then wrapped around the body. These are clothes cut to prepare the body for anything—battle included. "It's not a morbid fascination," Webber insists of his apparent quest for world domination through the newly invented science of genetic fashion engineering. "We are intelligent enough to decide how we want our bodies to look and clothing is the easiest way."

—AB

"I am intrigued by schoolgirls," explains Véronique Branquinho, "because they are adolescents, and that is the time of life when everything changes, when one has all those complex, confused feelings." Branquinho's fascination with schoolgirls, and her ability to transform the components of their uniforms into things of peculiar downbeat grace and beauty, have made the young Belgian designer one of the most sought-after new faces in the fashion world. Branquinho's work is romantic, gothic, and—oddly, for a graduate of Antwerp's Royal Academy of Fine Arts—traditional. ("I don't think it's bad to be classical," she says. "I really appreciate things that are a little timeless.") In her case, this means long pleated skirts that swish elegantly behind their wearer, high-collared blouses (spring/summer 1999) in silk and poplin, and Shetland wool knits in a rainbow of unusual hues (pistachio, berry, sky blue). The silhouette is always long and severe and, on occasion, layered: for fall/winter 1999, the long, somber skirts were lifted with an internal belt strap to reveal unfrilly petticoats, and knitted legwarmers were pulled up over narrow trousers or under knee-length skirts. The pieces in this collection are those that Branquinho imagines

Photography Raf Coolen Makeup Peter Philips Hair Guido Palau

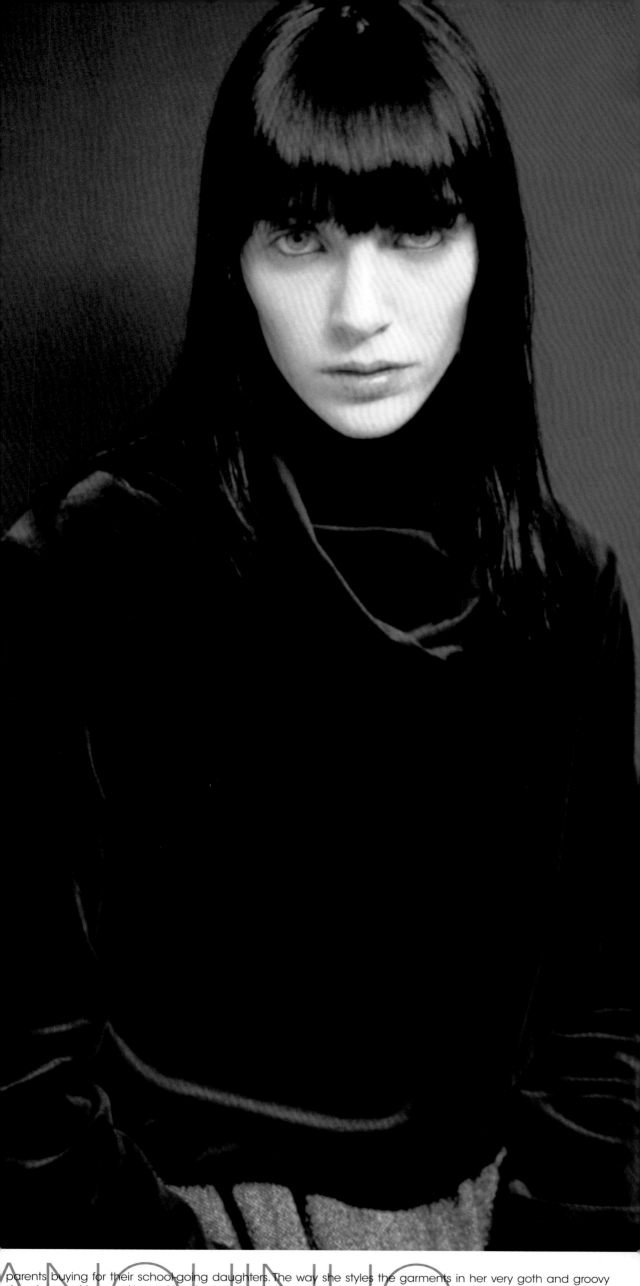

ANQUINHO

parents buying for their school-going daughters. The way she styles the garments in her very goth and groovy show is meant to reveal how girls adapt classic clothing to fit their own generationally specific or personal requirements. The strength of her work is that it manages to succeed on both levels: it appears hip enough to appeal to those who want "edge" (that mystical attribute), and it is exquisite enough in terms of design and textile quality to be a truly indispensable investment. Belgian fashion, according to Branquinho, is serious and introverted, and exudes a quiet intensity ("it's not a loud fashion—it's not screaming for attention"). With Raf Simons, Branquinho produced two collections for the Italian leather goods house of Ruffo Research. The woven leather strapless ball gowns in chocolate and black, for fall/winter 1999, and the puffy down-filled parkas in white and red leather were acclaimed as the most chic street style ever. But now that the contract with Ruffo has ended voluntarily, Véronique is relieved. "I didn't feel comfortable about it at the end; I'm not very comfortable selling my name," she says. "I'm a person who wants to be in control of everything," she adds, without a trace of schoolgirl bashfulness. —SS

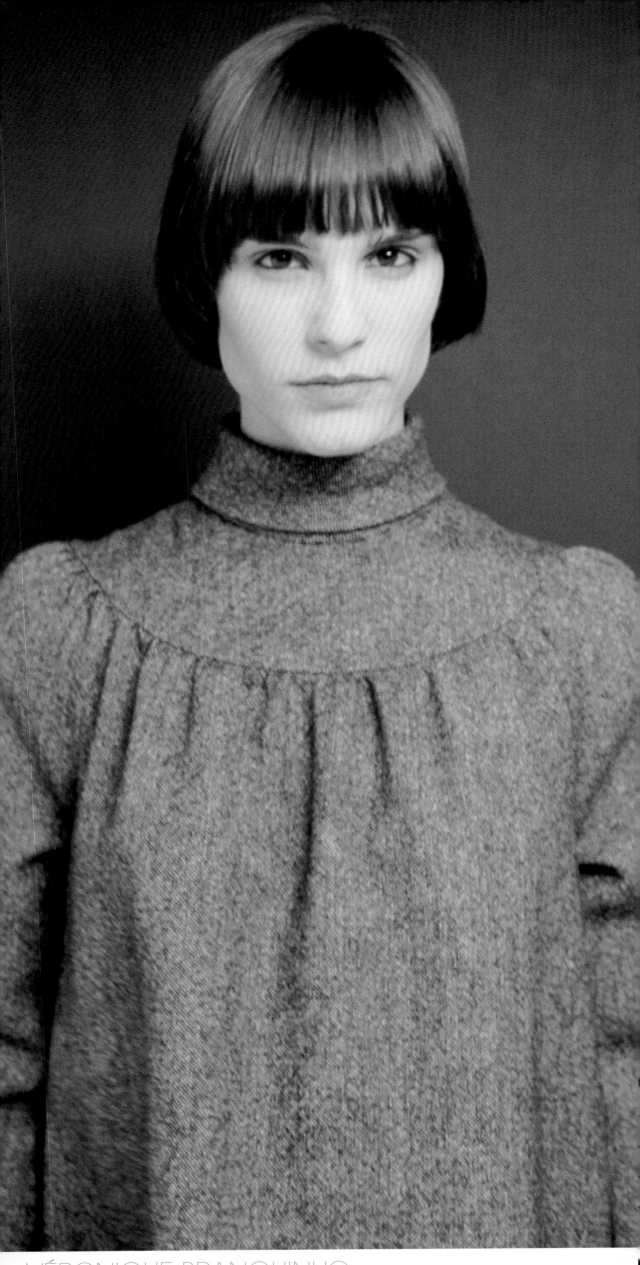

VÉRONIQUE BRANQUINHO

> Photography Raf Coolen Makeup Peter Philips Hair Guido Palau

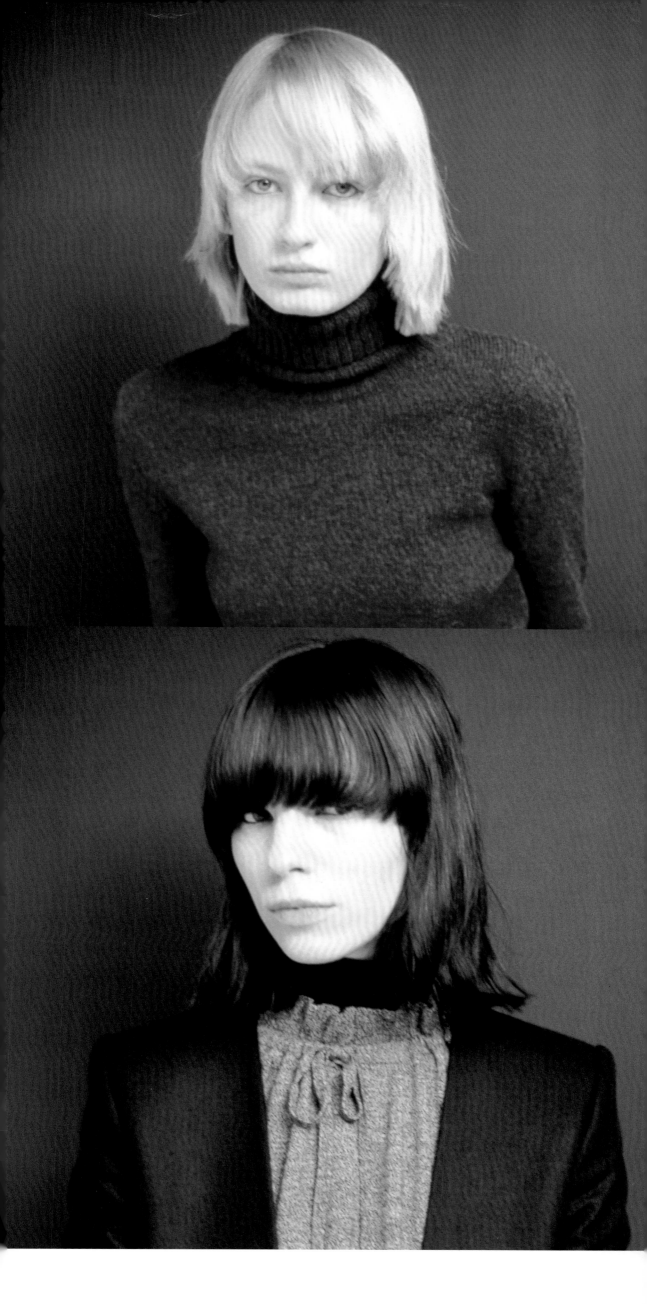

VIKTOR & ROLF

Viktor Horsting and Rolf Snoeren have been the inspiration for much of the new generation of Dutch fashion designers. Their visually arresting, highly conceptual clothing has defined the new wave of Dutch fashion both in look and, more significantly, in spirit. Horsting and Snoeren met when they were both students at the Arnhem Academy of Art; they graduated in 1992. From the beginning they have been focused on the constructs of fashion—glamour, commercialism, status—rather than on fashion itself. Clothing is often completely beside the point. "Fashion doesn't have to be something people wear," they say. "Fashion is also an image." The two became known for staging exhibitions and happenings as part of an ongoing commentary on the state of the fashion world and their own outsider status. These have included gallery installations, the creation of a fake perfume, and a strike. "We're not only about being hysterical, being clowns," they say in their defense. "It's very easy for people to make a joke out of what we do." With their first real runway show, presented during the Paris couture, they proved they could be taken seriously as designers. The technically sophisticated, jarringly elegant clothes

Illustration Mats Gustafson

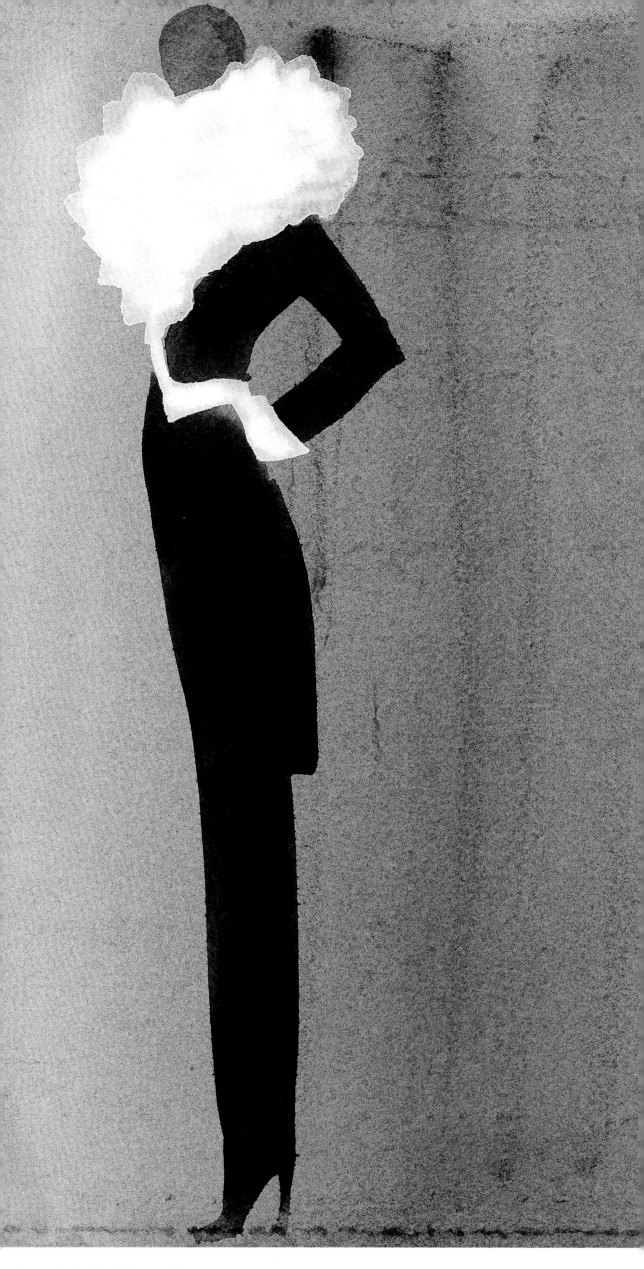

demanded a double-take. In fact, with three couture collections behind them, they've established a runway program based on this very idea. In their January 1999 collection, for example, models first walked out under black lights that in a ghostly fashion picked up only the white elements of each ensemble—a frilled ruff or a strand of trailing ribbon. The entire lineup then reappeared under normal lighting, revealing variations on the black tuxedo. The fact that these ensembles were all one-offs not intended for production, however, kept them stubbornly aloof. This black-and-white collection, which reprised an inventory of shapes the two had been working on since the beginning of their careers, was really about stepping into the light, showing people that they were ready to play on a big stage. "Until now our work has been very personal, haunted by our own demons. But we have conquered them," they say. The next step for Viktor & Rolf may very well be a commercial one. They would like to create a real perfume. And they are even thinking about doing a line of ready-to-wear. Already they are developing the concept: "It has to be different from what we do now," they say, "and from everything that is already out there." —AB

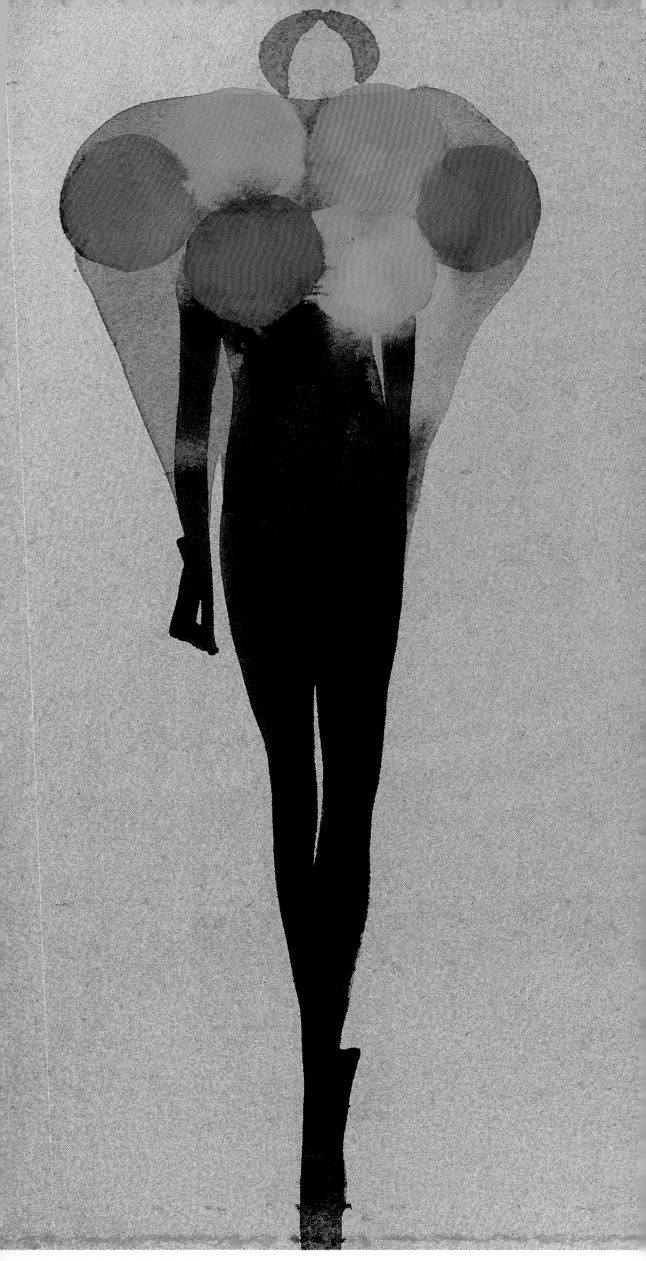

VIKTOR & ROLF

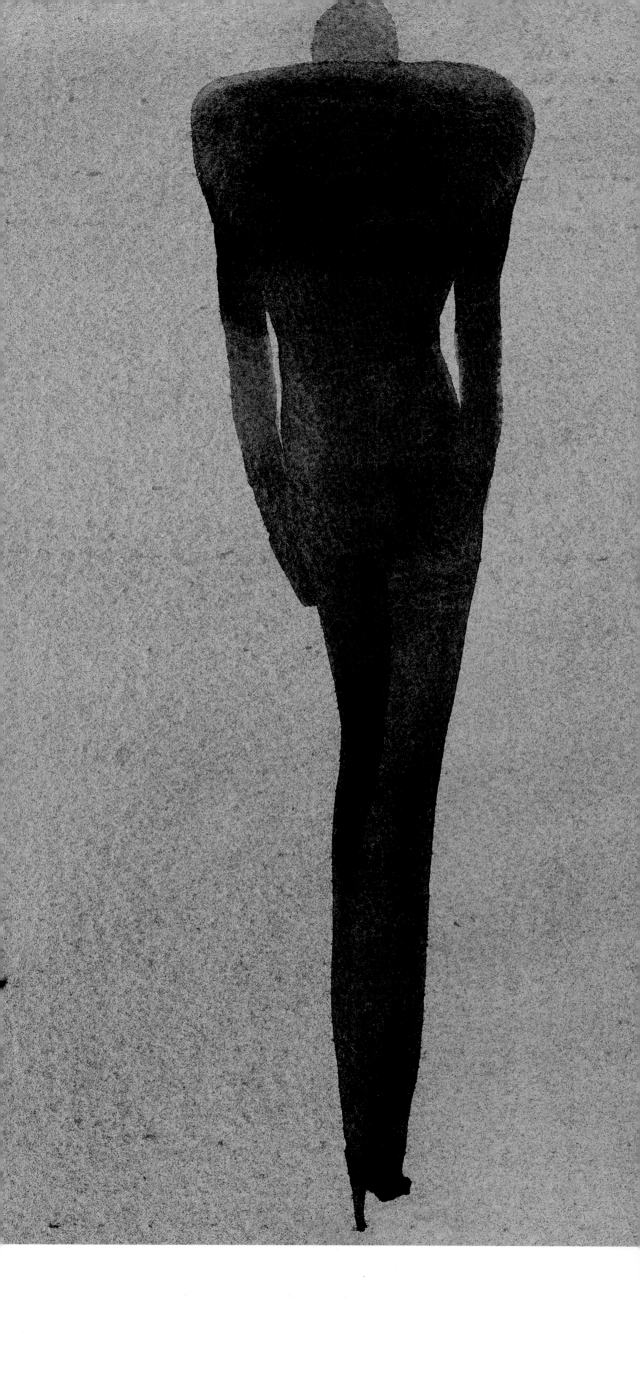

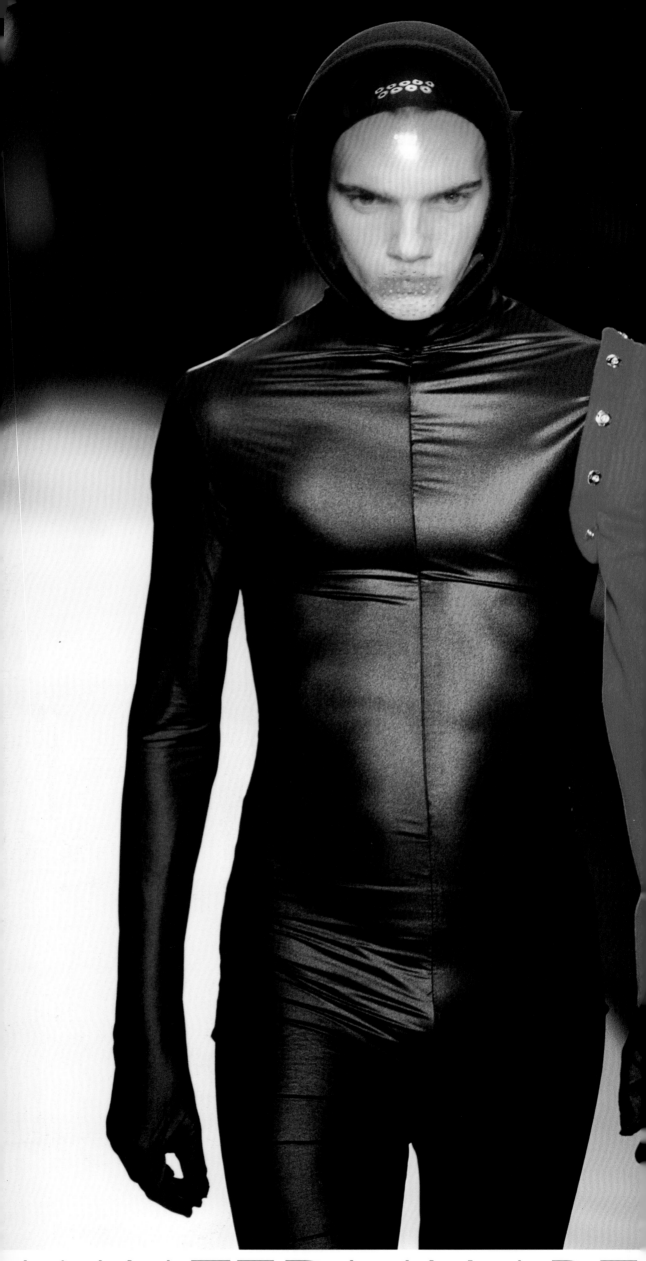

WALTER VAN BE

Walter Van Beirendonck was one of the original Antwerp Six—a group that included fellow Royal Academy of Art alumni Ann Demeulemeester and Dirk van Saene. But from the very beginning, the unflappably avant-garde Van Beirendonck stuck out from this predominantly deconstructionist pack. His colorful, optimistic, and futuristic stance couldn't be further from the earthbound aesthetic that defined that moment if Van Beirendonck had been sent to us in this fashion world from another planet. Walter Van Beirendonck launched his signature line in 1983. But he is perhaps best known for designing W<. Dating back to the mid-1990s and backed by the German company Mustang, W< stood for Walt (Van Beirendonck's nickname), but also for Wild and Lethal Trash. "Wild is obvious," Van Beirendonck once explained. "Lethal is something that can be over-the-top, like you are lethal in love. Trash stands for consumption and throwing away." As a testament to the constantly expanding reaches of his imagination, and to fashion's ultimate power of transformation, he once had himself photographed as part man, part dinosaur. Van Beirendonck's out-of-this-world ideas and even more out-of-this-world

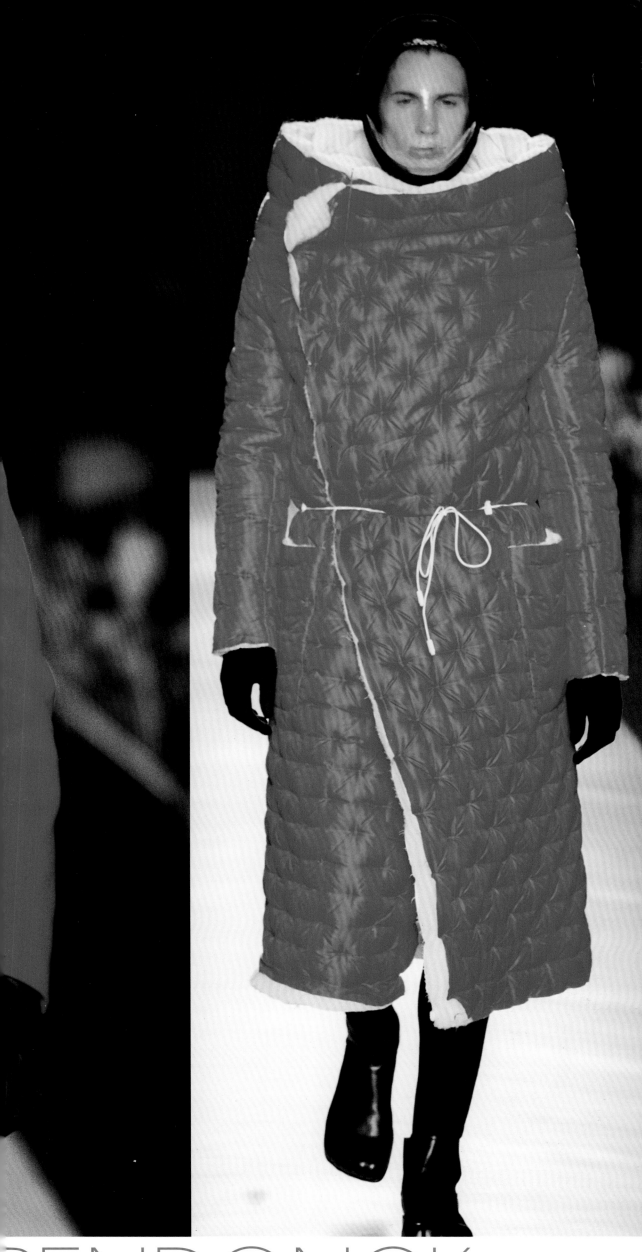

RENDONCK

ways of presenting them soon caught the eye of the members of U2, who later commissioned him to create cos-
tumes for their *Popmart* tour. The Edge's cowboy look and Bono's "Fly 2000" were inspired by cartoon superheroes
and action-man dolls. Some think Van Beirendonck's clothes are amazing. Some think they are amusing. Others
have found them vaguely disturbing. "I think the best interpretations were from the rubber show," Van
Beirendonck once said. "I did 120 men covered in rubber latex and then on top I put the clothes. For me, the
idea was an ecological statement. Some people saw it as a safe-sex message. Others saw it as an S&M thing.
So many interpretations. I was amazed!" Now that his relationship with Mustang is over, Van Beirendonck is
returning to research and the original spirit of his work. In January of 1999, Walter Van Beirendonck made his run-
way debut at the age of forty-two. The collection, called "No References," was a series of studies in cut, a new
archetype for menswear, without allusion to the past, other cultures, or other fashion movements. Members of
Van Beirendonck's extensive toy collection, all seated prominently in the front row, were there to cheer him on. —AB

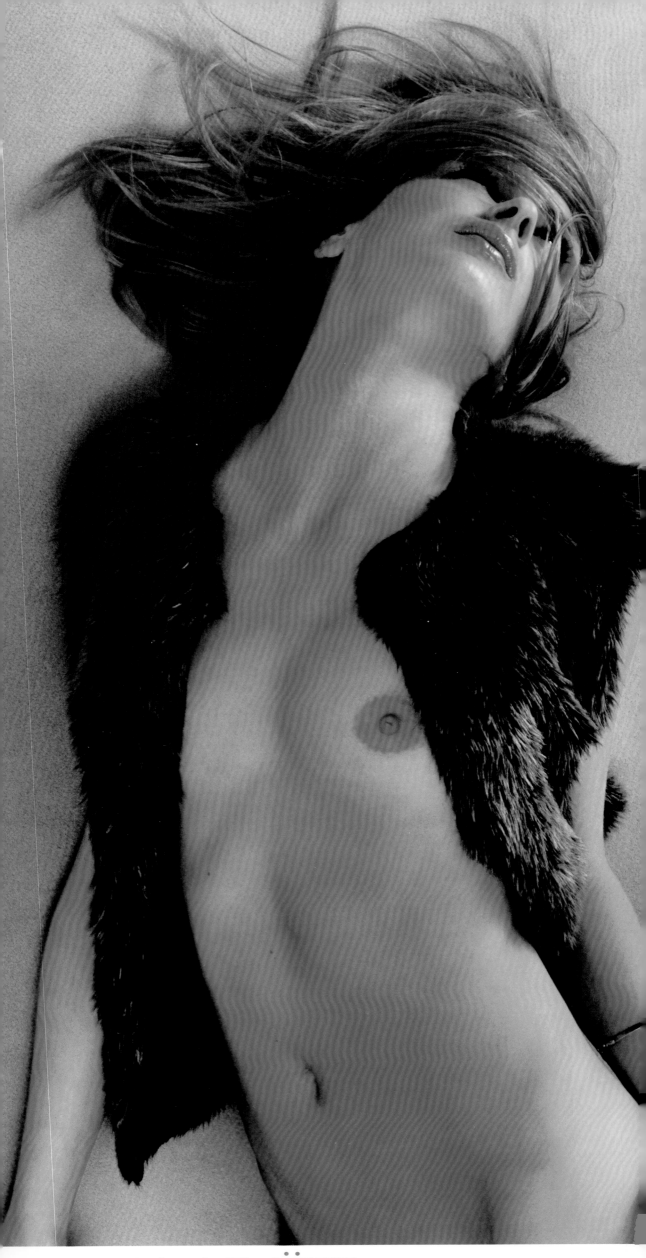

XULY BËT

Lamine Kouyate's Xuly-Bët label was launched in 1991 in Paris to immediate critical acclaim. The Mali native's layering of slinky, patterned stretch-knit tube dresses, skinny suits, wildly colorful African-inspired graphics, and doctored secondhand gear fit well with global pop culture's embrace of postmodern kitsch and world-beat aesthetics. Kouyate and his "funkin' fashion," as he calls it, became such a super-hip phenomenon that Robert Altman parodied the young designer's peculiar brand of celebrity in the film *Prêt-à-Porter*. Nearly a decade later, the hype around Xuly-Bët has subsided, and Kouyate can now get on with the business of designing his highly personal and wickedly sexy line of clothes. Working with a team of eight, he still recycles vintage gear and textiles, bought at flea markets across Paris, into modern shapes (for fall/winter 1999, patchwork knit blankets became earthily glamorous separates). And the clothes are still super-tight: lycra tube dresses are a constant in every collection, although a Xuly-Bët customer never wears just one at a time, and never only as a dress (consider a skirt, a tunic, and a head wrap). Xuly-Bët menswear is equally body-conscious: shirts, jackets, and trousers

Photography Dana Menussi *Makeup Tracey Murphy/Jed Root* *Hair Dan Sharp/Garren* *Model Kim Iglinsky/Women*

hug the body with a *Boogie Nights* luridness. ("Maybe it comes from the '70s when I was young," says Kouyate, "but I like to see the body.") Proportion, however, is always at the center of his thinking. Kouyate trained as an architect in Paris before turning his attention to sartorial pursuits, and his design process borrows much from his thinking about physical forms—both man-made and natural. There is a logic to Xuly-Bët eclecticism, a thought-fulness about the way patterns and colors are made vibrant through layering, about the playful sensuality that is evoked when a snug jacket skims the top of even snugger hips. It is not clothing for everyone. But the spirit behind the clothes—which is always evident at Kouyate's rollicking, exuberant runway shows—is groovy, gener-ous, and inspiring. At the century's turn, the global nomad—a person who can pick up and fit comfortably in to all cultures—is the true fashion icon of the times. And given Kouyate's pack-and-go stretch knits and polyesters, his unprecious and environmentally friendly appropriation of vintage items, and his freehand mixing of African and European designs, Xuly-Bët is the label that most embodies that nomadic sensibility. —SS

YOSHIKI HISHINUMA

Ask Japanese designer Yoshiki Hishinuma how he keeps his creativity fresh, and the subject of food inevitably comes up. "I love cooking," he says. "My cooking comes from the old Japanese traditional cuisine, and I often go to the Tsukiji fish market, which is the biggest fish market in the world, to see the fish first. The cooking process is sometimes very similar to designing clothes." Sound a little far-fetched? Well, consider the following: once Hishinuma wanted to make a three-dimensional dress without using a conservative process such as sewing. He created a large wooden frame and covered it with a piece of special fabric and placed the entire thing in a large oven. With the application of heat, the fabric shrunk down into the form of a dress. He called this technique Propella Dress and he has used it in many of his collections. See? Cooking. For Hishinuma, the making of materials—like the selection of ingredients—is the most compelling part of the creative process. He has been known to fuse materials together into strange and wonderful hybrids, or concoct specialty fabrics (in a recent collection polyester was made from Lycra, synthetic suede thread, and gloss enamel). "I'm very interested in high technol-

Photography Elsbeth Struijk van Bergen Styling Wouter van der Tol/Unit Makeup and Hair Mylene Jansen/Angelique Hoorn Model Lymke/Steff Modelmanagement

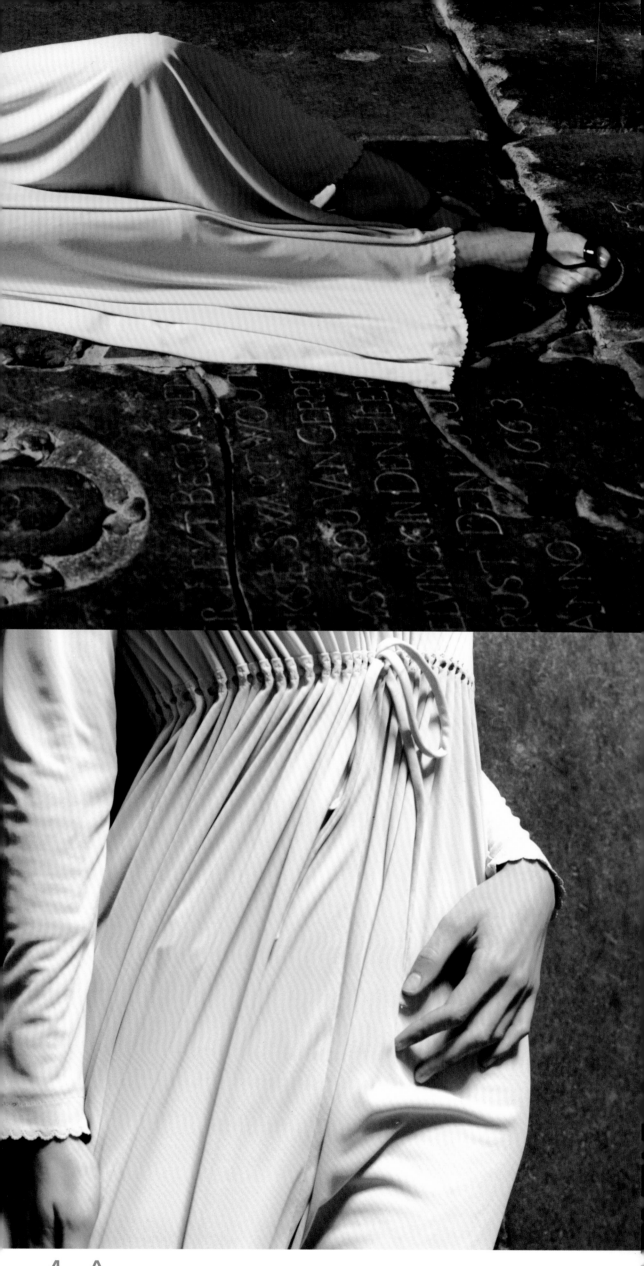

ogy," he says. "Probably living in Japan has a lot to do with it." Hishinuma was born in Sendai. As a high-school student, he was already cutting up clothes and putting them back together again. He studied fashion at Bunka College but found the program "completely uninteresting" and left to become an assistant to Issey Miyake. Even while Hishinuma learned from his hands-on experience in Miyake's studio, he fought with his employer nearly every day. Miyake would say to him, "This is my studio—not yours." Hishinuma lasted there only eight months. After winning the New Designer Prize at the first Mainichi Fashion Grand Prix, he created his first official collection in 1984, something he describes in hindsight as totally out of fashion. "It was absolutely impossible to wear in town," he says. But people in the art and architecture world thought it was great. Architecture is another of Hishinuma's passions, second to cooking. "I admire Buckminster Fuller the most," says the designer. "Most architects create style, but he created construction." And one has only to look at Hishinuma's ballooning jacket modeled after Frank Gehry's Guggenheim Museum in Bilbao to see that the chef is also a master builder himself. —AB

Stephen Gan is the founder of Visionaire
and the director of Visionaire Design.

Alix Browne is an editor at Visionaire
and a freelance writer in New York City.

Mark Holgate is fashion features editor
for British *Vogue*.

Sally Singer is the fashion director
of *New York* magazine.

This book would not have been possible without the tireless help and dedication of the following people: Sarah at Colette; Ivan Bart at IMG; Kuki de Salvertes, Jérôme Momenteau, Claus Estermann and Jonathan Ferrari a Totem; Sylvie Grumbach, Nicholas Delarue and Bruno Michel at 2e Bureau Priska at Raf Simons; Kate Monckton at Abnormal; Kate Larkworthy; Guillaume Chaillet at PRESSing; Sophie Pay at A.F. Vandevorst; Elsa Arras at Walter van Beirendonck; Sarah Seyfried, Patrick Corcoran and Alessandro Magania at The Agency; Karla Otto; Hallie Logan and Jillian McVey at Purple; Sara Kapp a Lawrence Steele; Emma Birney at Timothy Everest; Amy Matravers at Beverley Cable P.R.; Christiane at Akira Isogawa; Moya Hanif-Banks at Transit; Fiona a Stephen Jones; Léila Campbell Badiane at XULY.Bët; Mandie Erickson a Seventh House; Victoria Hennessy at Chloé; Kate Ellis; Kim Sion at Smile; Marie at Quartier Général; Nick King at Francesca Amfitheatrof; Stephanie Berthelo at Fred Sathal; Jae Choi at Art+Commerce; Philippe El Koubi; Massimiliano d Battista; Yasmine Eslami at Bernhard Willhelm; Aurora Lopez at Taller Talavera Eugenia Melian and Marc Zaffuto; Laurence at Service Presse; Sean Dixon a Richard James; Catherine Demeester; Emma Wheeler at NK; Fanny Martel a Rodolphe Menudier; Frédérique Lorca; Jasper Bode, Tim Groen and Doe Blerma at Unit; Philip Stephens at Concrete; Charlotte Miran at RHAMSA; Malou at Christian Louboutin; Alexander at Kostas Murkudis; Laurent Suchel; Justine a Relative Public Relations; Dennita Sewell at Visionaire. And tremendous thanks to all of the designers and photographers whose incredible work provided the inspiration and the substance for *Fashion 2001*. You know who you are.